GALLERY 1988's

CRAZY4CULT

CULT MOVIE ART

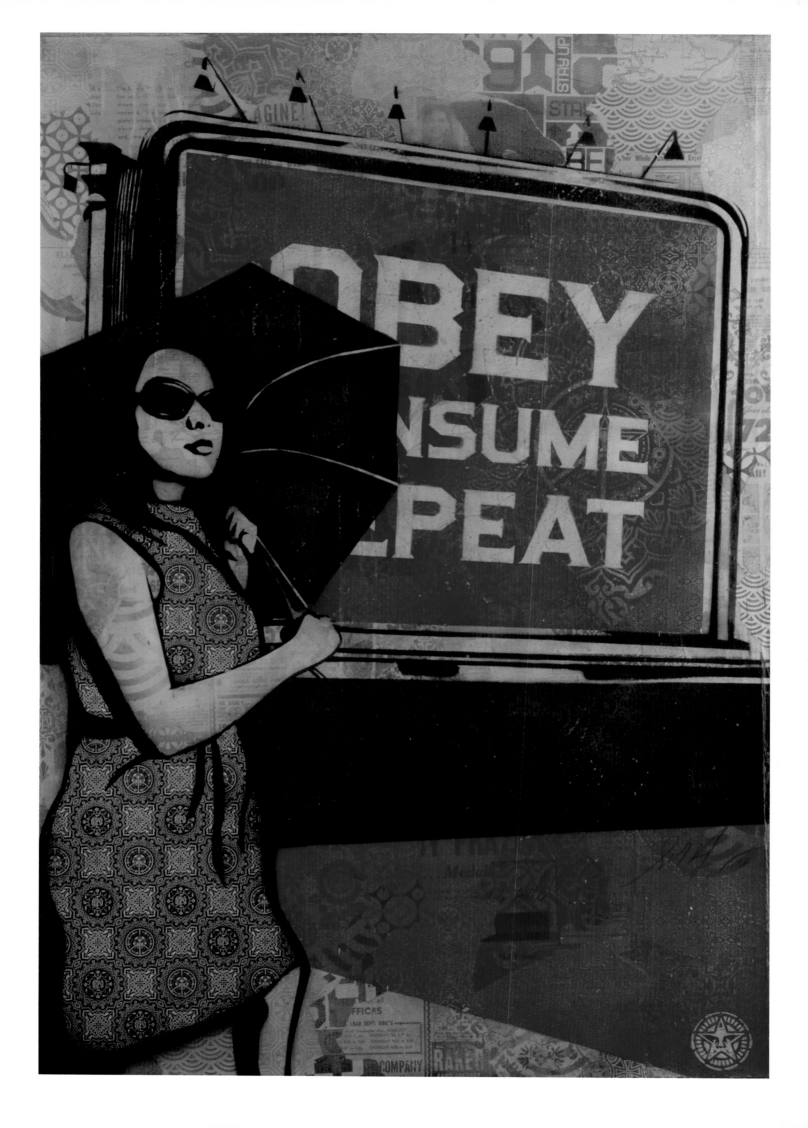

GALLERY 1988's

CRAZY4CULT

CULT MOVIE ART

INTRODUCTION BY

KEVIN SMITH

TITAN BOOKS

KEVIN SMITH

IN THE BEGINNING...

Over the course of my 40 years here on the big blue marble, I've had many original concepts hurled at me via all manner of man and media. But in the pantheon of truly great ideas, only one stands out as so perfectly obvious, brilliant, creative and fun that I literally leapt into the air and stamped down hard on the ground with both feet – like a thwarted cartoon villain.

My physical outburst – which is noteworthy for how rarely I ever exert myself, let alone express any emotion with motility of any kind – was an expression of both joy and rage: joy because the idea was so fucking keen, rage because I shoulda thought of that shit MYSELF.

Crazy 4 Cult was that idea.

Scott Mosier was merely the messenger for the idea but he was the only actual witness to my display. After remarking that he'd never seen me move that fast even for food, he continued his explanation.

"This guy Jensen owns this really cool art gallery on Melrose called Gallery 1988. I go in there a lot and we got to talking. He knows I do the flicks with you and he's got this idea for a show where artists paint cult-movie themed pieces."

"It's like a painted version of slash fiction," I observed.

"What's that?" Mos asked.

"People take their favorite characters from movies, tv, comics, etc. and write stories about 'em – all usually involving those characters fucking."

"Get out of here."

"s'True. I read one once where Jay and Silent Bob start sucking each other's dicks."

"Bullshit!"

"I swear. You can find it online still, I think."

"Was it hot?"

"It WAS, a little – in that 'It's been awhile since I jerked-off thinkin' about a guy' kinda way."

Then, there was this weird bit of silence, after which Mos asked, "You think about guys when you jerk off?"

"Nooo!" I rolled my eyes. "Just, like, once a year. Usually a three-way fantasy where a dick winds up in my face and in that moment, I've gotta decide how polite to be."

Mos changed the subject after that. It was really awkward. Still hasn't been right since then, as a matter of fact. Sometimes, you can just say too much, I guess.

Anyway, Crazy 4 Cult is a genius idea, and Jensen is a smart, funny guy (seriously – read his Tweets). I've known him for almost five years now and we've NEVER had one of those weird conversations like I had with Mosier – where Mosier kinda admits he masturbates thinking about guys (which is how I tell the story now, ever since... I re-read what I wrote above).

I've never had my ego boosted so much as when I spend beaucoup art bucks on eye-poppingly beautiful painted canvases that featured ME. Being involved with this show as Scott and I have been since year one is a real feather in my cap (and a drain on my wallet; I can't NOT buy Jay & Bob pieces). And as far back as year one, I kept bugging Jensen about putting all these incredible pieces under a cover, so cats who couldn't make the show could at least see the painted magnificence after the fact. Big props to Jensen and Titan for getting it done.

No words I use here can prepare you for what you're gonna see inside: artists painting other artists. Andy Warhol would be so proud. Fuck all this chatter... LET'S GO TO THE MOVIES!

Kevin Smith
2/22/11

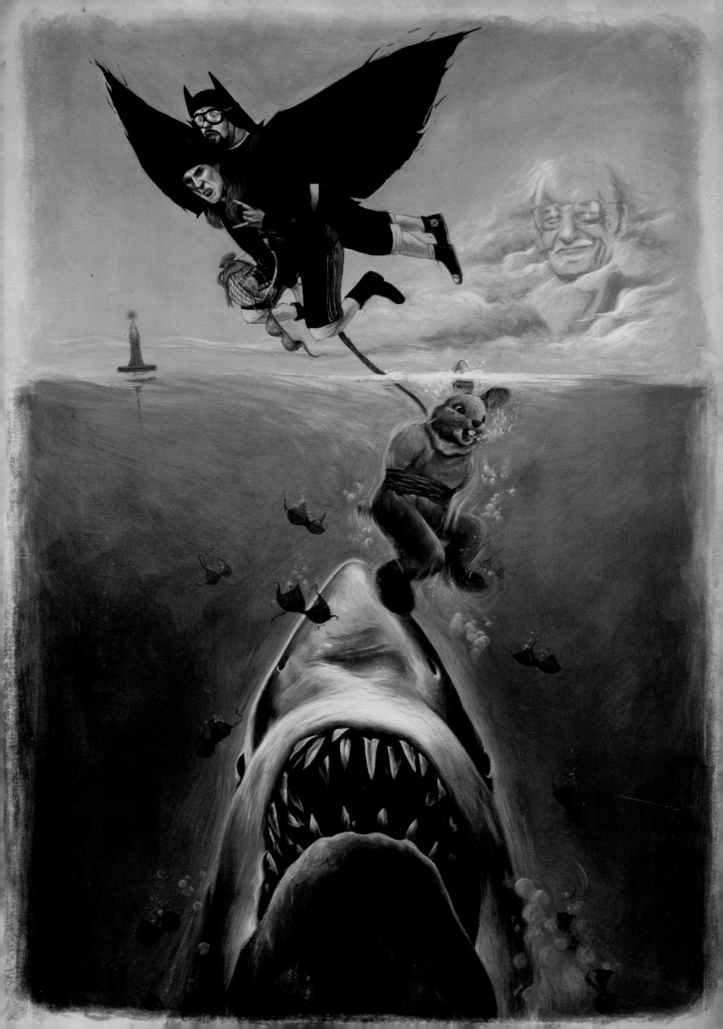

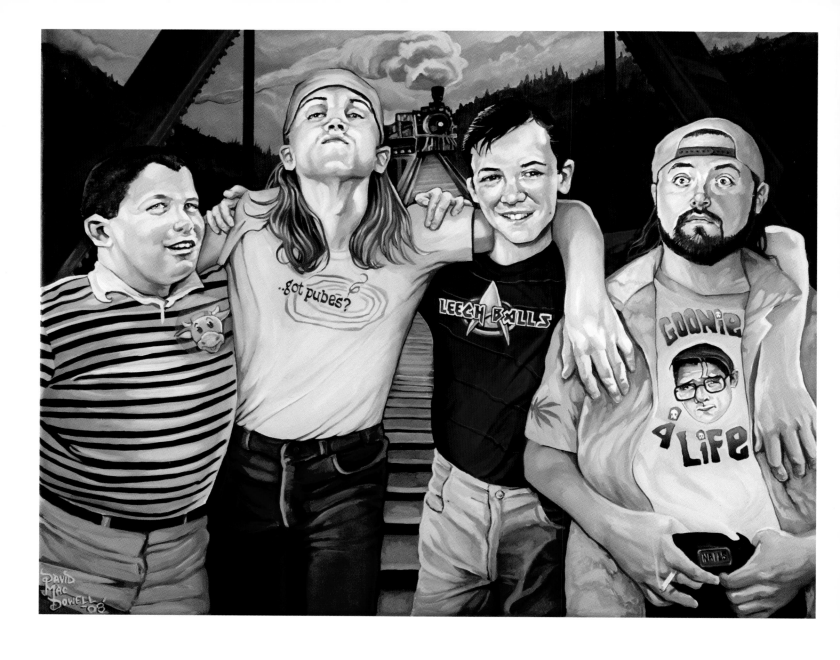

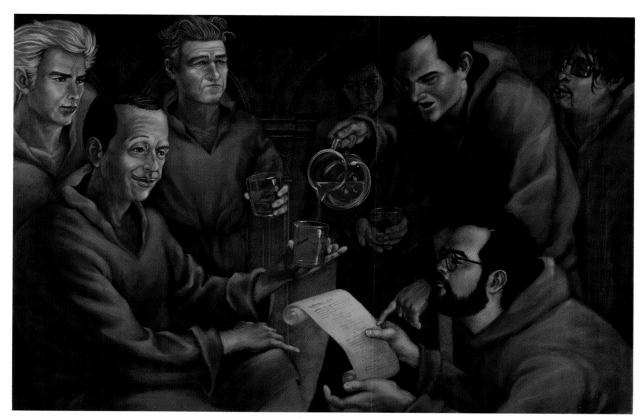

Above:
Dave MacDowell
'Stand By Snootch'
Acrylic on canvas, 16 x 12 inches
Stand by Me and Clerks

Right:
Casey Weldon
'The Reading'
Acrylic on wood, 30 x 20 inches
**Various cult movie
directors, from left to right:
Jim Jarmusch, John Waters,
David Lynch, Wes Anderson,
Quentin Tarantino,
Kevin Smith, Tim Burton**

Opposite:
Jon Smith
'The Mallrats: Kevin Smith Sized
Annual'
4 color screenprint,
16 x 23 1/2 inches
Mallrats

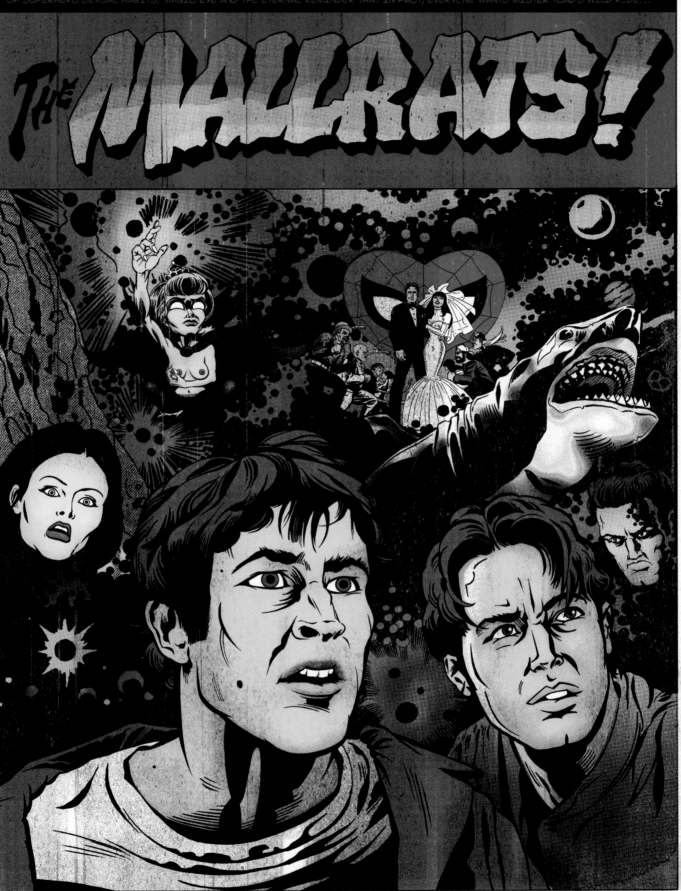

Above:
Keith Noordzy
'Not Impressed'
Pen, ink and watercolor on
paper, 11 x 14 inches
Dogma

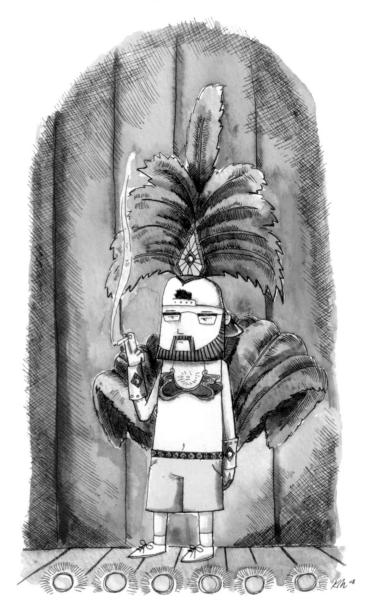

Above:
Keith Noordzy
'Bitch, what you don't know about me I
can just about fit into the Grand fucking
Canyon'
Pen, ink and watercolor on paper,
12 x 18 inches
Chasing Amy

Right:
Laz Marquez
'Self-Respecting Consumers'
Giclee print on Epson Ultrasmooth Fine
Art Paper, 19 x 25 inches
Mallrats

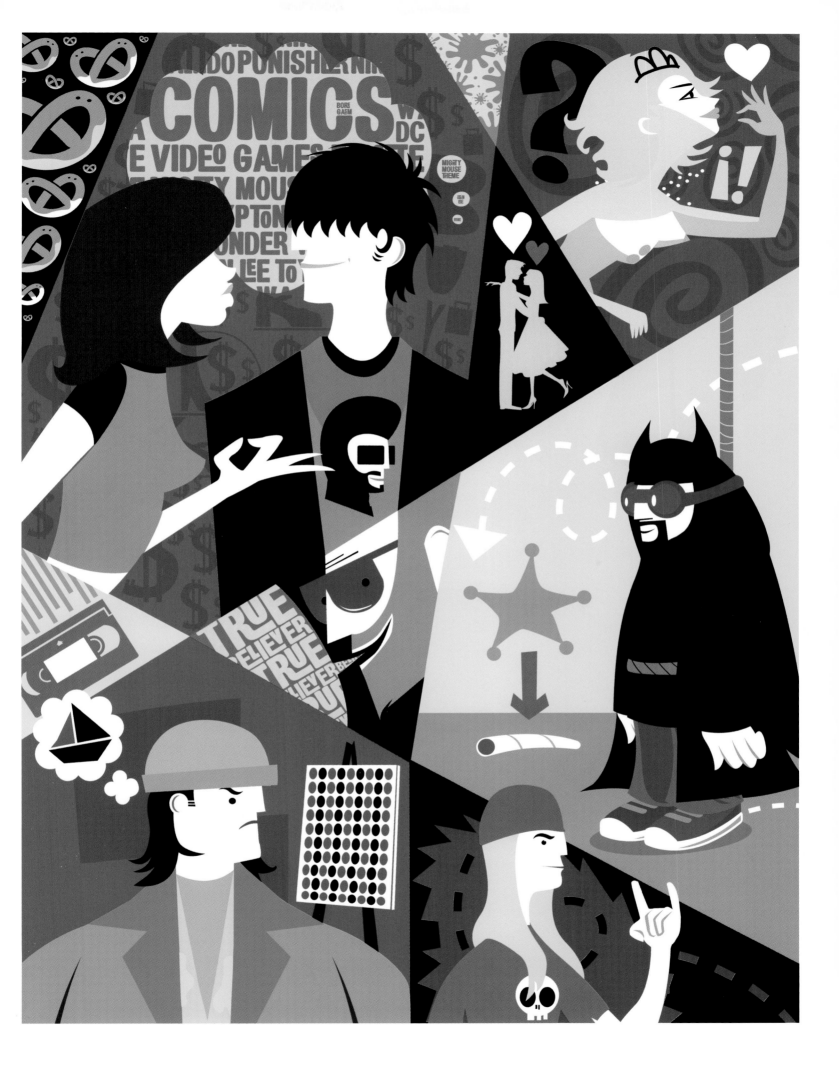

9

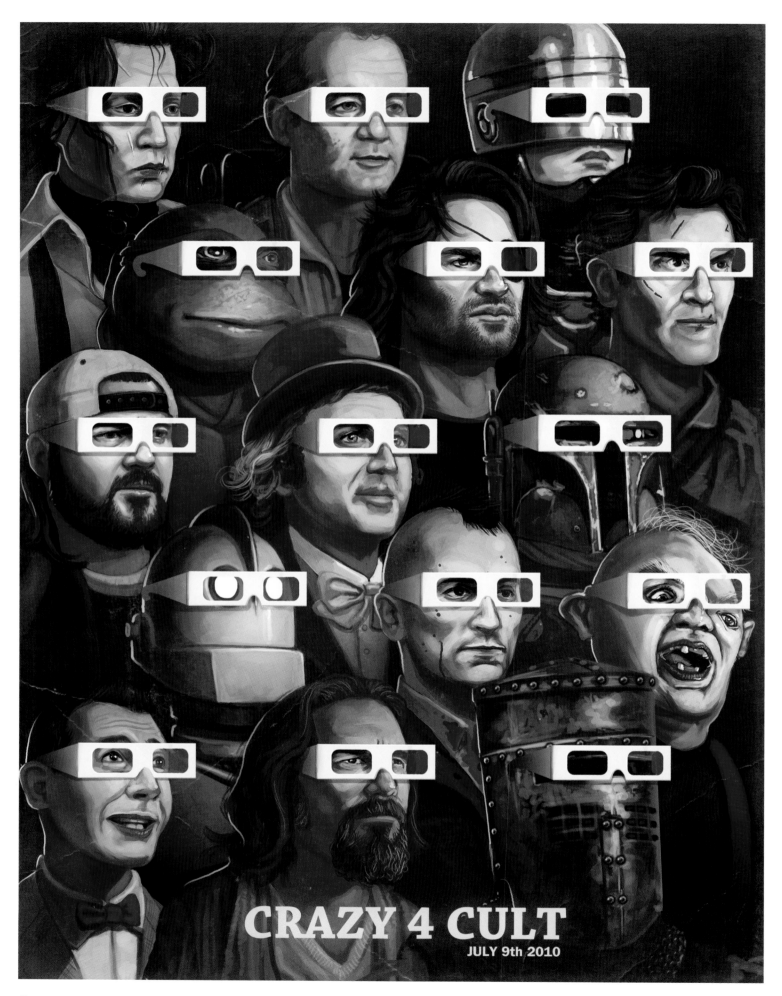

CRAZY 4 CULT

JULY 9th 2010

Above:
Mike Mitchell
'Crazy 4 Cult 4 Show Poster'
Digital print, 18 x 24 inches
Various cult movies

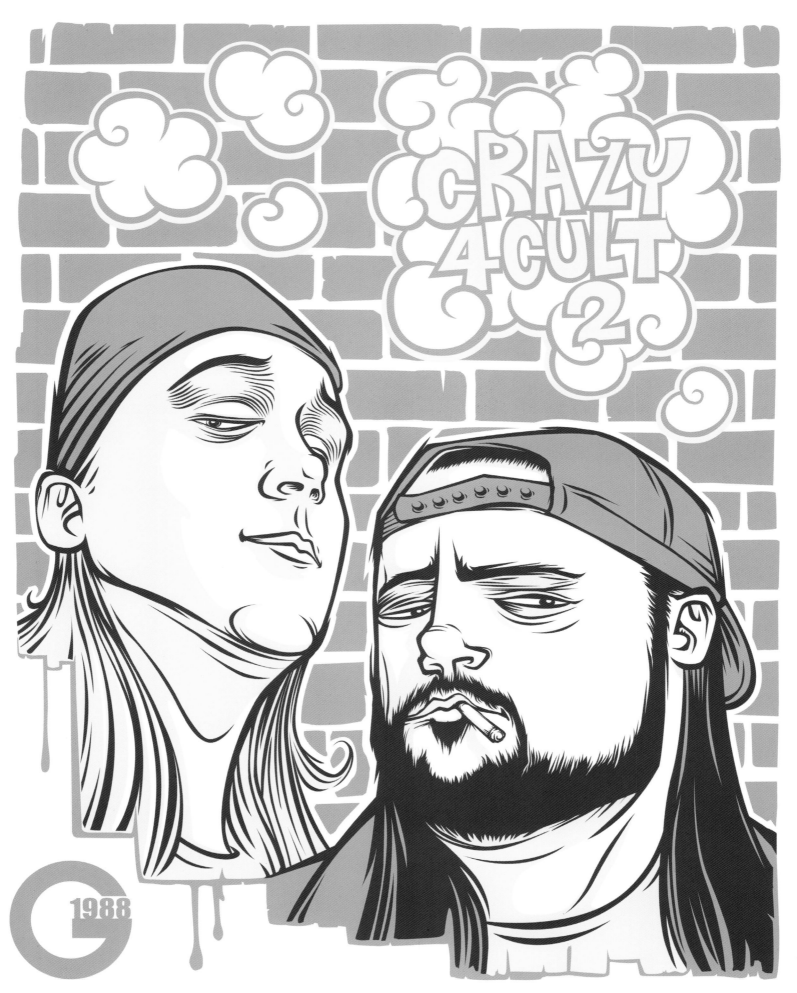

Above:
Reuben Rude
'Jay and Bob'
Hand-pulled screenprint, 16 x 20 inches
Clerks

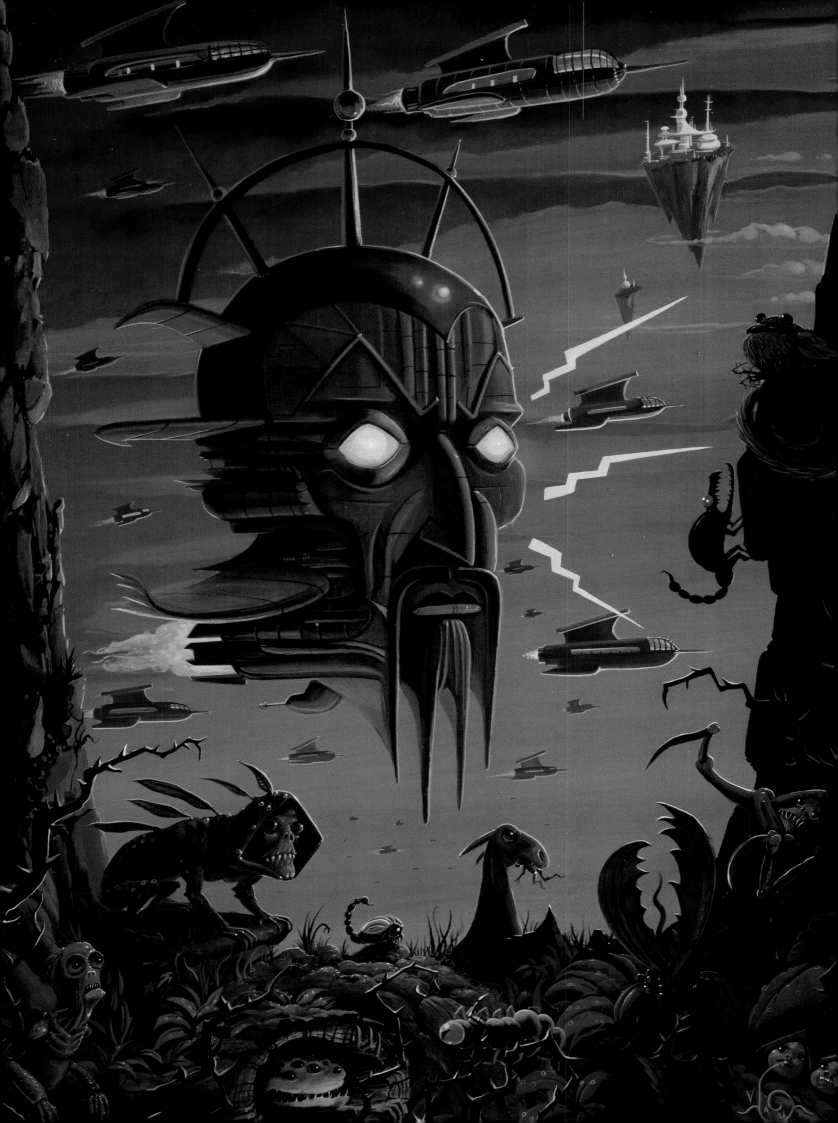

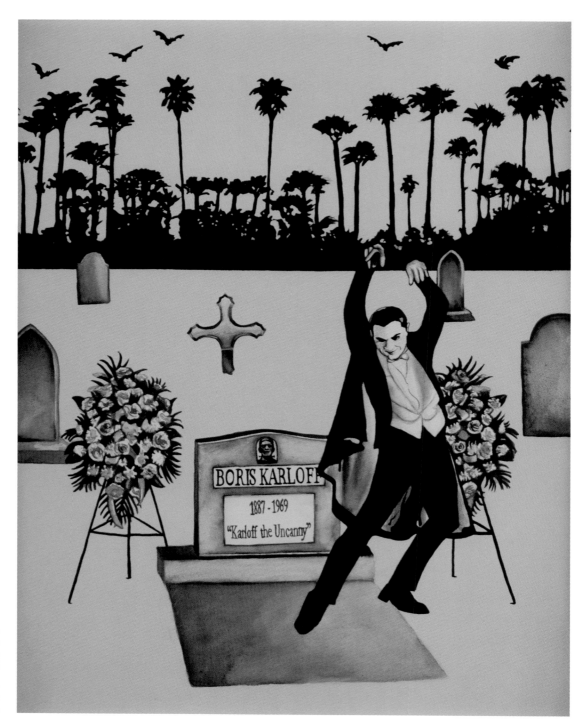

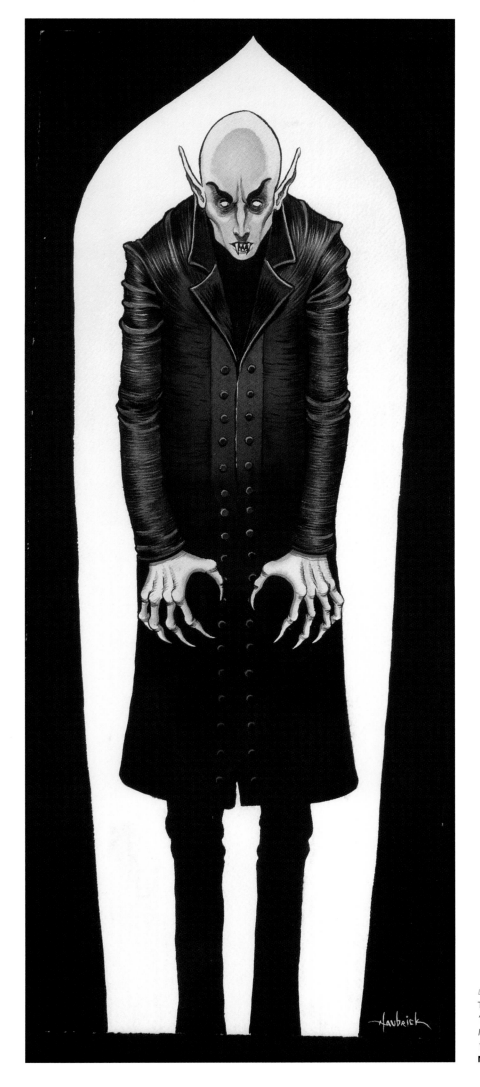

Left:
Tom Haubrick
'Nosferatu'
Ink and wash on paper,
10 x 20 inches
Nosferatu

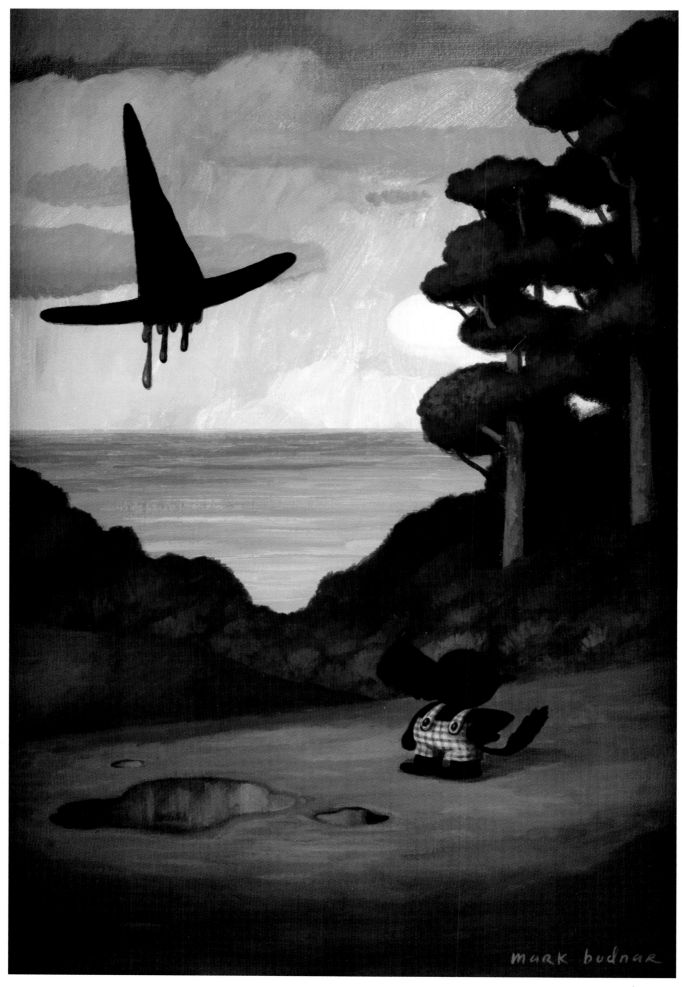

Above:
Mark Bodnar
'Toto and the Hat'
Acrylic on canvas, 18 x 24 inches
The Wizard of Oz

Right:
Marcus Schafer
'The Extra'
Acrylic on canvas, 7 x 9 inches
The Wizard of Oz

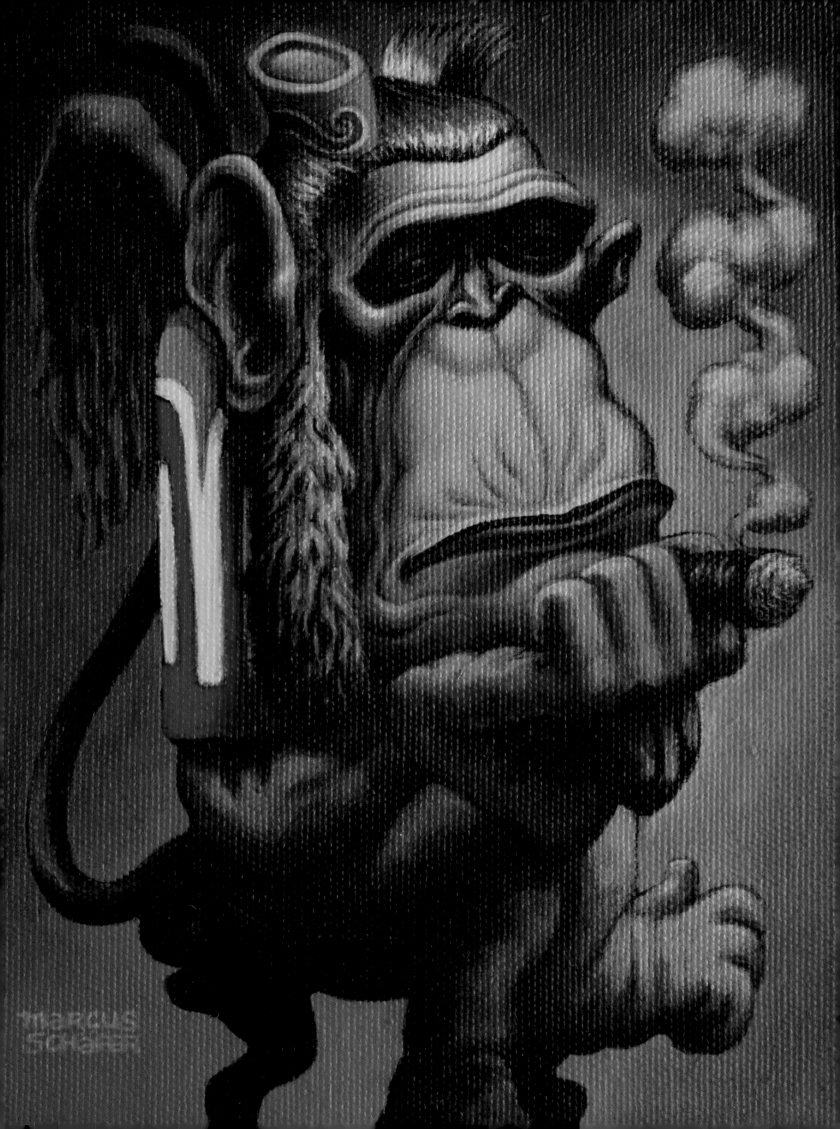

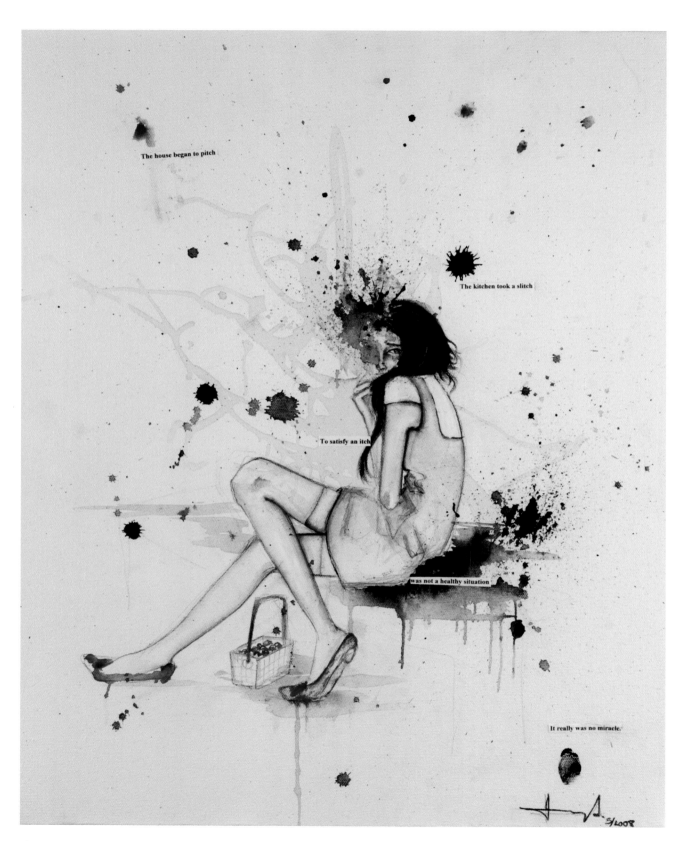

The house began to pitch

The kitchen took a slitch

To satisfy an itch

was not a healthy situation

It really was no miracle.

Above:
Cherri Wood
'Dorothy Who'
Watercolor on canvas, 16 x 20 inches
The Wizard of Oz

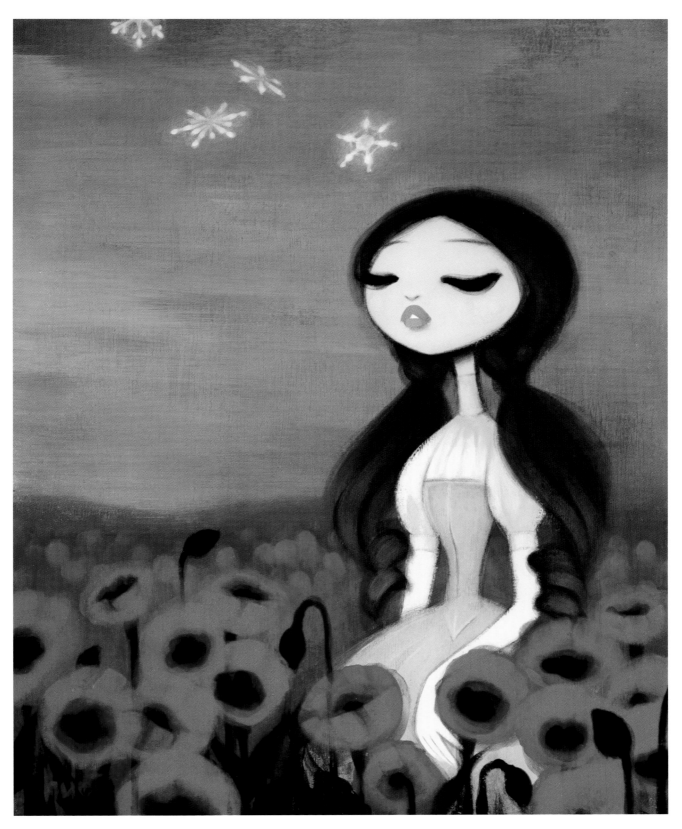

Above:
Krista Huot
'Snowfall Over Poppies'
Acrylic on canvas, 16 x 20 inches
The Wizard of Oz

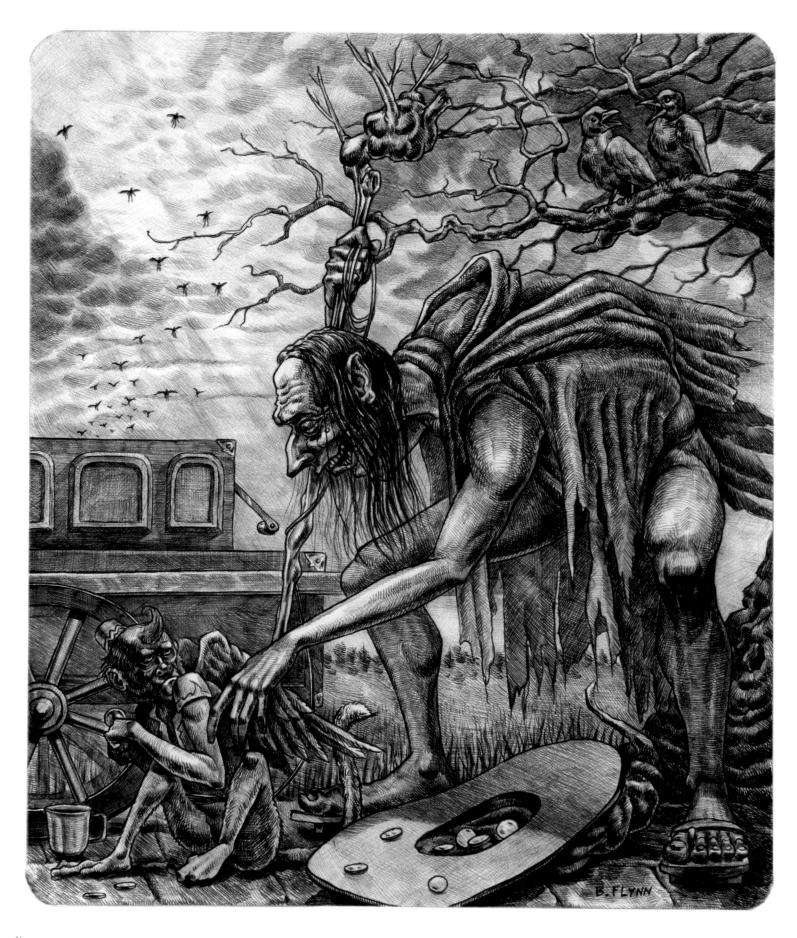

Above:
Brendon Flynn
'The Organ Grinder'
Ink on paper, 18 x 20 inches
The Wizard of Oz

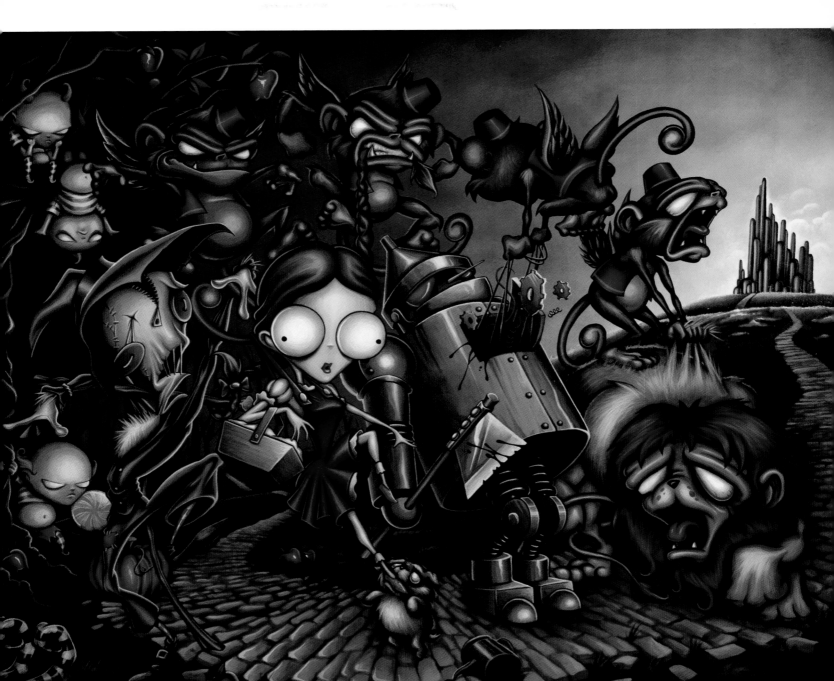

Above:
Anthony Clarkson
'The Wickedly Wonderful World
of Oz'
Acrylic on board, 20 x 16 inches
The Wizard of Oz

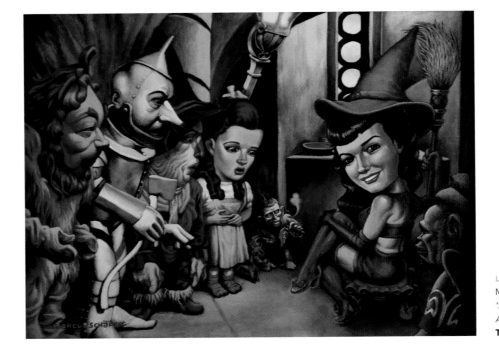

Left:
Marcus Schafer
'Shoe Shine Witch'
Acrylic on canvas, 18 x 14 inches
The Wizard of Oz

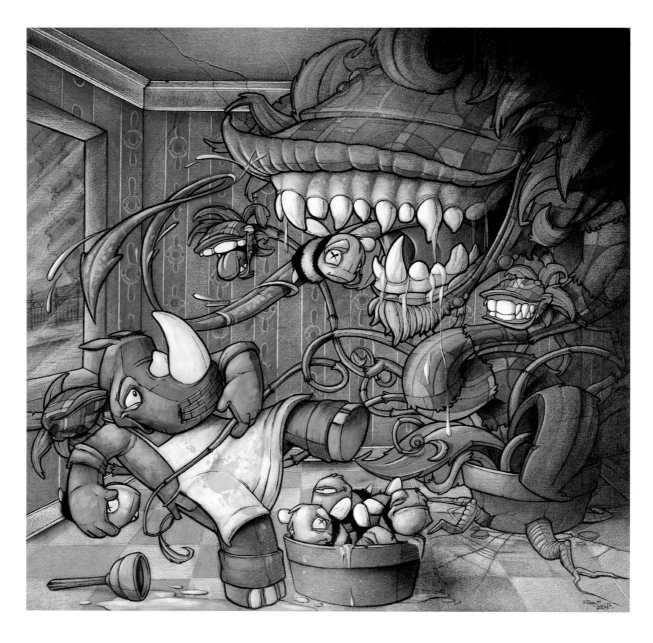

Above:
Scribe
'Feed Me All Night Long'
Mixed media on wood panel,
24 x 24 inches
Little Shop of Horrors

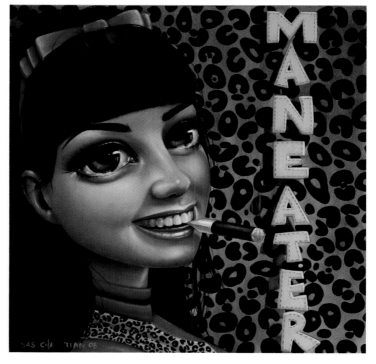

Right:
Sas Christian
'She-Devils on Wheels'
Oil on linen, 8 x 8 inches
She-Devils on Wheels

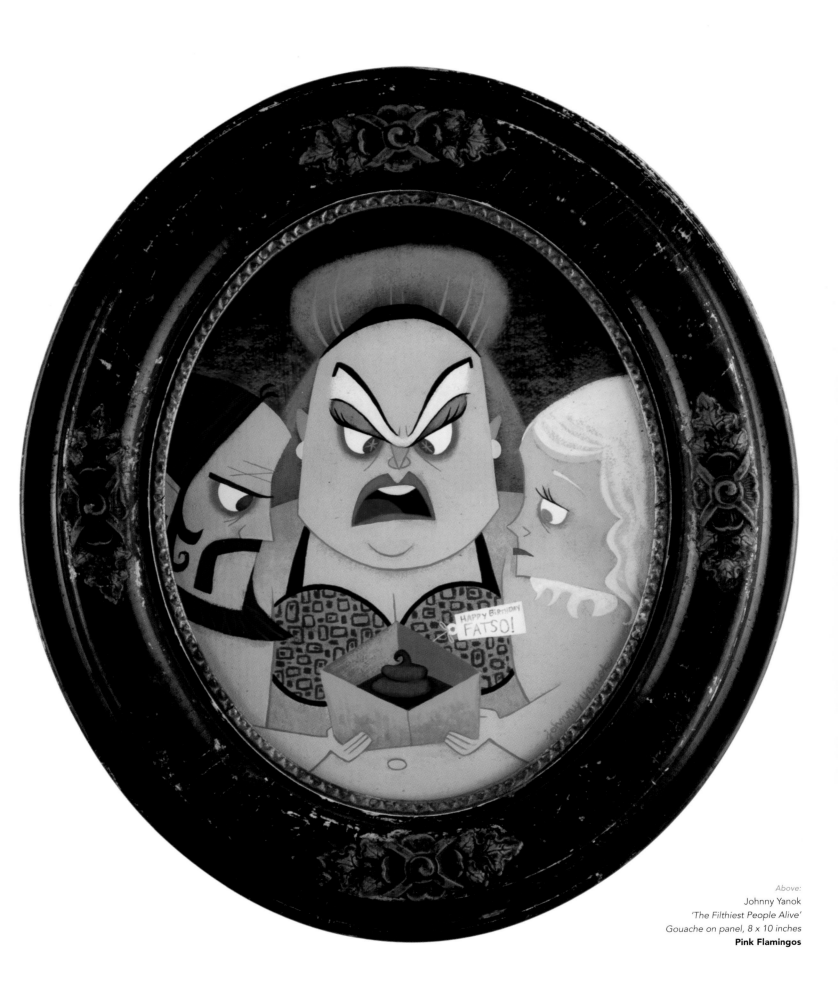

Above:
Johnny Yanok
'The Filthiest People Alive'
Gouache on panel, 8 x 10 inches
Pink Flamingos

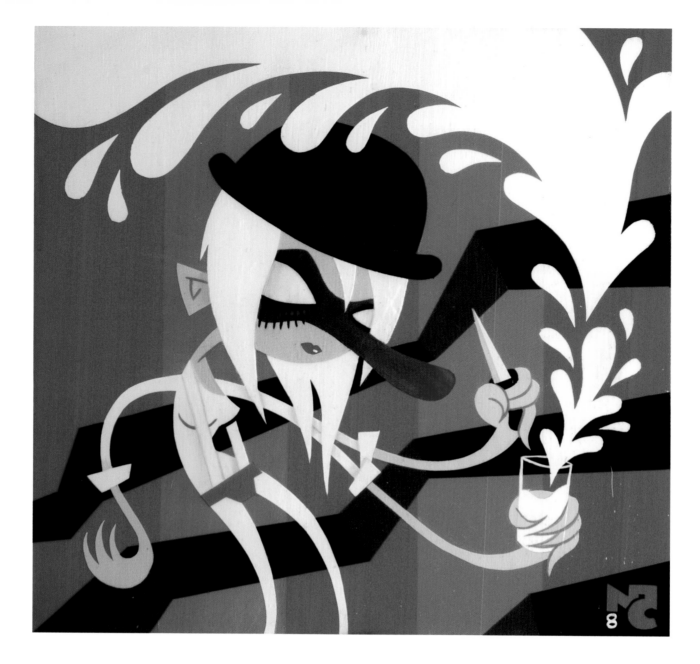

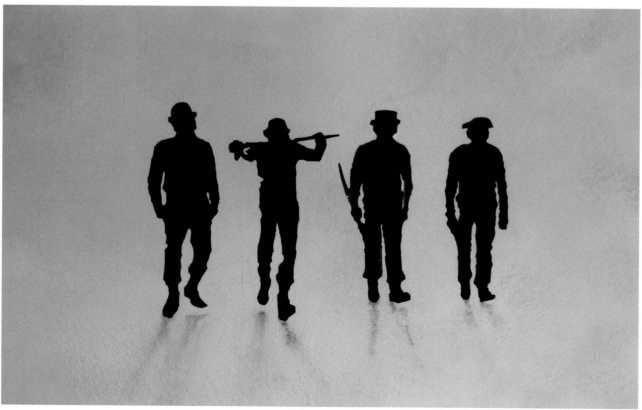

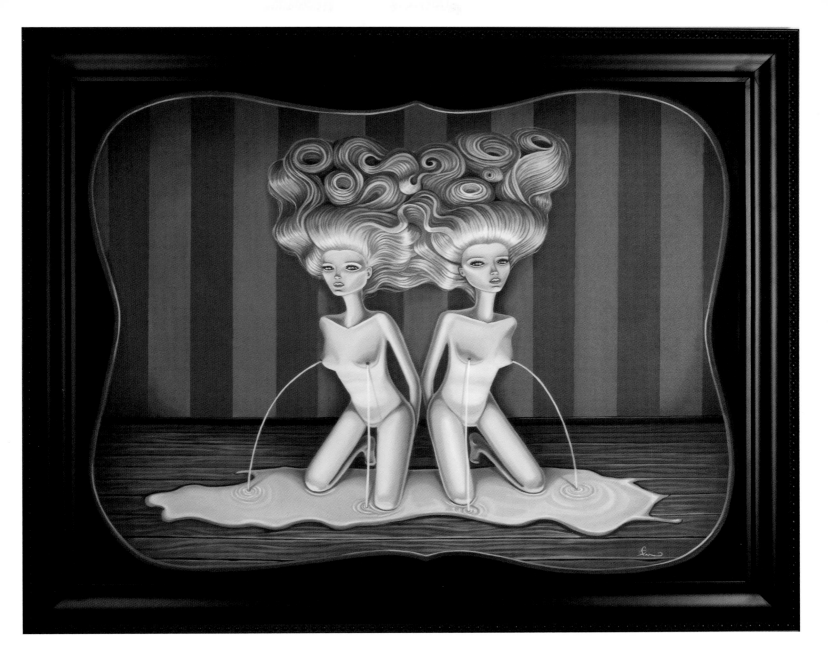

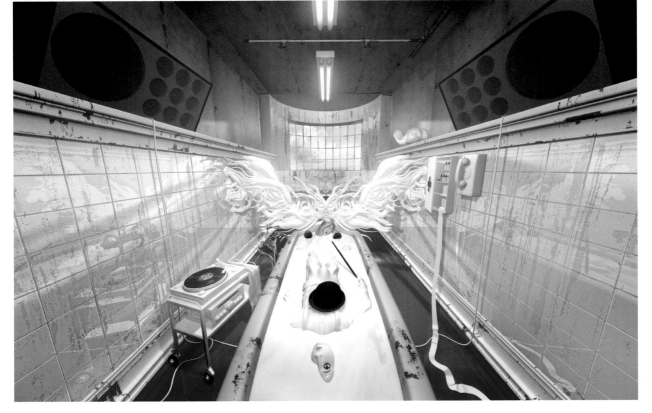

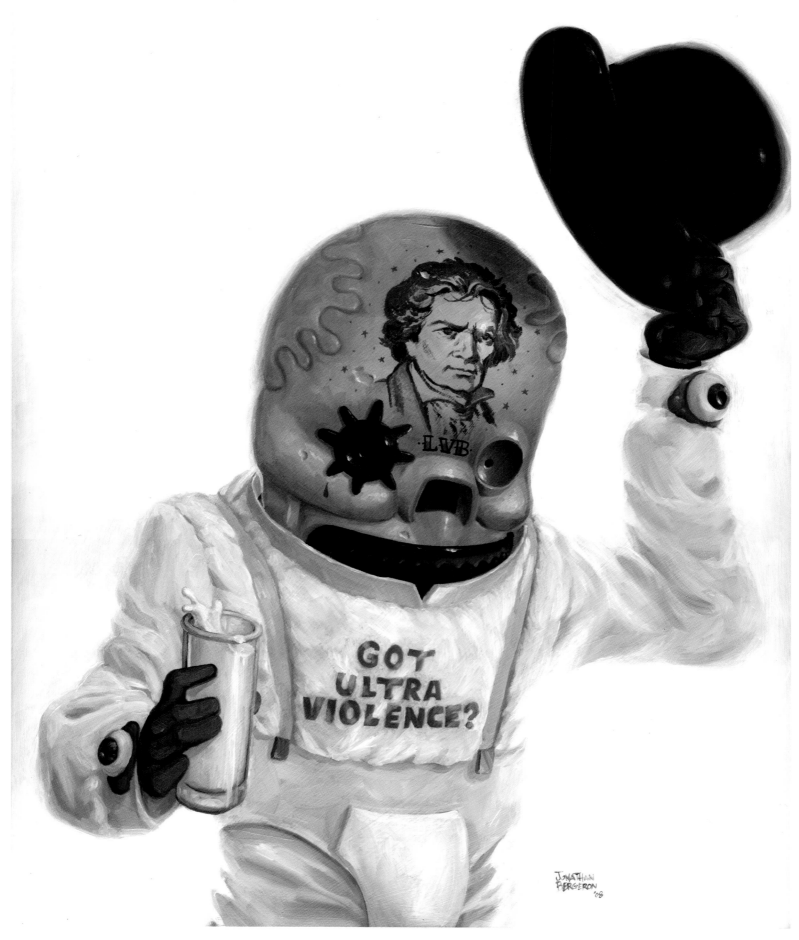

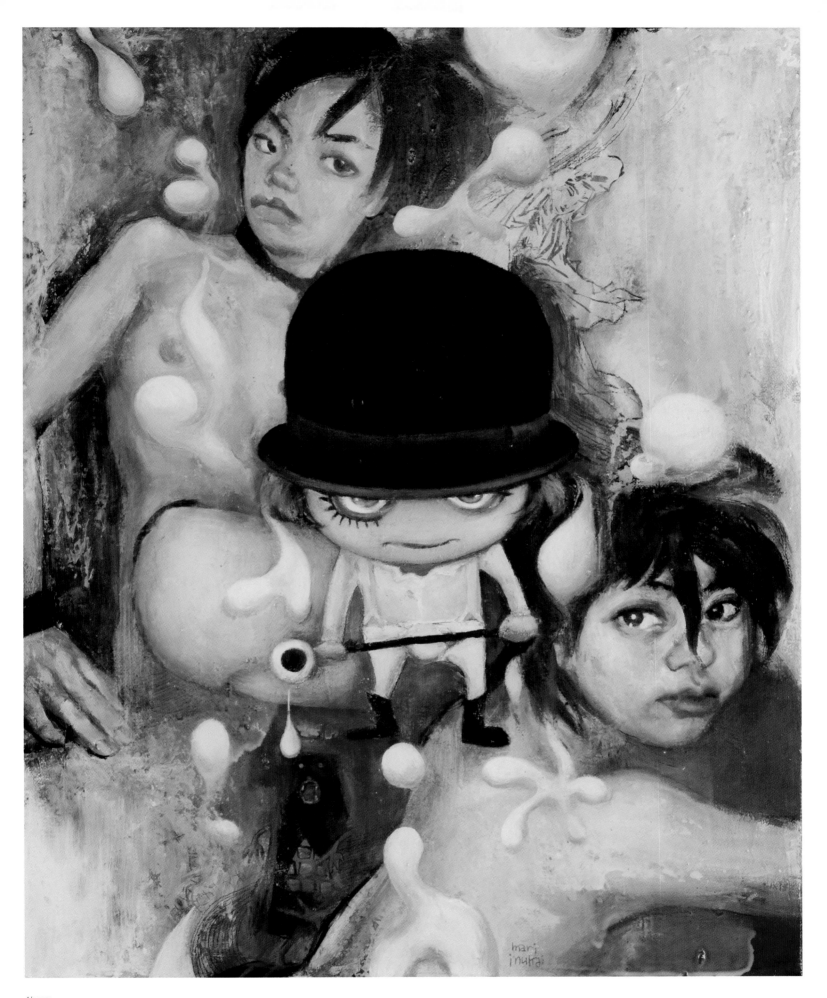

Above:
Mari Inukai
'Milk'
Oil on canvas, 17 x 21 inches
A Clockwork Orange

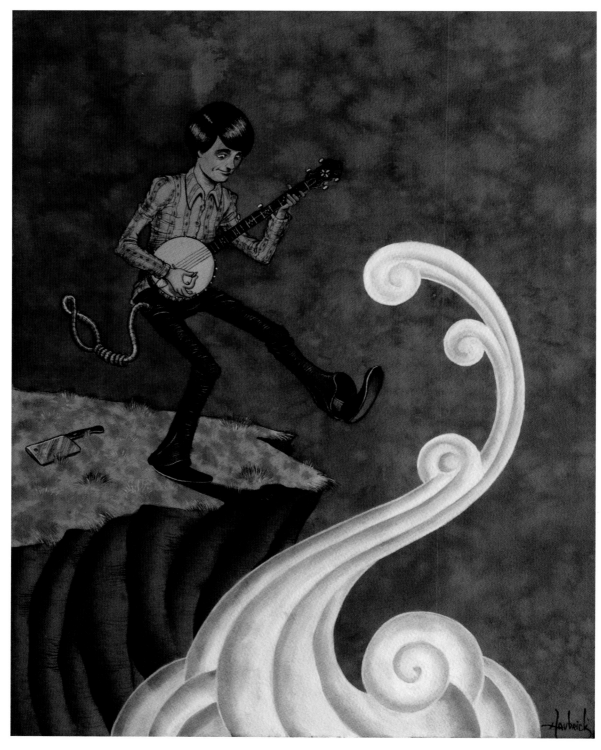

Above:
Tom Haubrick
'If You Want to Sing Out, Sing Out'
Ink and wash on paper, 16 x 20 inches
Harold and Maude

Right:
Steve Purcell
'Repose'
Acrylic on paper, 13 x 15 inches
Harold and Maude

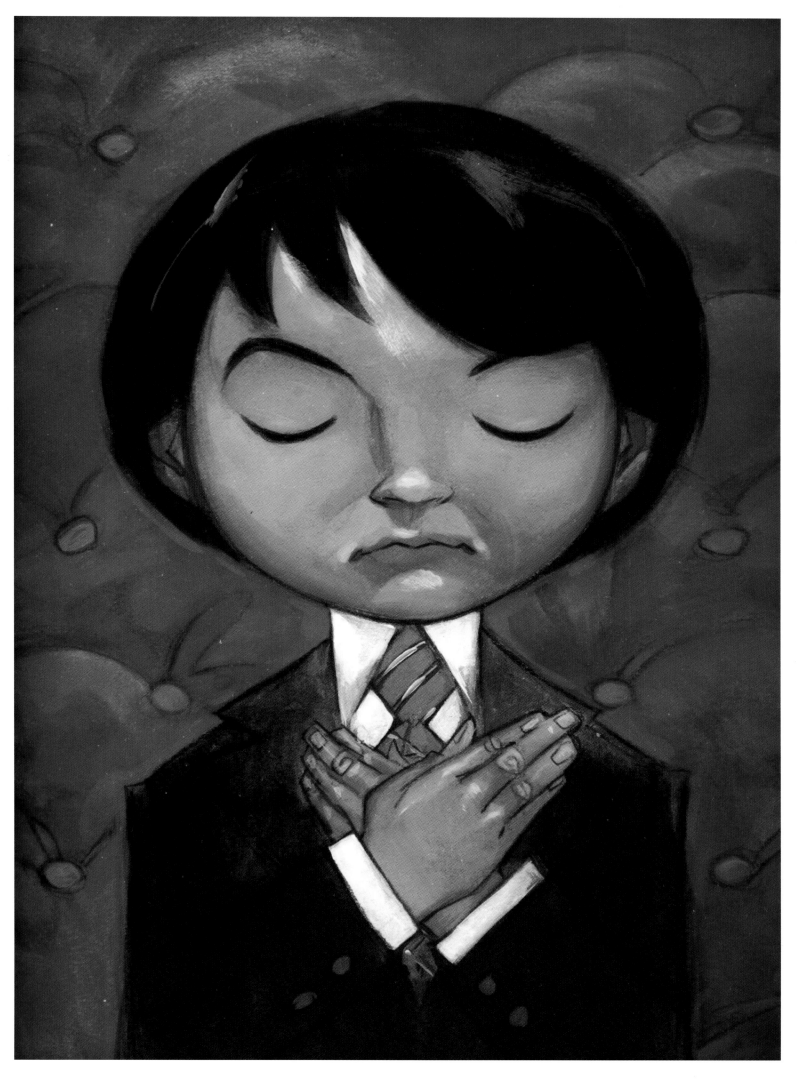

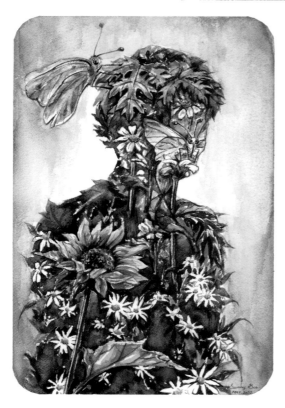

Right:
Sunny Gu
*'The Sunflower Lady and
the Wild Daisy Boy'*
*Watercolor on paper,
19 x 13 inches*
Harold and Maude

Below:
Danielle Buerli
'Harold Love Maude'
*Mixed media sculpture,
12 x 5 x 9 inches*
Harold and Maude

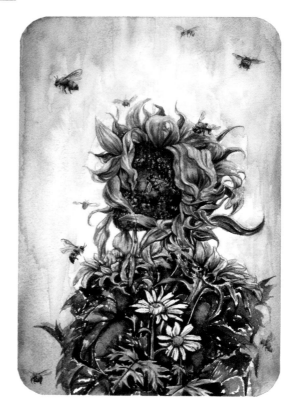

Right:
Jason Hernandez
'Deflowered'
*Ink on paper,
11 x 14 inches*
Harold and Maude

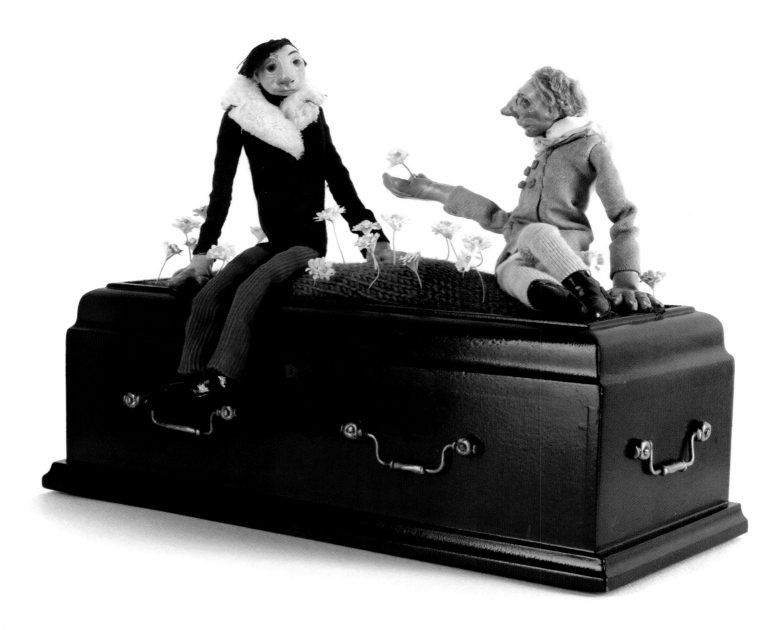

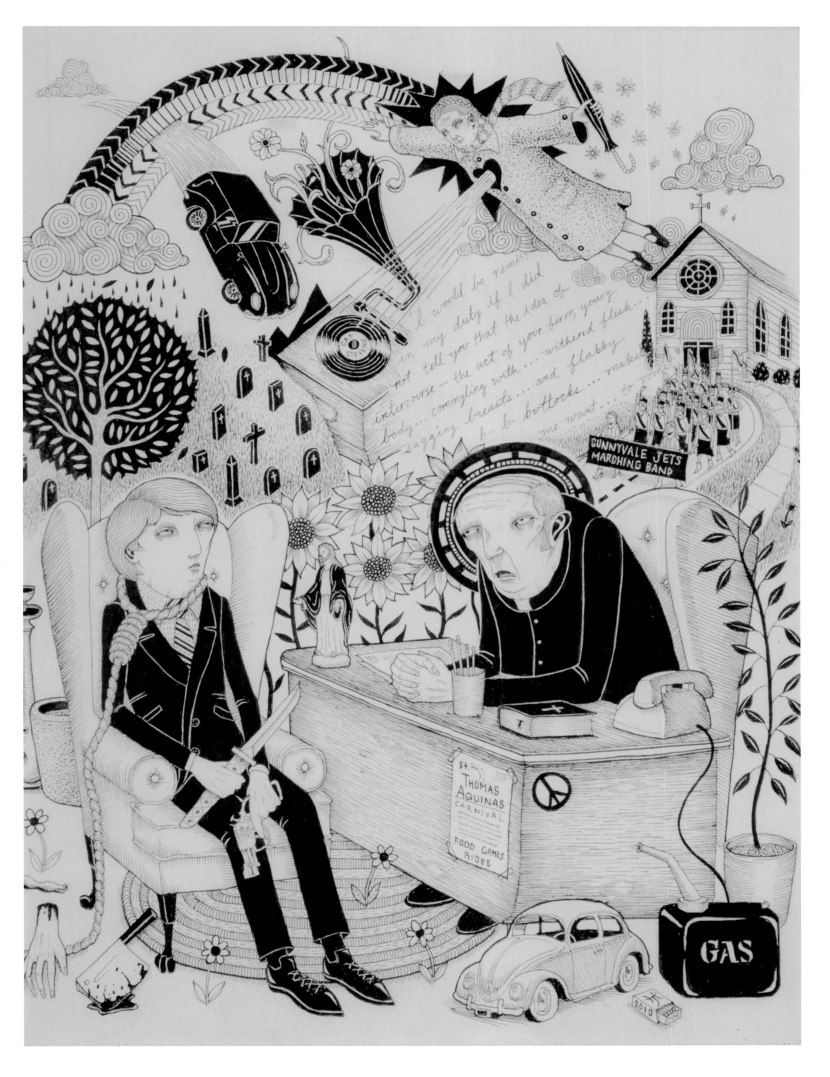

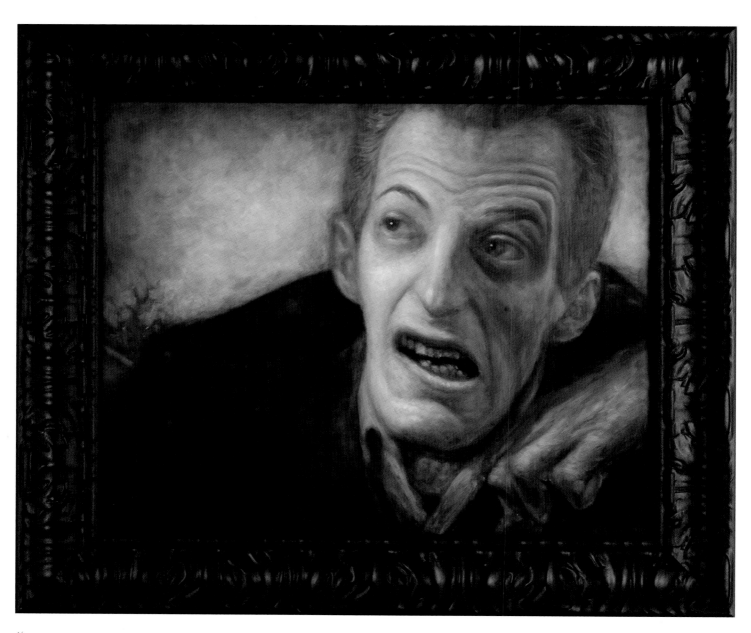

Above:
Chet Zar
'Night'
Oil on board, 20 x 16 inches
Night of the Living Dead

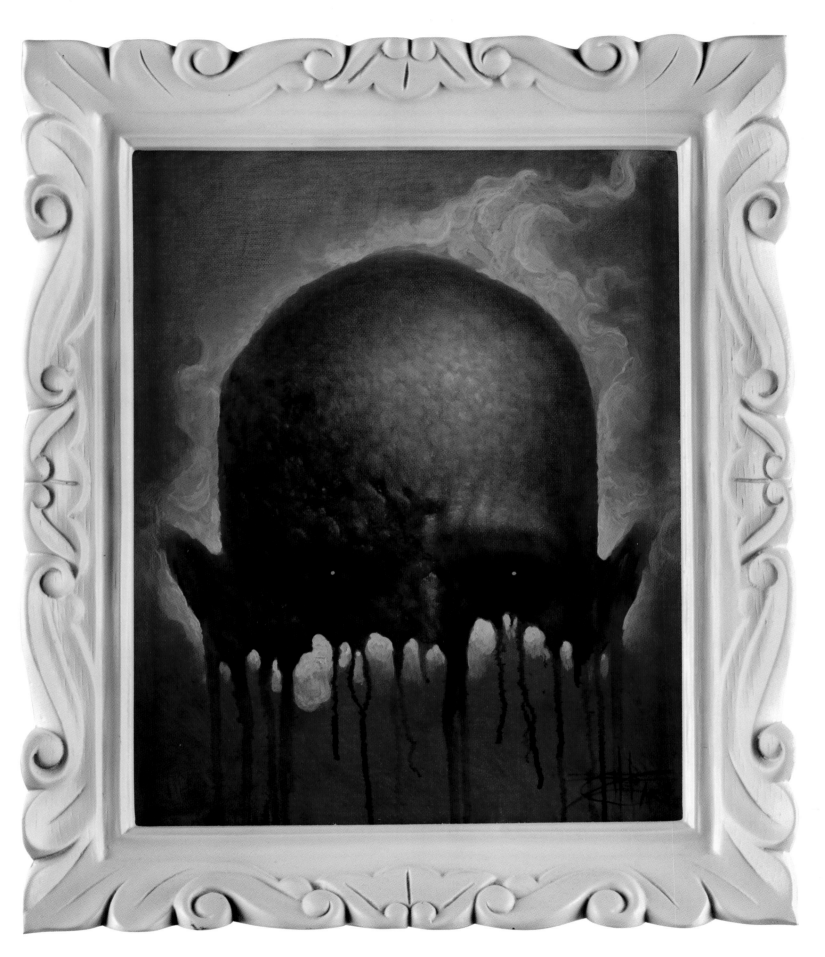

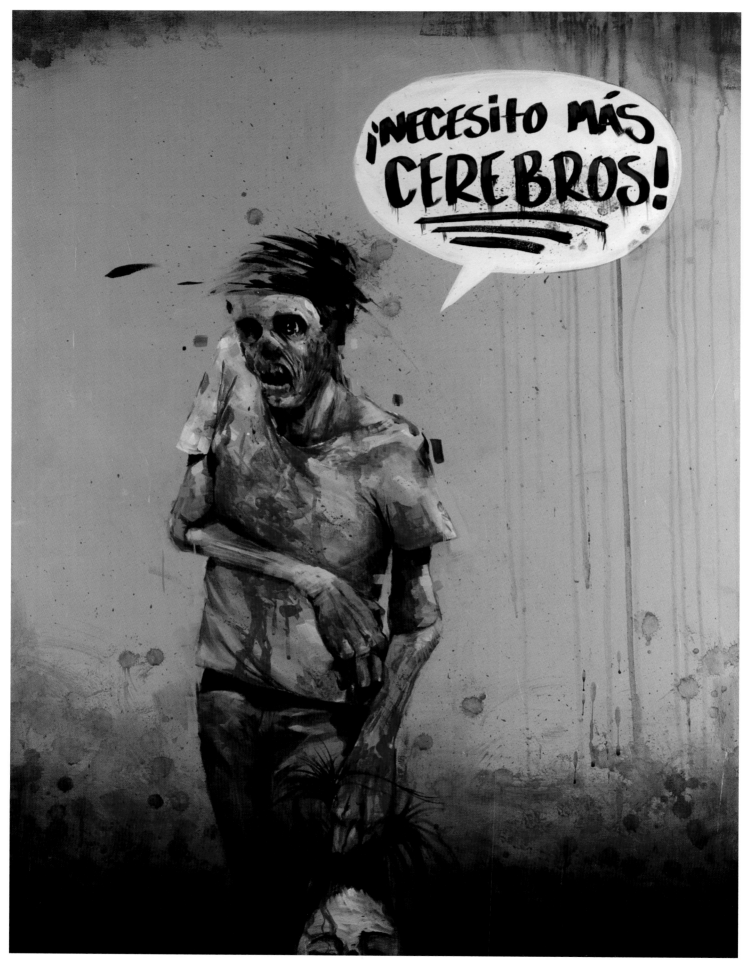

Above:
Frank Gonzales
'Necesito Más Cerebros'
Acrylic on canvas, 30 x 40 inches
Dawn of the Dead

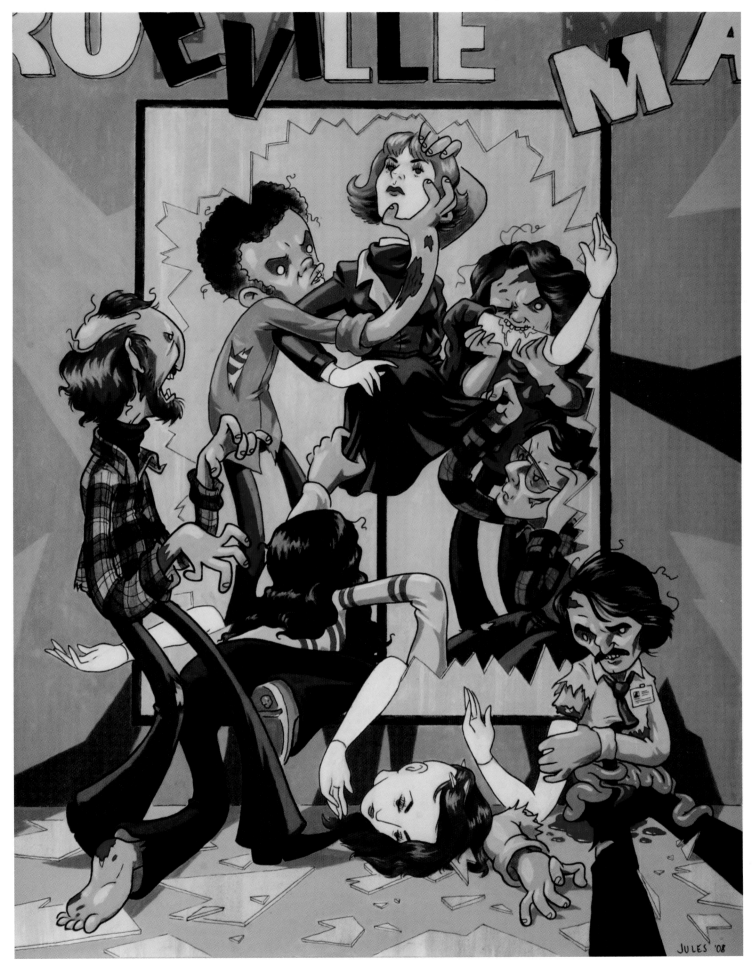

Above:
Julian Callos
'Consumers'
Ink, acrylic and watercolor on illustration board,
12 x 16 inches
Dawn of the Dead

Following page:
Carlos Ramos
'Godzilla'
Cel vinyl on wood, 24 x 36 inches
Godzilla

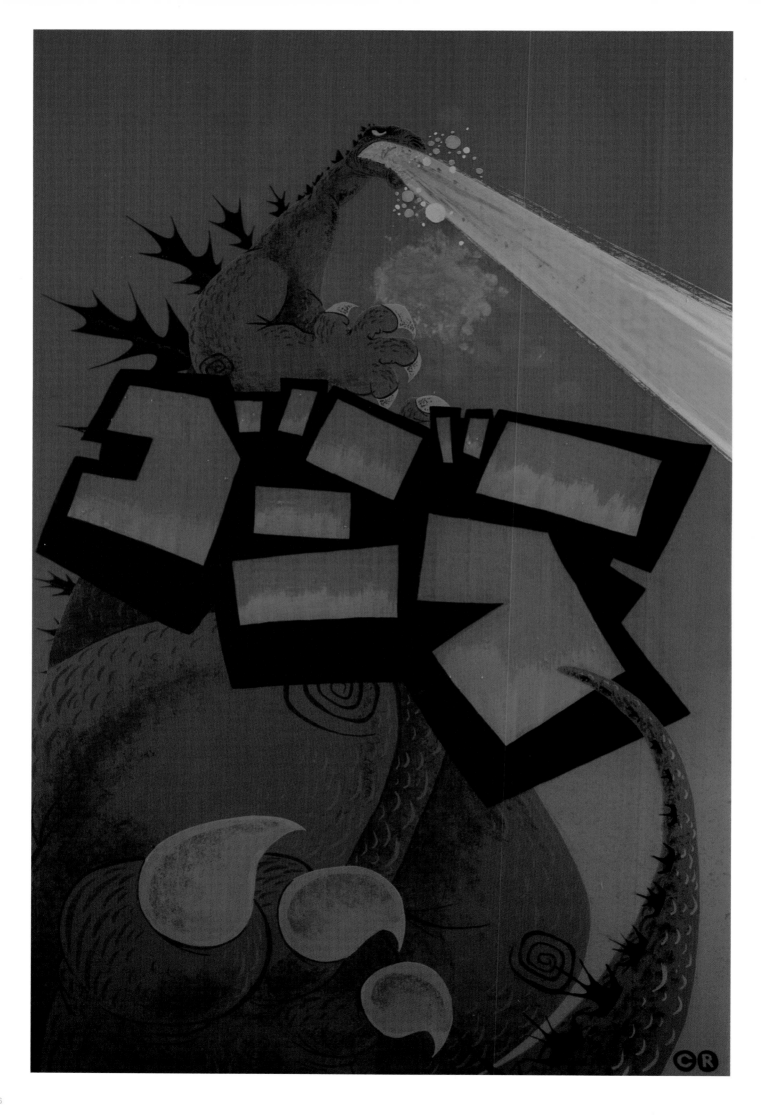

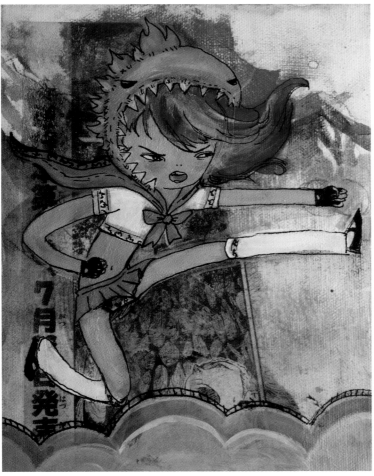
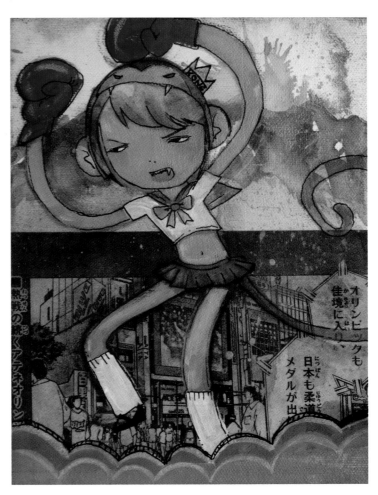

Above, clockwise from top left:
Mylan Nguyen
'Vs. Mothra', 'Vs. Ghidra', 'Vs. Kong', 'Godzilla'
All mixed media, 6 x 8 inches
Godzilla series

Following spread:
Scott Listfield
'The Parking Ticket'
Oil on canvas, 40 x 30 inches
Star Wars

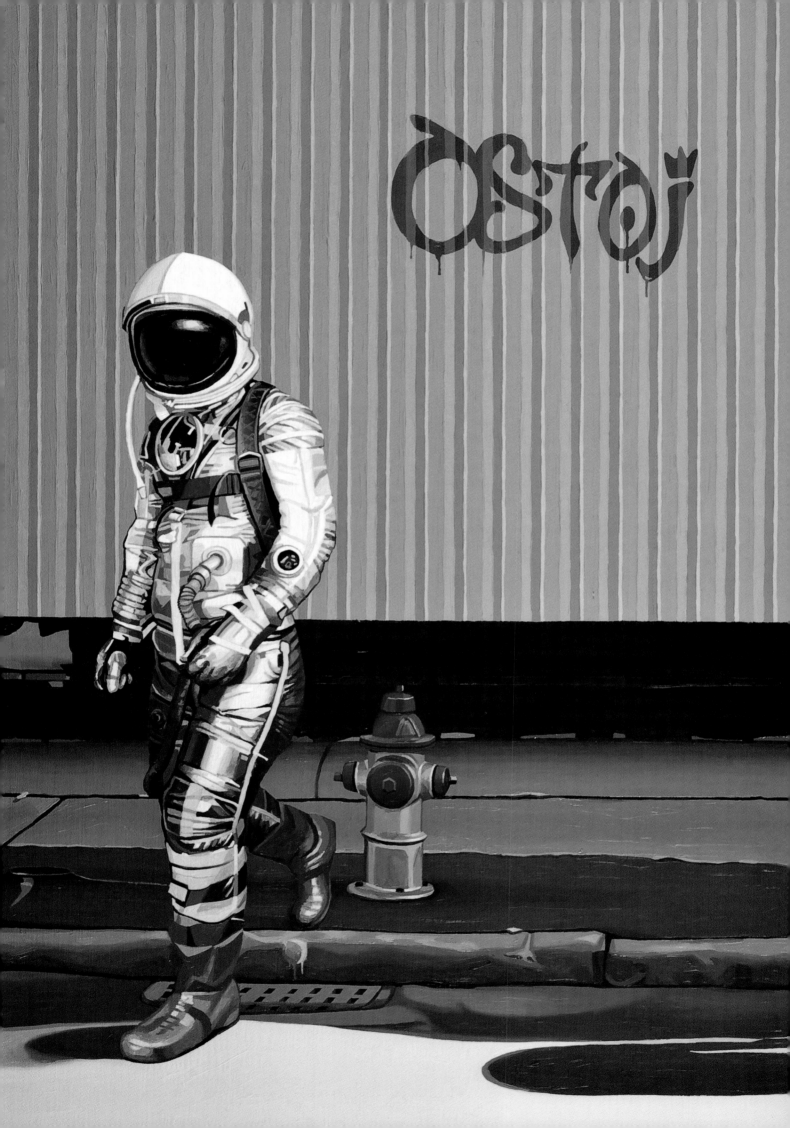

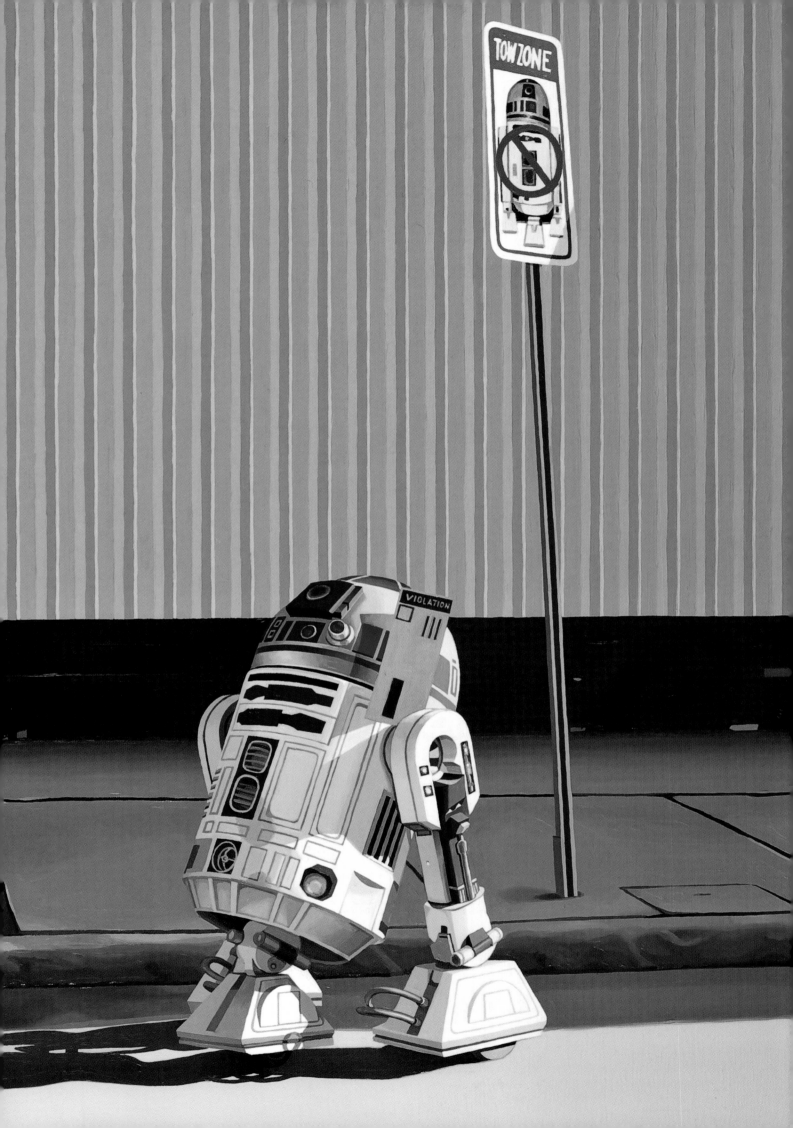

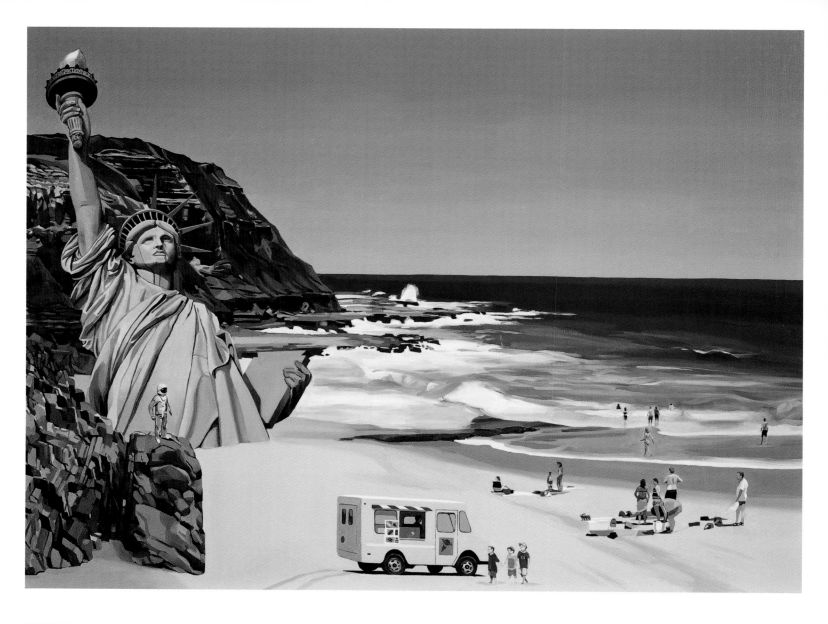

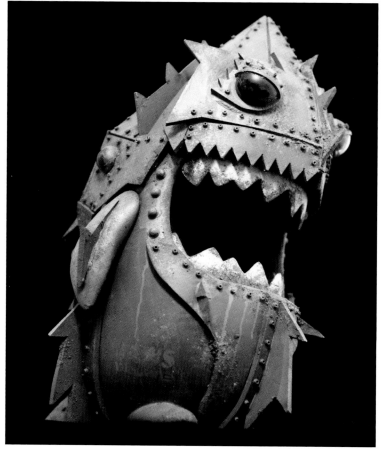

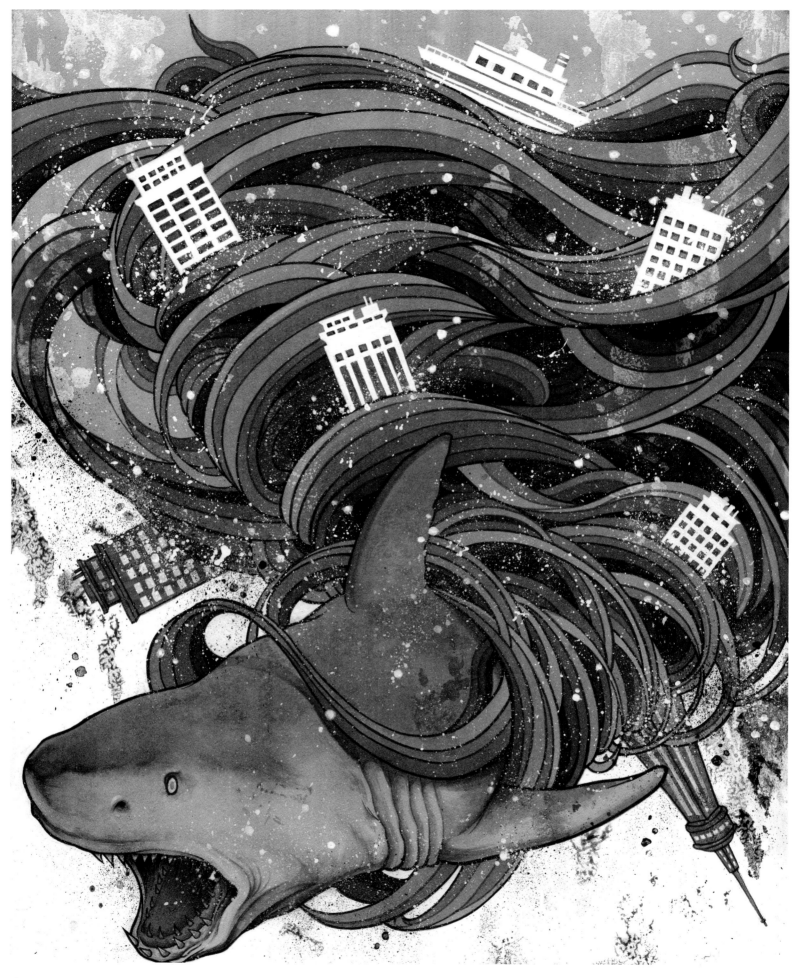

Above:
Yuta Onoda
'He Is The Water'
Acrylic and pastel on paper, mounted on wood,
16 x 20 inches
Jaws

Shark Toof
'Shark Toof's Chainsaw Massacre Starring Jessica
Alba and Mike White'
Screenprint on archival paper, 24 x 36 inches
The Texas Chain Saw Massacre

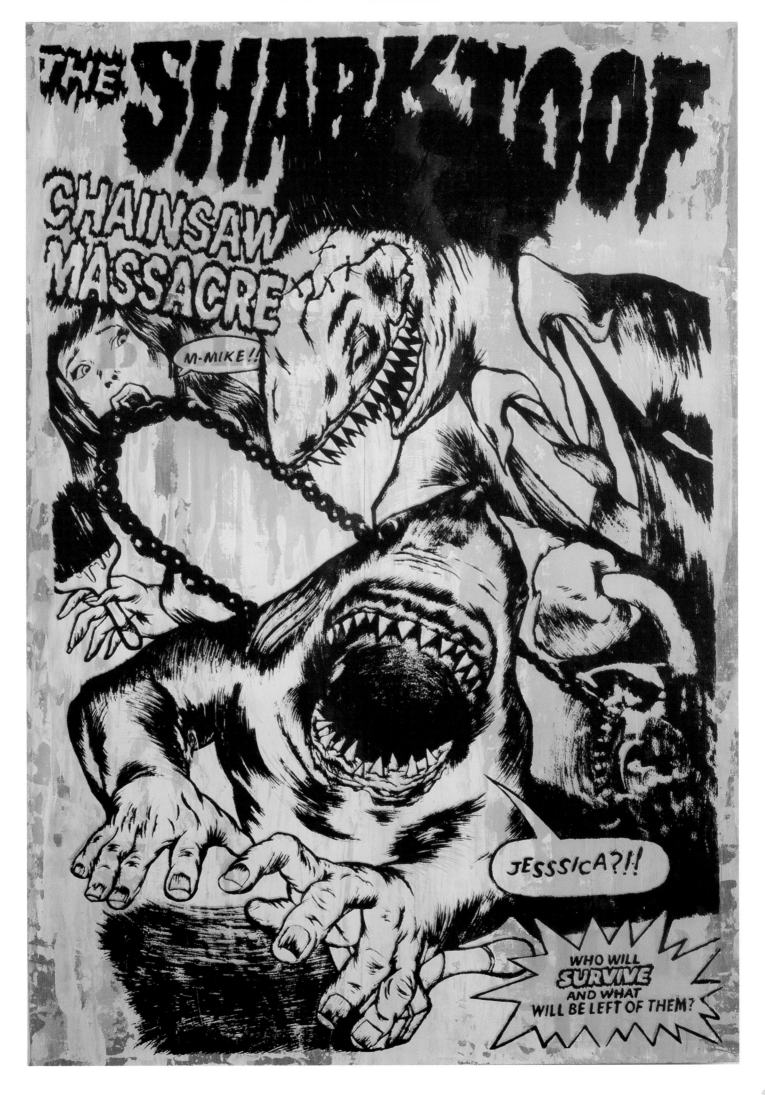

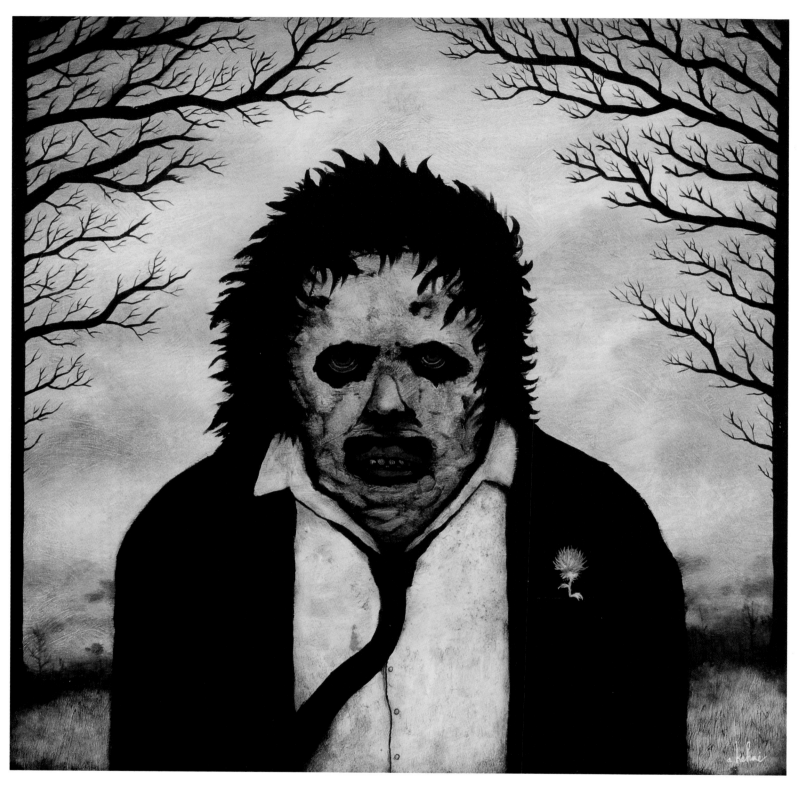

Above:
Andy Kehoe
'Leatherface Wanders Alone'
Acrylic and oil on panel, 18 x 18 inches
The Texas Chain Saw Massacre

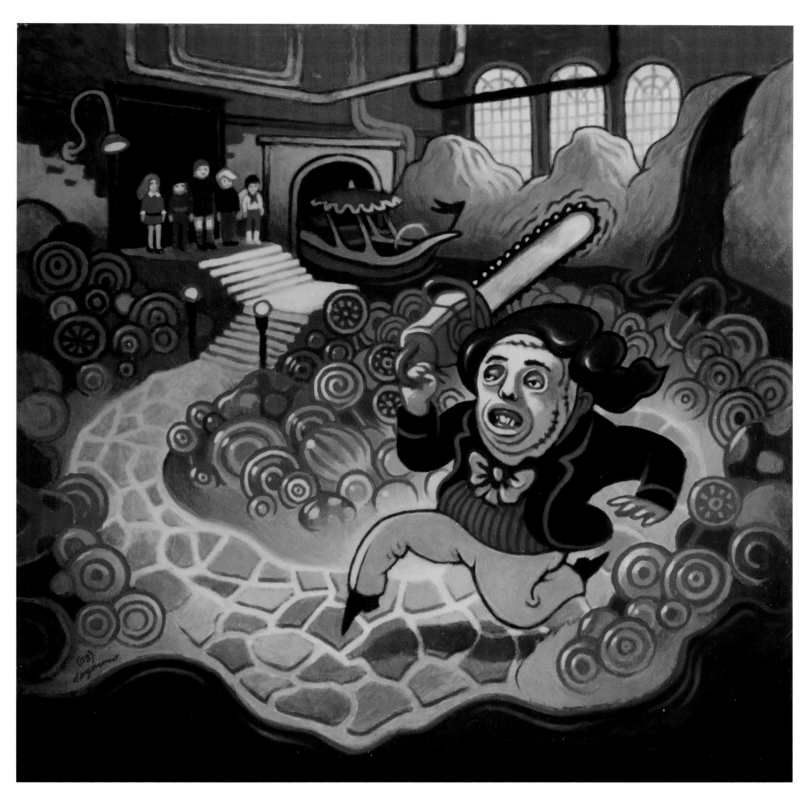

Above:
Justin Degarmo
'Five Scrumdiddliumptious Youths'
Acrylic on canvas, 12 x 12 inches
Willy Wonka & the Chocolate Factory

45

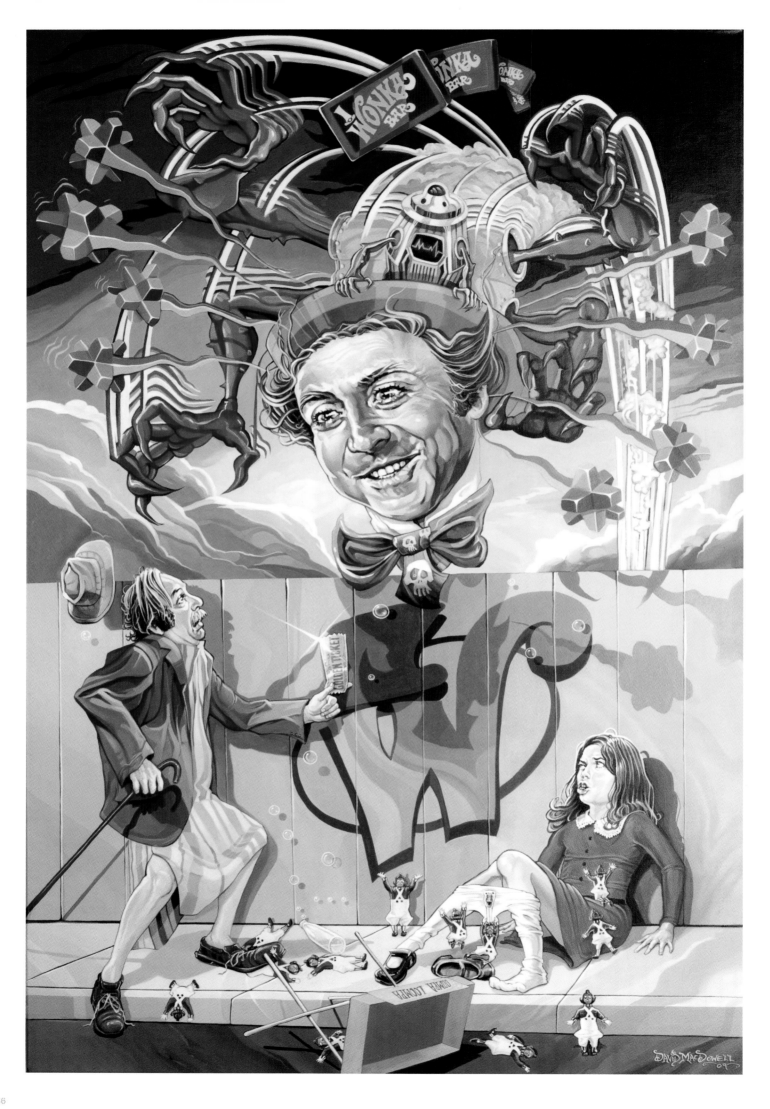

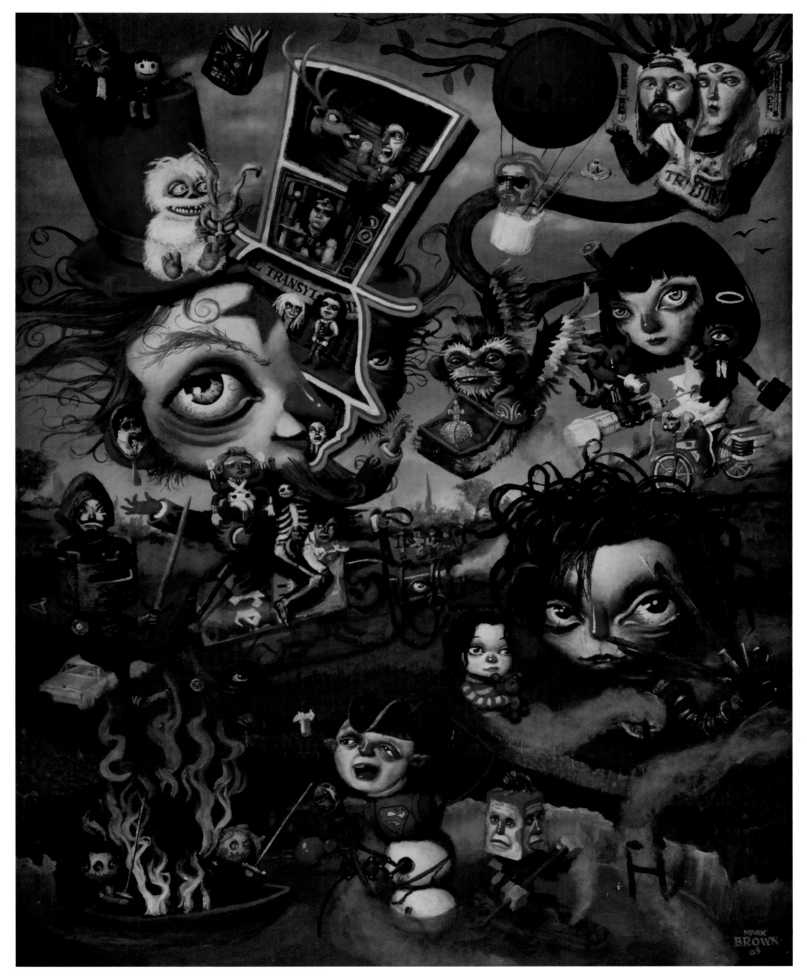

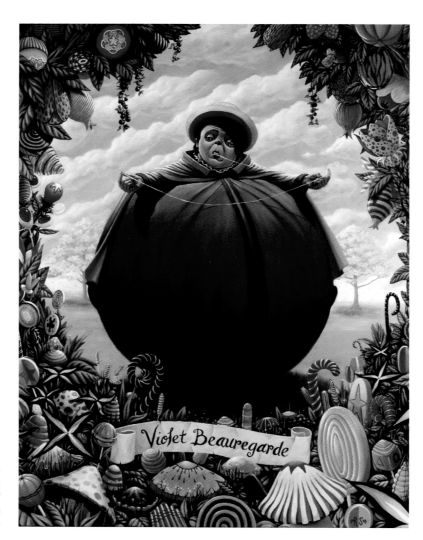

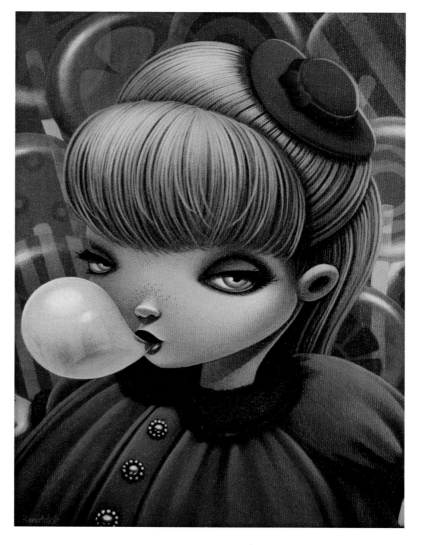

Right:
Ryan Sanchez
'Violet Beauregarde'
Oil on canvas, 22 x 28 inches
Willy Wonka & the Chocolate Factory

Right:
Shannon Bonatakis
'Little Violet Beauregarde'
Acrylic on canvas
Willy Wonka & the Chocolate Factory

Right:
Kathie Olivas
'Veruca Salt'
Oil on canvas, 18 x 24 inches
Willy Wonka & the Chocolate Factory

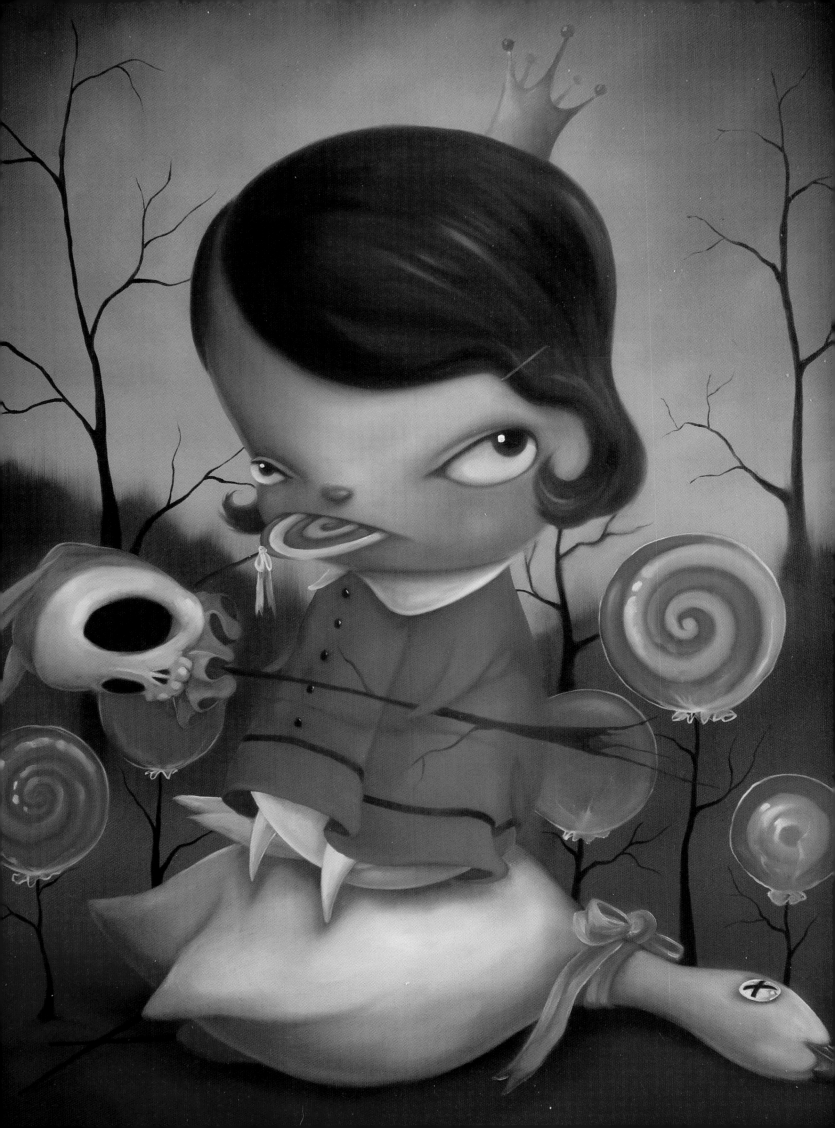

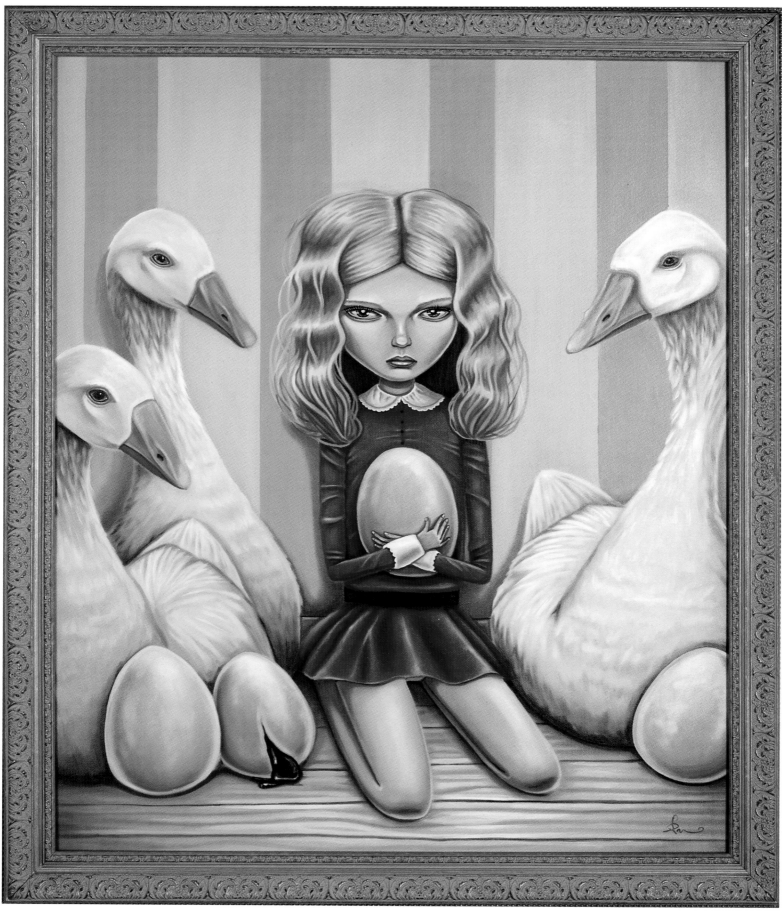

Above:
Audrey Pongracz
'Gooses Geeses'
Oil on canvas, 20 x 24 inches
Willy Wonka & the Chocolate Factory

Right:
Rich Pellegrino
'Wonka'
Gouache, ink, watercolor and acrylic on hard-
board, 5 x 7 inches
Willy Wonka & the Chocolate Factory

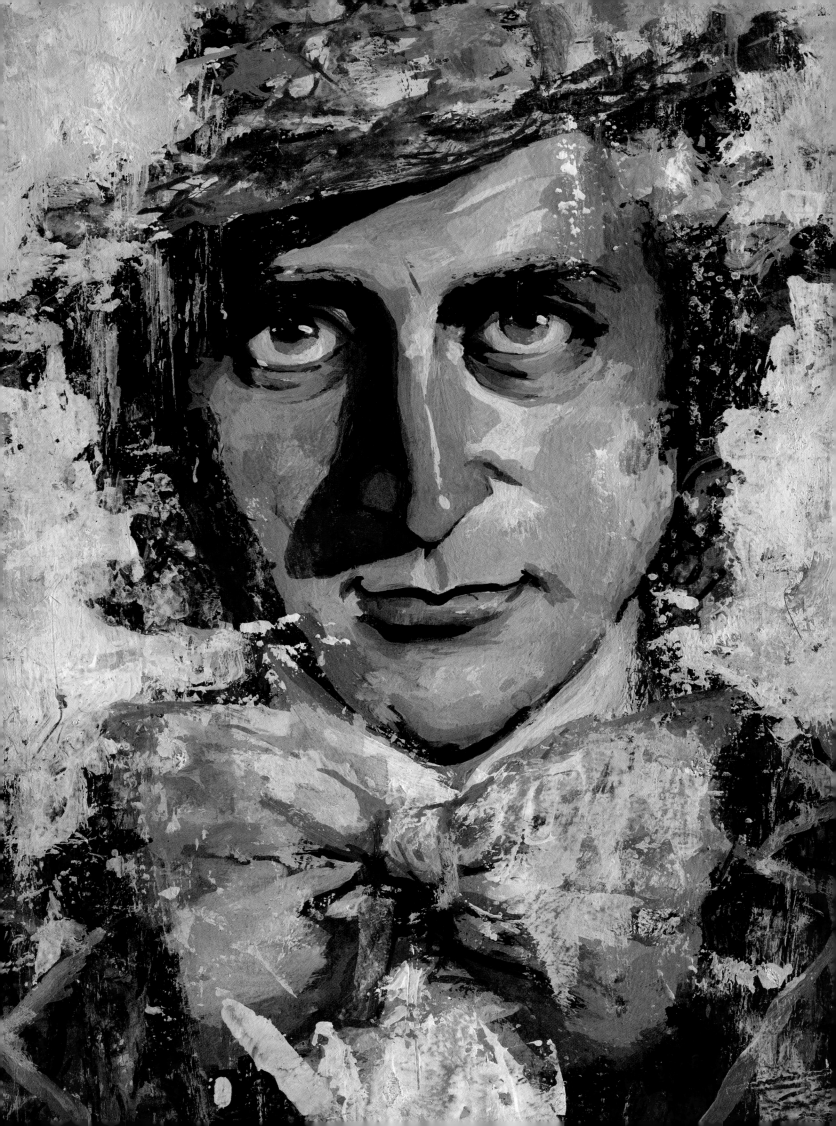

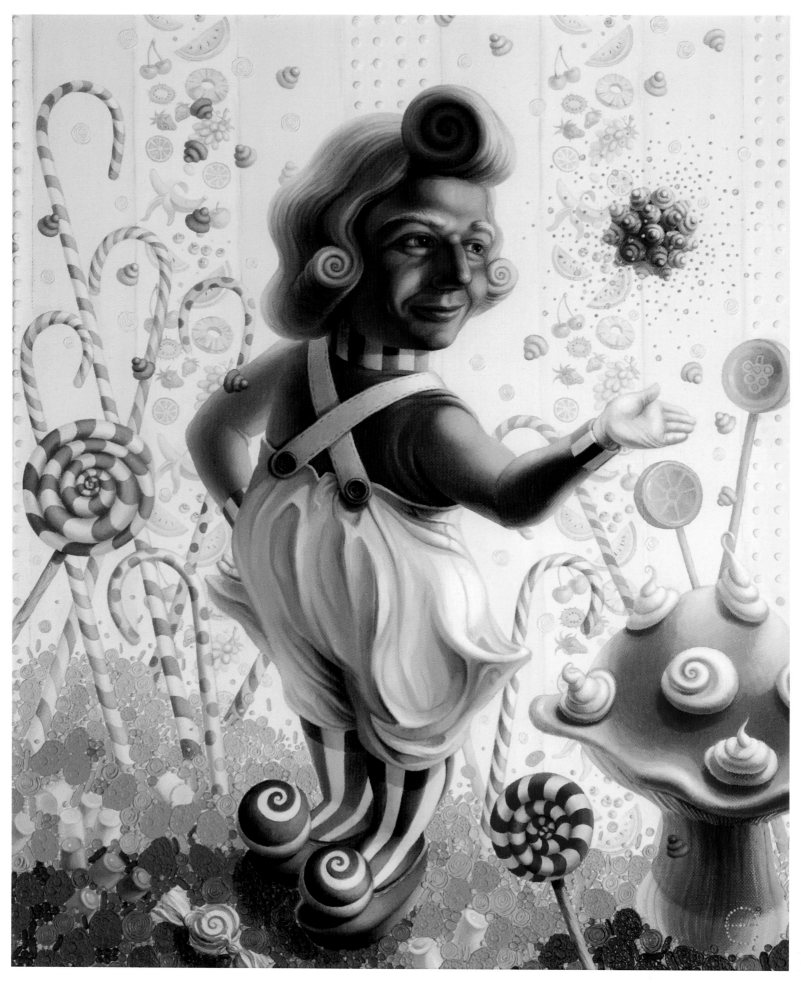

Above:
Ewelina Ferruso
'Everlasting Gobstopper'
Oil on canvas, 16 x 20 inches
Willy Wonka & the Chocolate Factory

Right:
APAK
'Goodbye Loompa Land'
Gouache on poplar, 5 x 7 inches
Willy Wonka & the Chocolate Factory

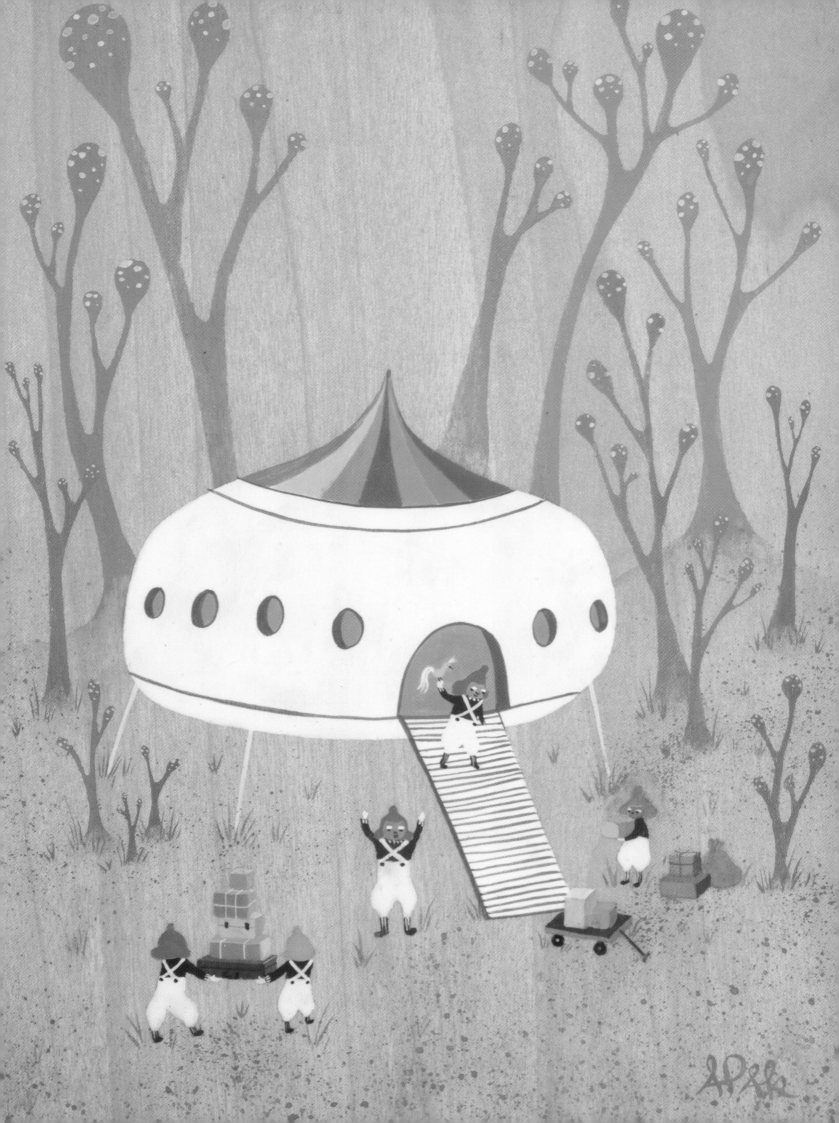

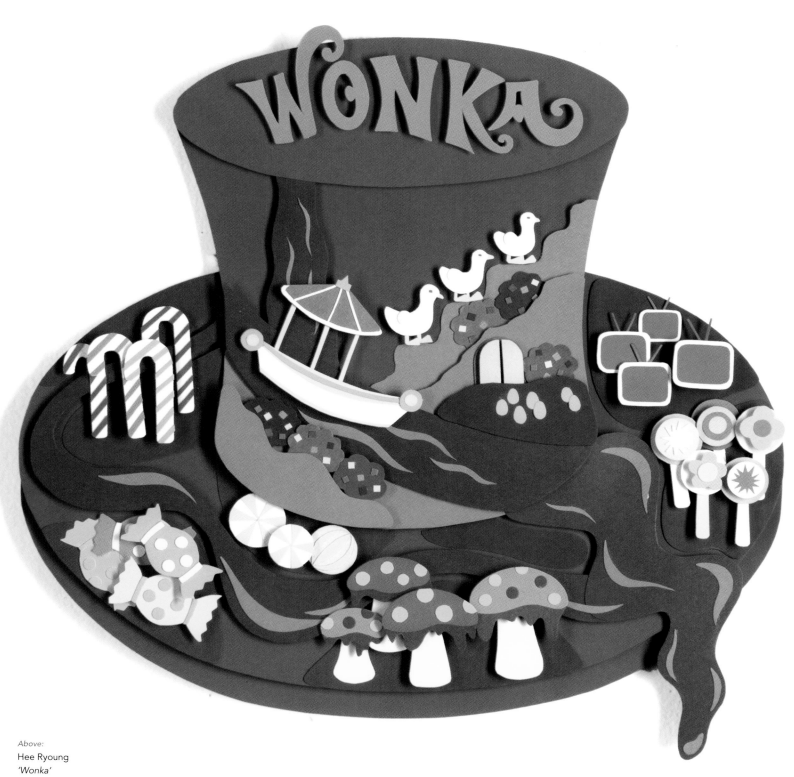

Above:
Hee Ryoung
'Wonka'
3-D paper collage, 11 1/2 x 11 1/2 inches
Willy Wonka & the Chocolate Factory

Right:
Sarah 'Sae' Soh
*'Augustus Gloop', 'Violet Beauregarde', 'Charlie Bucket', 'Veruca Salt', 'Mike Teevee'
All acrylic on wood, 7 inch diameter*
Willy Wonka & the Chocolate Factory

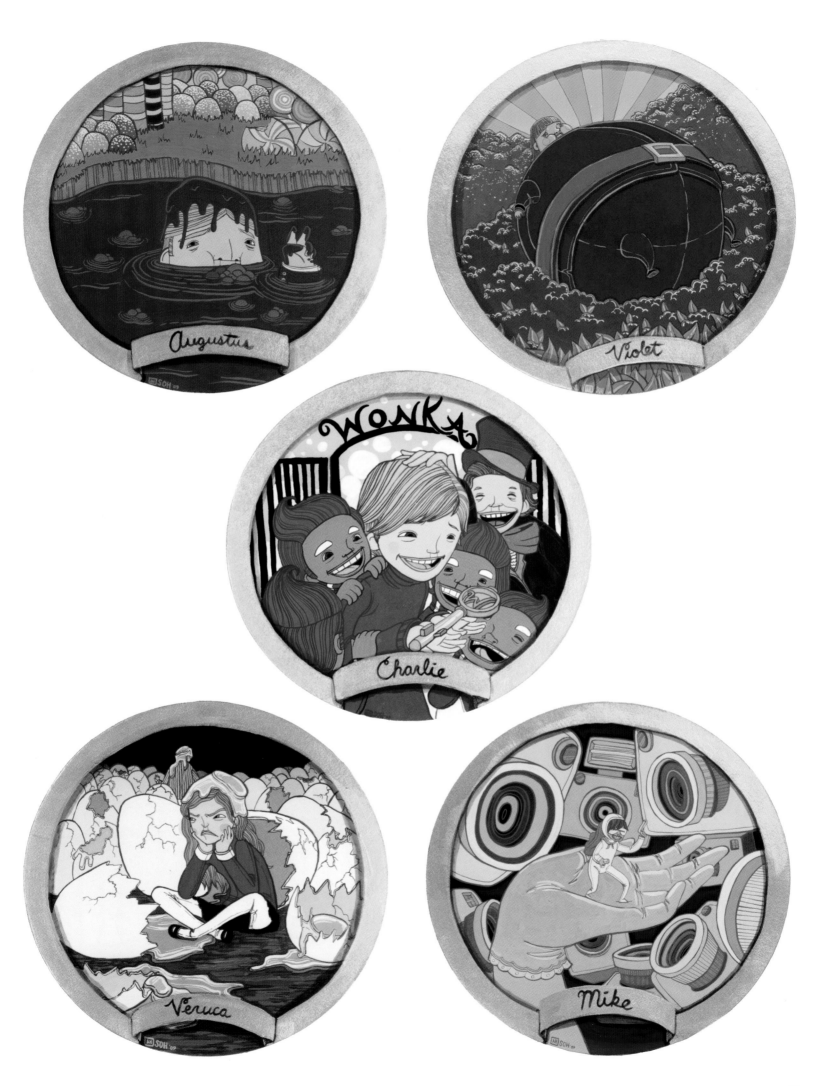

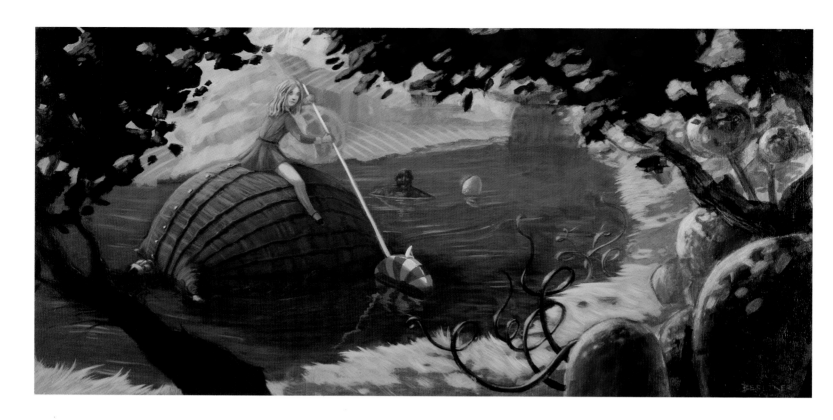

Above:
Luke Berliner
'The Rejects'
Acrylic on paper, mounted on board,
23 x 12 inches
Willy Wonka & the Chocolate Factory

Right:
Ayami Kawashima
'I Want It Now!'
Oil and graphite on wood, 12 x 12 inches
Willy Wonka & the Chocolate Factory

Opposite:
Nathan Stapley
'Deliverance'
Oil on canvas, 5 x 7 inches
Deliverance

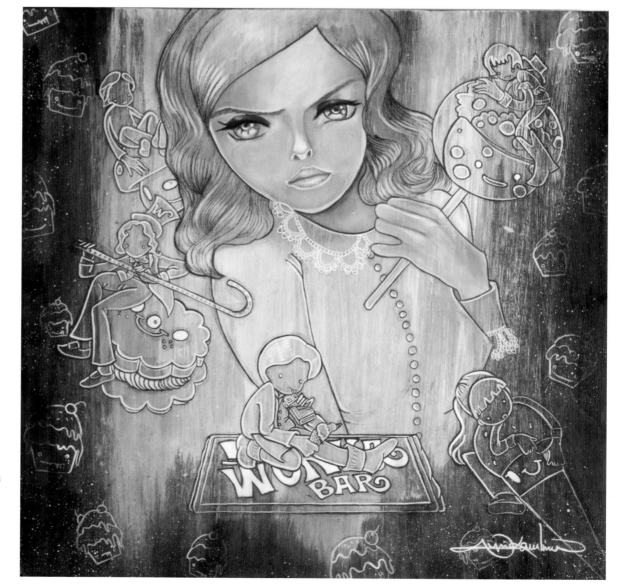

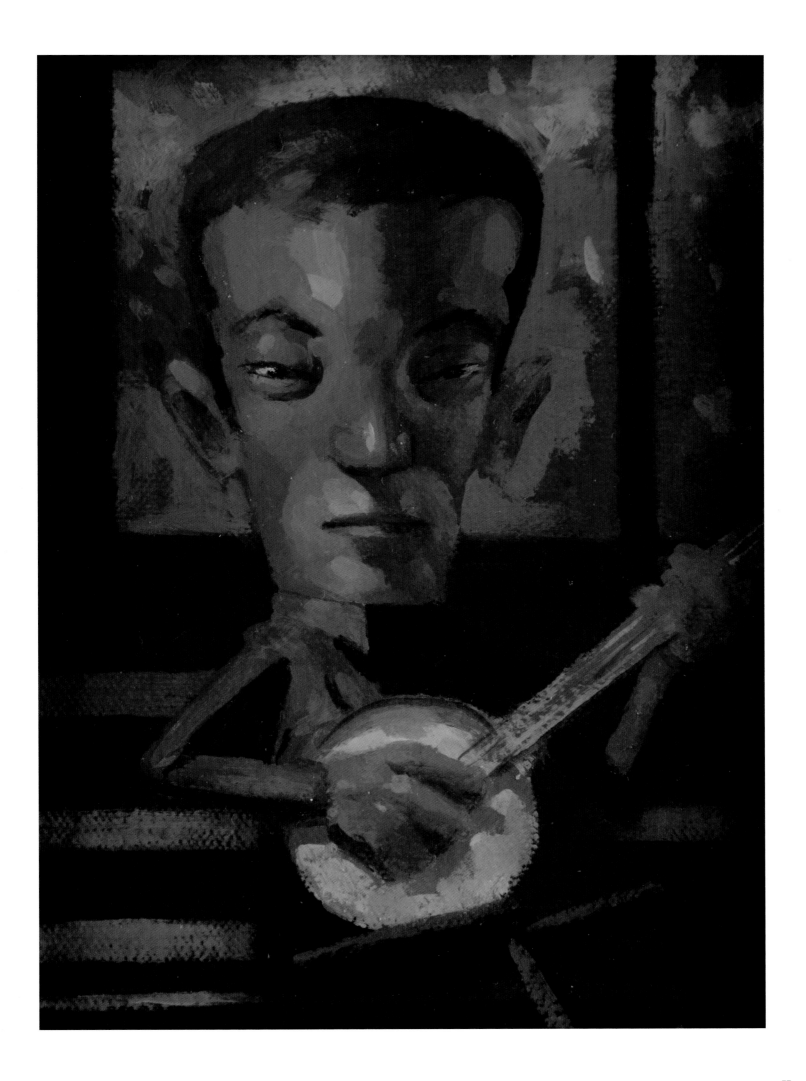

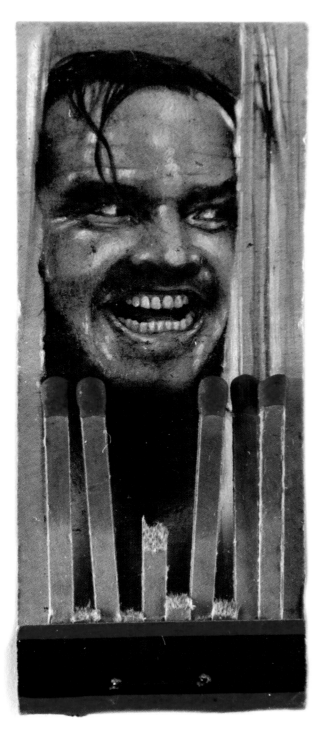

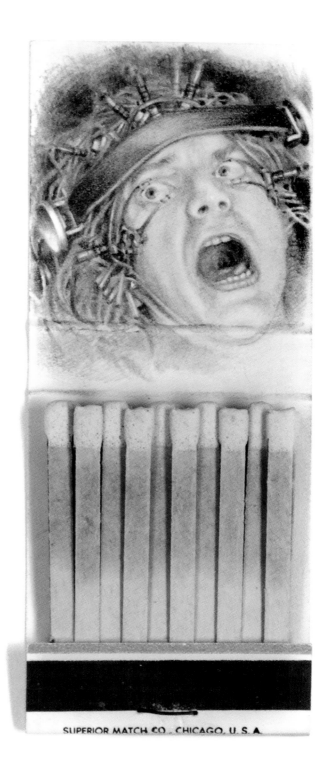

This spread, left to right:
Jason d'Aquino
'Shining', 'Alex', 'Wonka', 'Regan'
All graphite on matchbook, 1 x 1 inch
**The Shining, A Clockwork Orange, Willy Wonka
& the Chocolate Factory, The Exorcist**

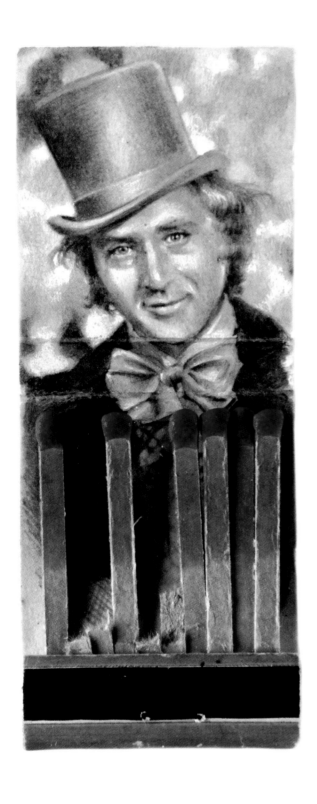
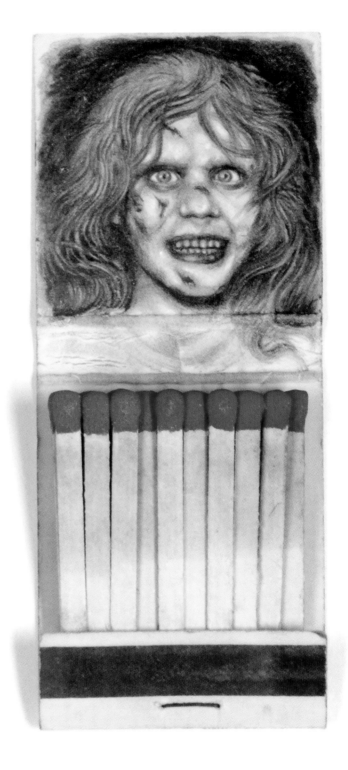

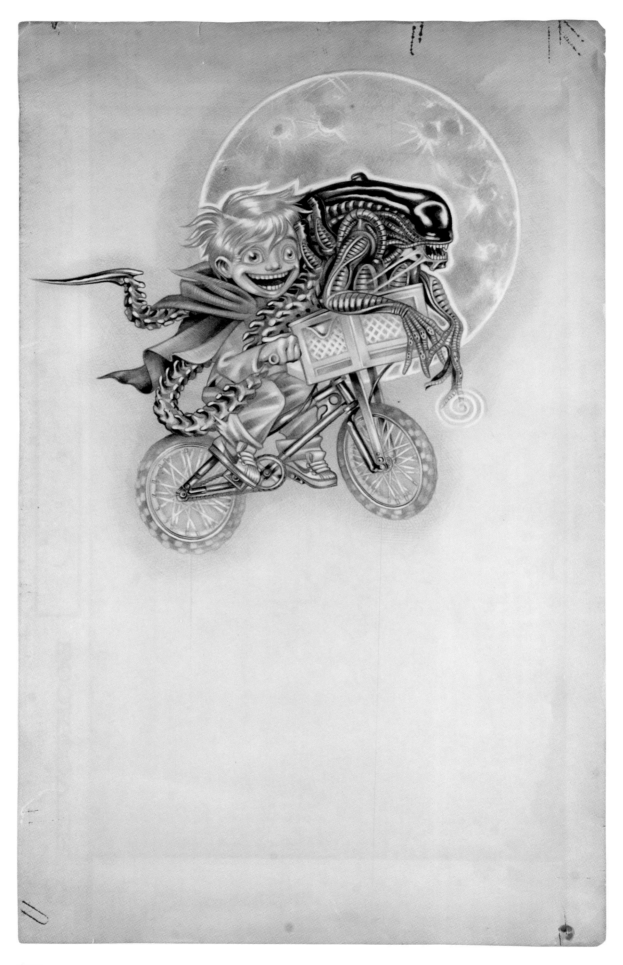

Above:
Jason d'Aquino
'Joyride'
Graphite on vintage paper, 12 x 16 inches
Alien and E.T. The Extra-Terrestrial

Above:
Julian Callos
'Sweets for the Sweet'
Ink and acrylic on paper mounted on cradled
board, 16 x 20 inches
Rocky Horror Picture Show

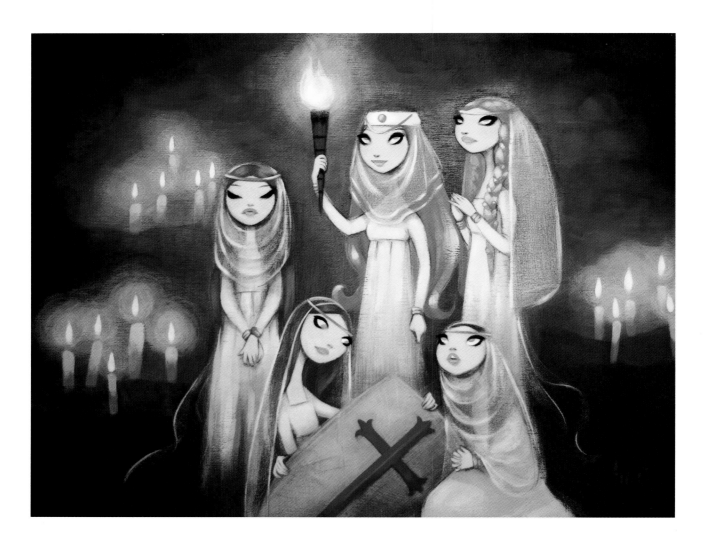

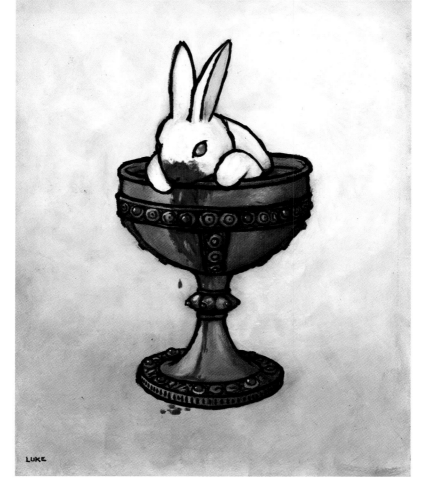

MONTY PYTHON
AND THE
HOLY GRAIL

WIK GRAHAM CHAPMAN · JOHN CLEESE · ERIC IDLE · TERRY GILLIAM · TERRY JONES · MICHAEL PALIN
PRØDUCËD BI MARK FORSTATER · **CINËMATØGRAPHI BI** TERRY BEDFORD · **DIRËKTËD BI** TERRY GILLIAM & TERRY JONES

PG

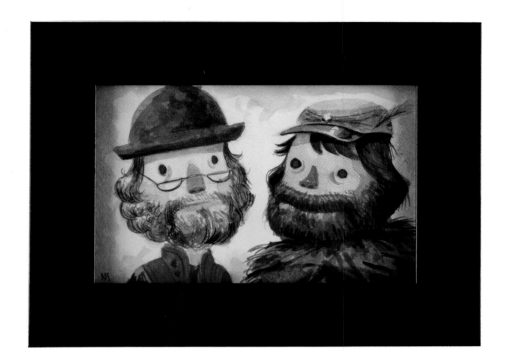

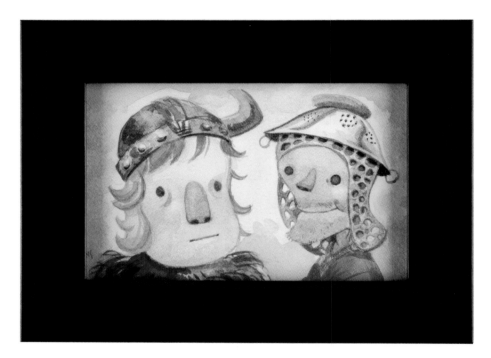

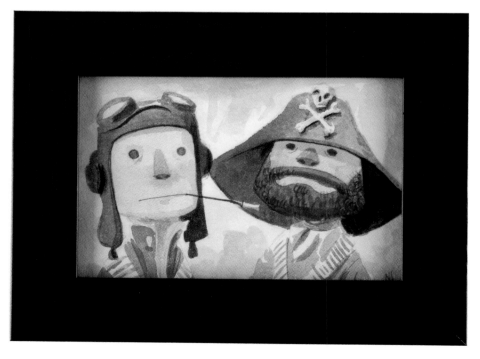

Above:
Megan Kimber
'In Absentia'
Ink and acrylic, 14 x 11 inches
The Shining

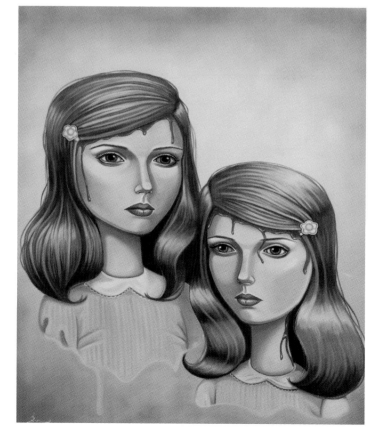

Right:
Audrey Pongracz
'A Father's Duty'
Oil on canvas, 20 x 24 inches
The Shining

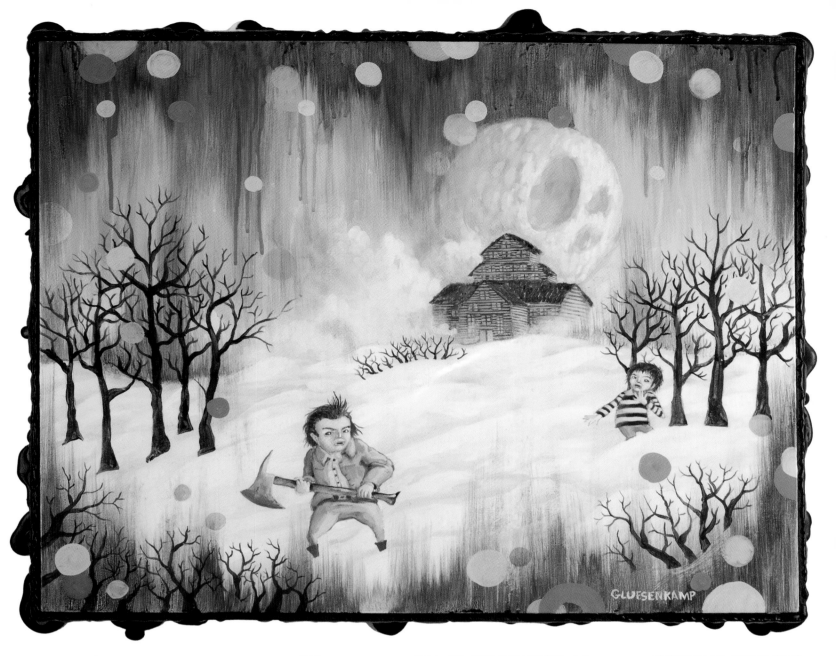

Top:
Lucas Gluesenkamp
'The Caretaker'
Acrylic on canvas, 28 x 22 inches
The Shining

<div align="right">

Above:
Israel Sanchez
'Come Play With Us'
Gouache on illustration board,
26 x 9 inches
The Shining

</div>

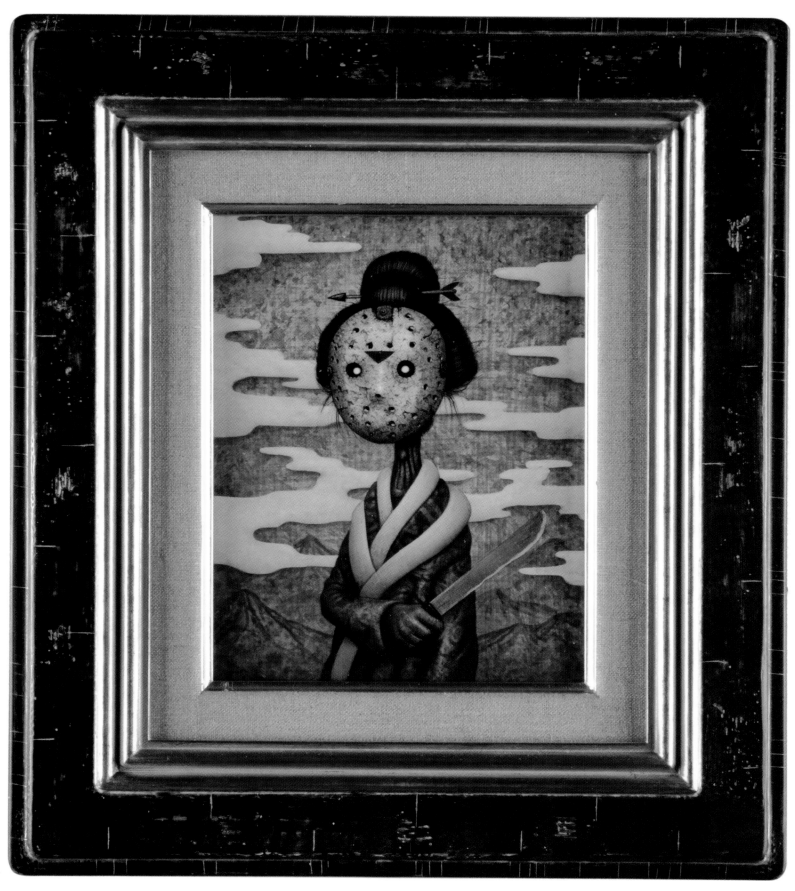

Above:
Naoto Hattori
'Shitto'
Acrylic on board, 5 5/8 x 7 1/8 inches
Friday the 13th

Right:
Roland Tamayo
'Reminiscing the Fast Times'
Acrylic on wood, 16 x 24 inches
Fast Times At Ridgemont High

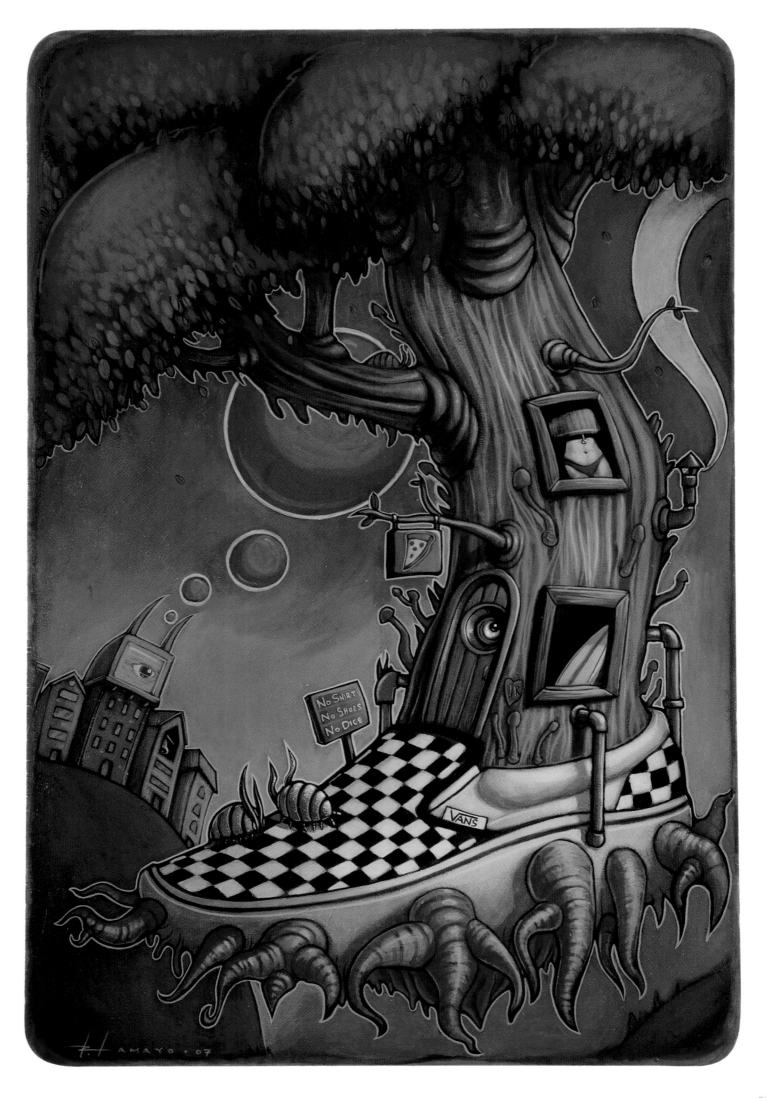

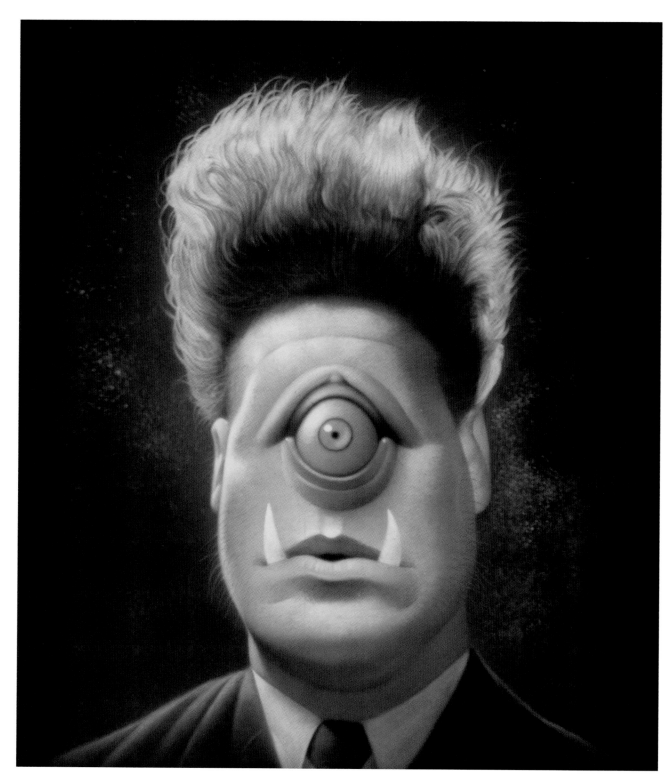

Above:
Travis Louie
'Eraser Head Bill'
Acrylic on board, 8 x 10 inches
Eraserhead

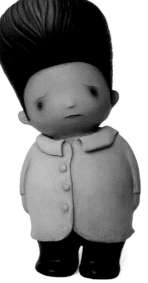

Right:
Paul Barnes
'Henry'
Acrylic on polymer clay,
6 inches tall
Eraserhead

Opposite:
64 Colors
'Worm'
Acrylic on cherry wood,
11 1/4 x 16 inches
Eraserhead

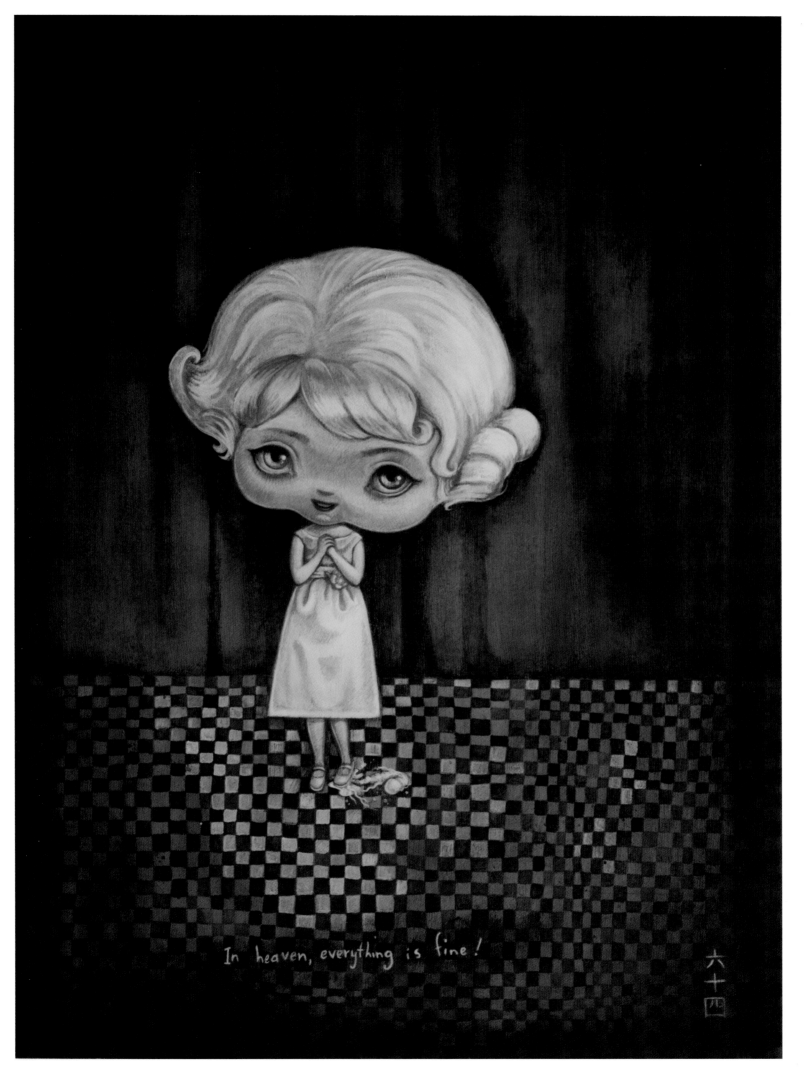

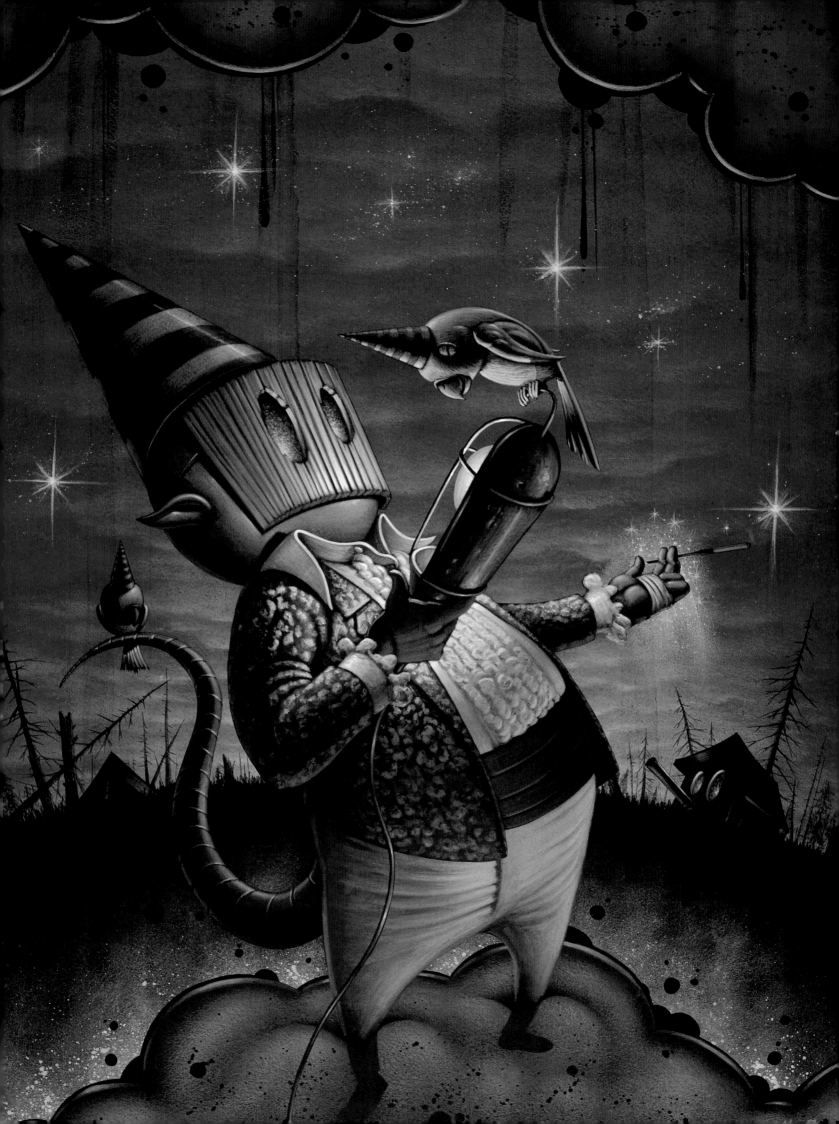

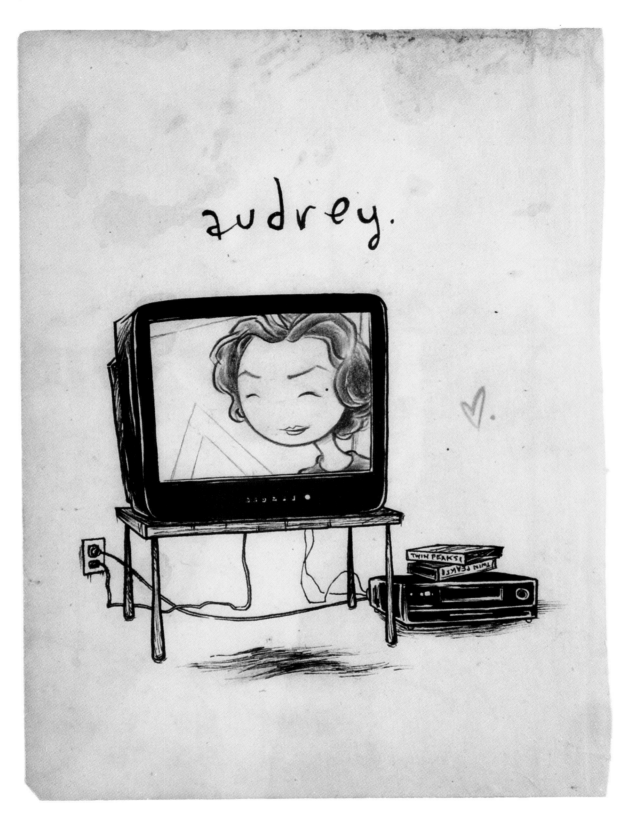

Above:
Kurt Halsey Frederiksen
'Audrey'
Ink and pencil on paper, 8 x 10 inches
Twin Peaks: Fire Walk with Me

Left:
Nathan Ota
'Candy Colored Clown'
Acrylic on panel, 8 x 10 inches
Blue Velvet

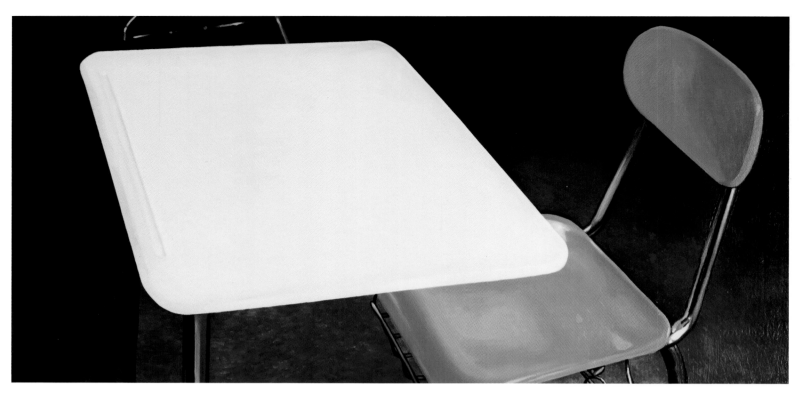

Above:
Jeff Ramirez
'Desk'
Oil on panel, 20 x 10 inches
Twin Peaks: Fire Walk with Me

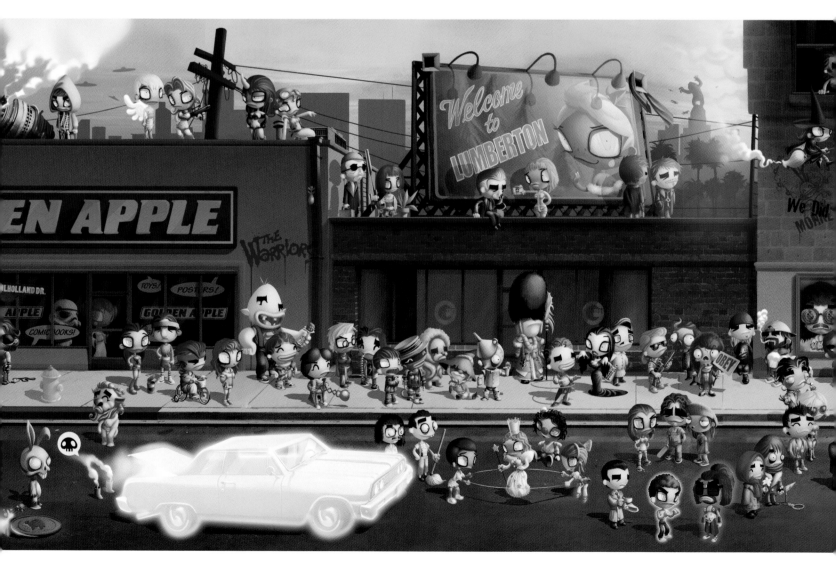

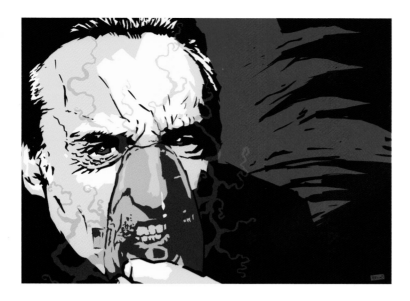

Above:
Billy Perkins
'Don't You Look At Me'
4 color screenprint, including gloss varnish
overprint, 24 x 18 inches
Blue Velvet

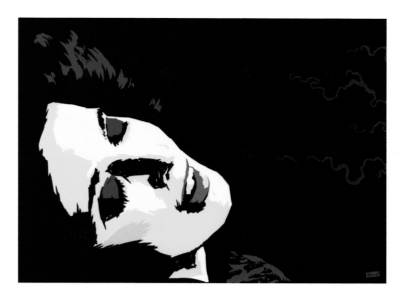

Above:
Billy Perkins
'She Wore Blue Velvet'
4 color screenprint, including gloss varnish
overprint, 24 x 18 inches
Blue Velvet

Below:
Andrew Wilson
'Crazy 4 Cult 2008 Poster'
Digital poster, 39 x 12 inches
Various cult movies

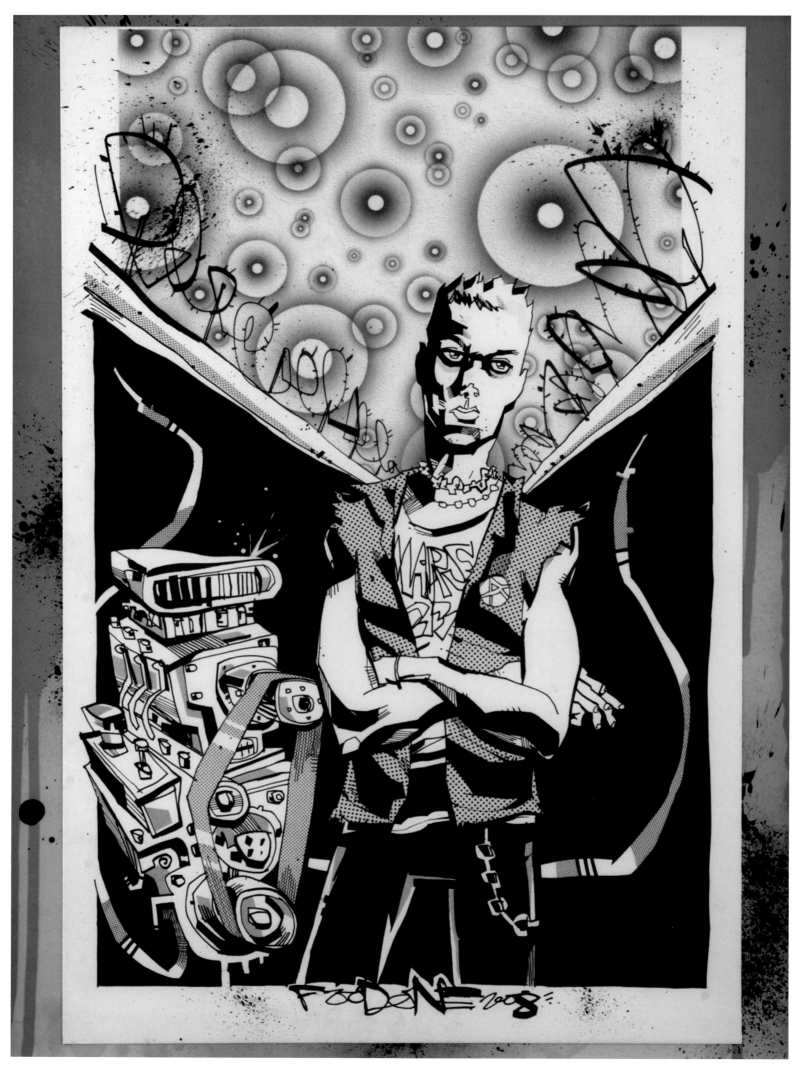

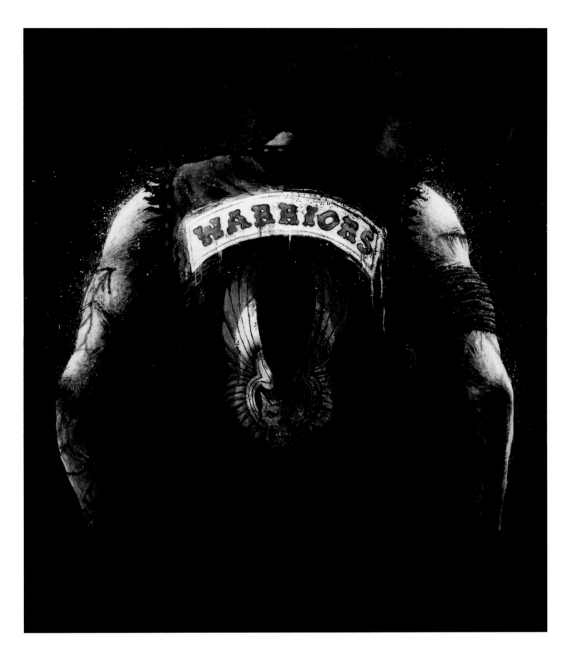

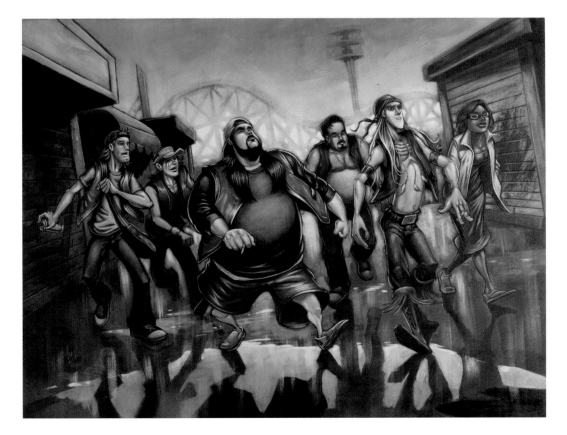

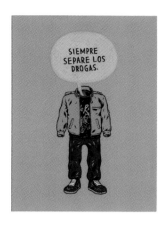
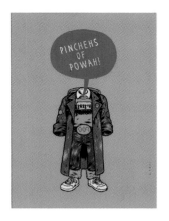
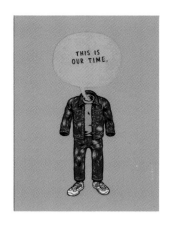
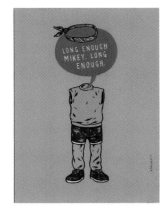
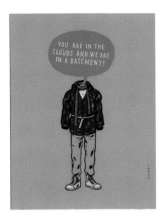
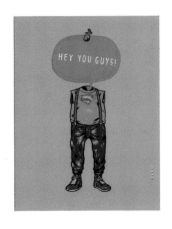

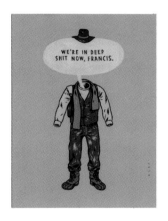
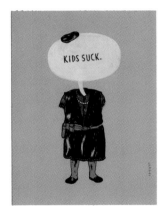
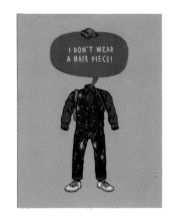
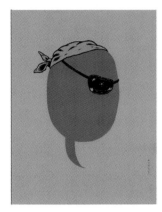

Above:
Andrew DeGraff
Titled as per quote; bottom right: 'Willy'
All gouache on BFK,
5 x 7 inches
The Goonies

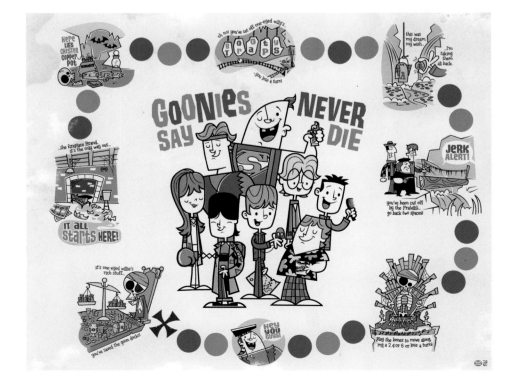

Left:
Dave Perillo
'Goonies Never Say Die'
Digital print, 20 x 16 inches
The Goonies

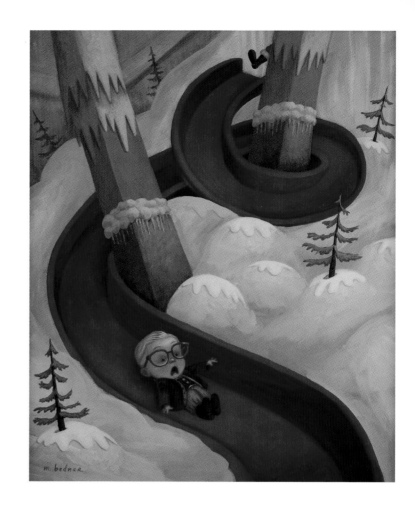

Right:
Mark Bodnar
'Santa Slide'
Acrylic on canvas
A Christmas Story

Bottom left:
Cameron Tiede
'Vote for Bob and Doug'
Acrylic on board, 23 x 31 inches
Strange Brew

Bottom right:
Kiersten Essenpreis
'Take Off, You Hoser'
Flash paint on wood with resin, 10 x 13 1/2 inches
Strange Brew

Opposite:
Andrew Wilson
'Home of Space Paranoids'
Digital print, 18 x 24 inches
TRON and TRON: Legacy

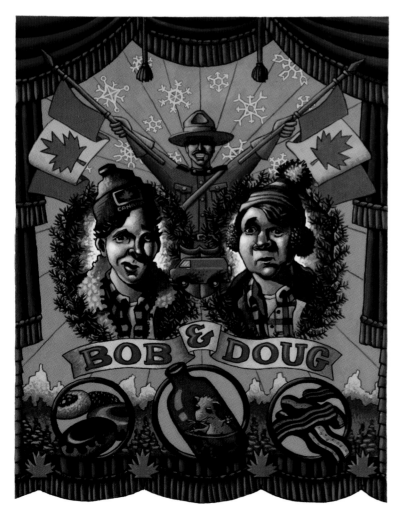

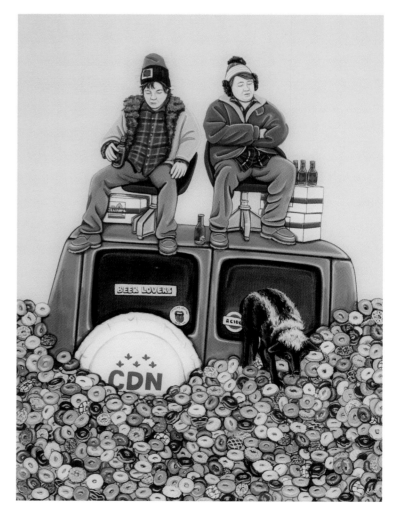

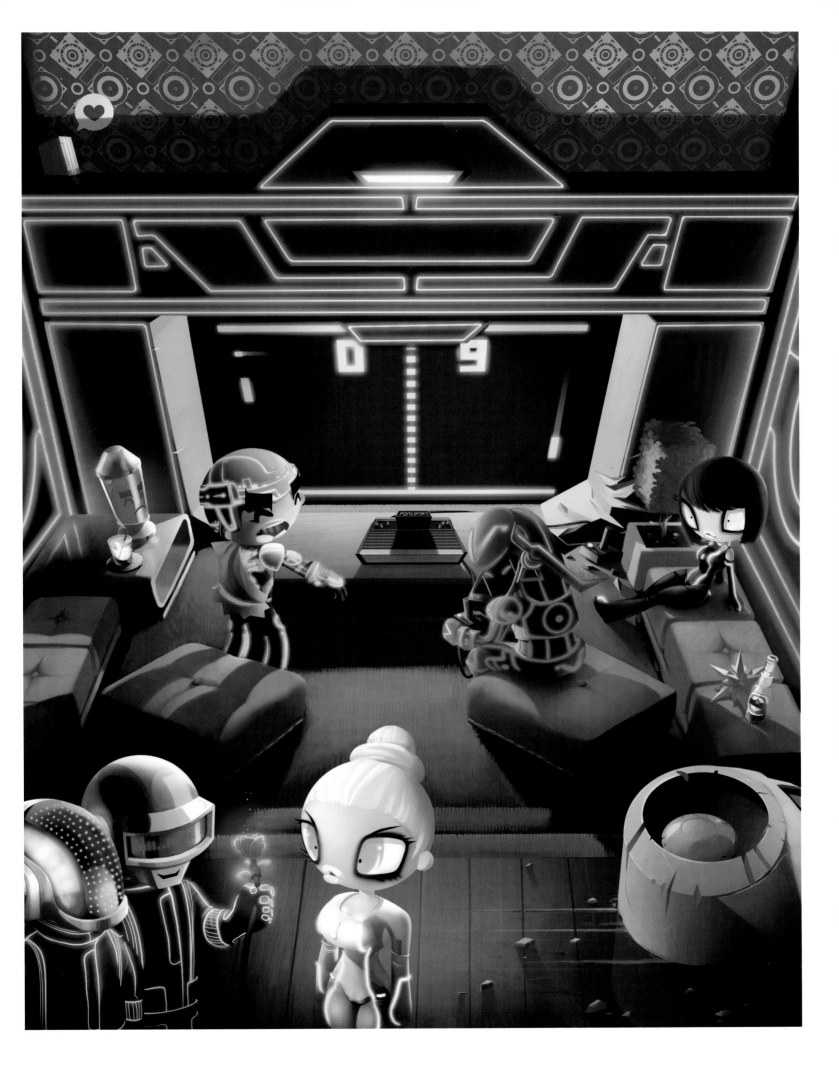

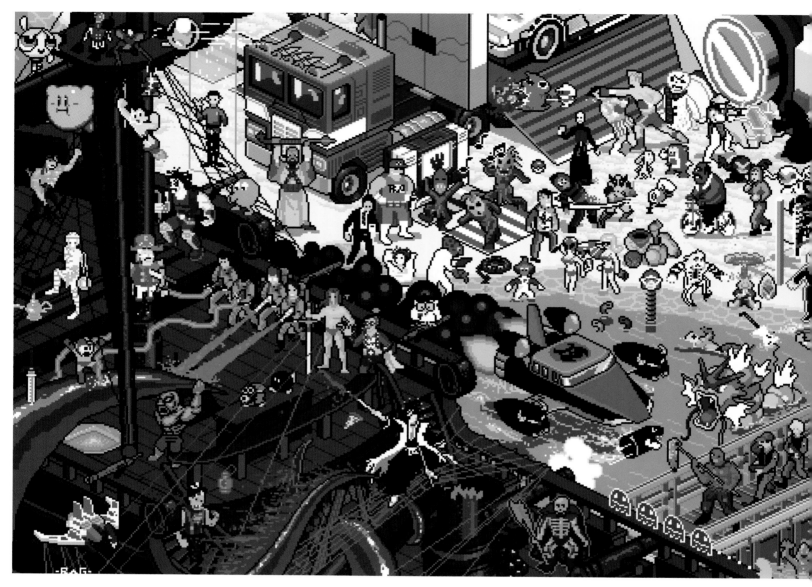

Above:
Roger Barr and Louis Fernet-Leclair
'8-Bit Beach Party'
Digital print, 34 x 13 1/2 inches
Various cult movies

Right:
Daniel Elson
'Meese #30 & #31' (Ghostbusters)
*Acrylic and enamel on wood and metal
and rubber (Ghostbuster), acrylic on
wood with glow-in-the-dark enamel and
acrylic base (ghost), 3 x 6 x 1 inches*
Ghostbusters

Opposite left:
Daniel Elson
'Meese #29' (Sloth)
*Acrylic and enamel on wood and metal,
3 x 3 x 1 inches*
The Goonies

Opposite right:
Daniel Elson
'Meese And Silent Meese'
*Acrylic and enamel on wood and metal,
3 1/2 x 7 x 2 inches*
Clerks

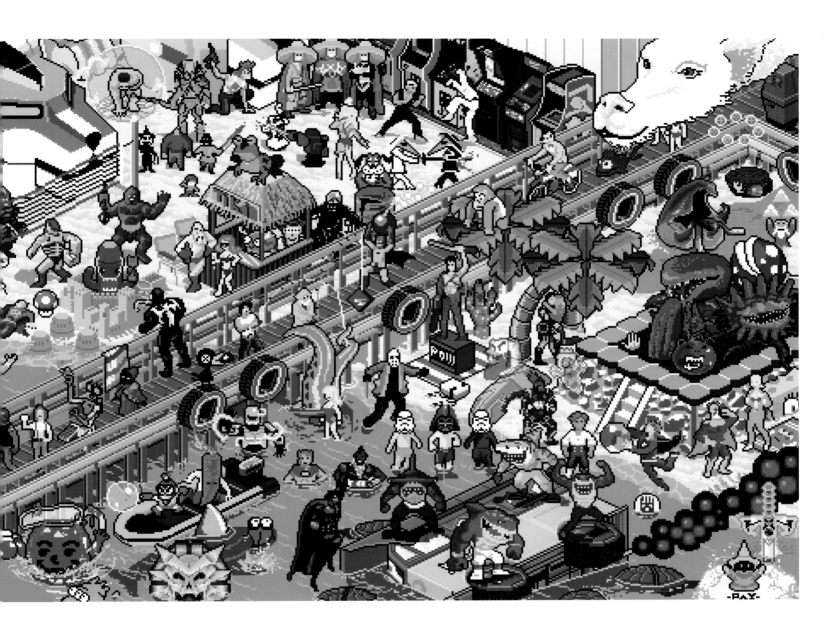

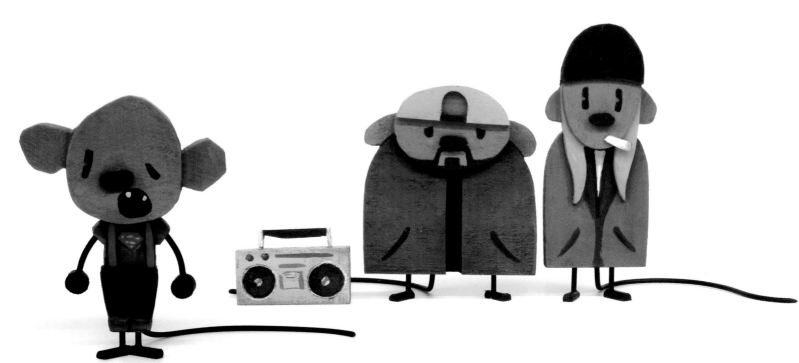

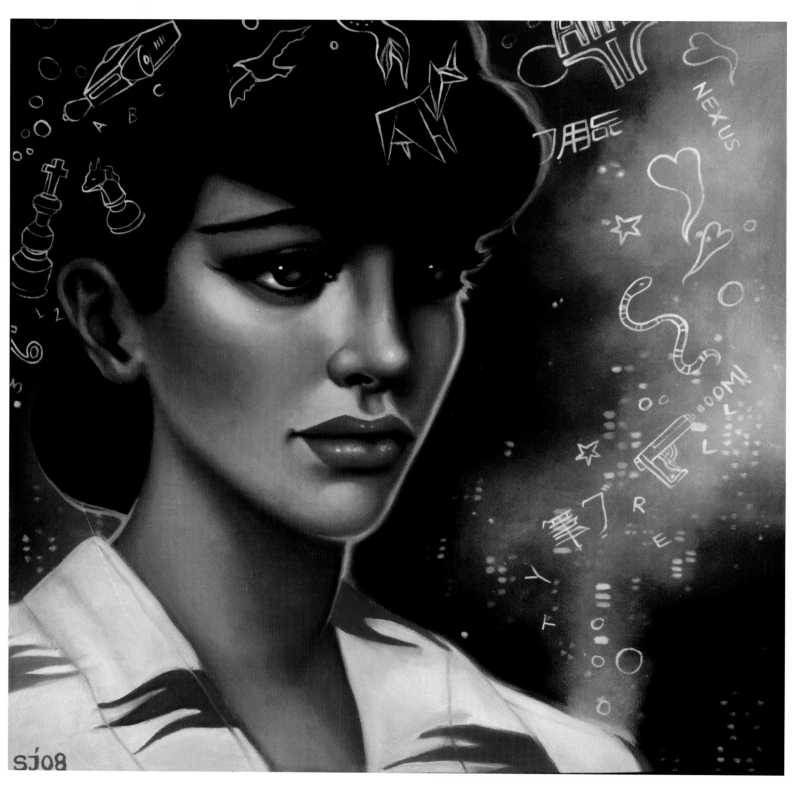

Above:
Sarah Joncas
'Blush Response'
Oil on canvas, 18 x 18 inches
Blade Runner

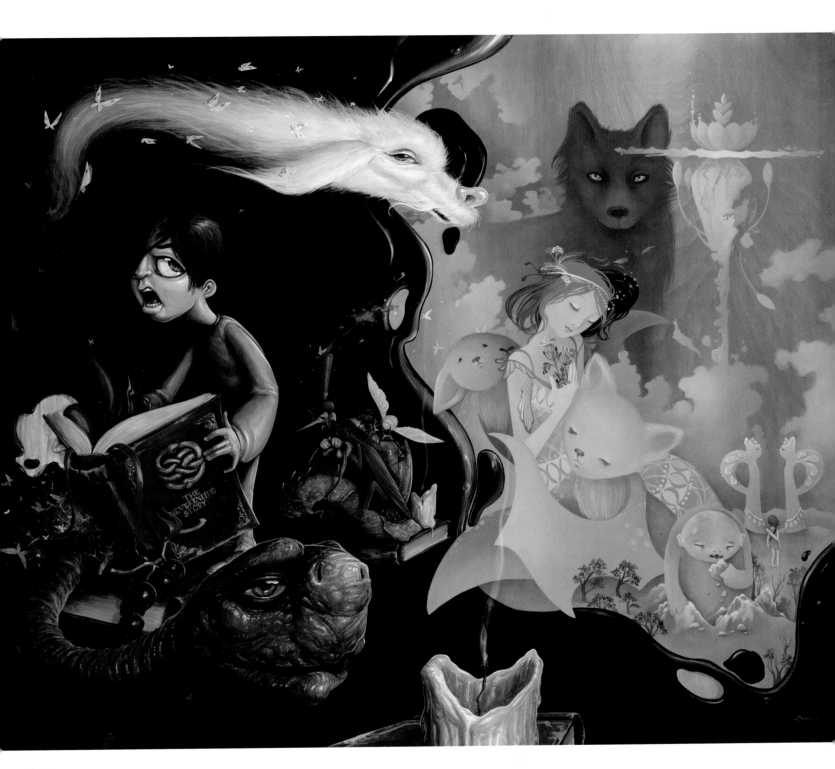

Above:
Greg Simkins and Amy Sol
'Give Me A Name, Bastian!'
Acrylic on board, 24 x 20 inches
The Neverending Story

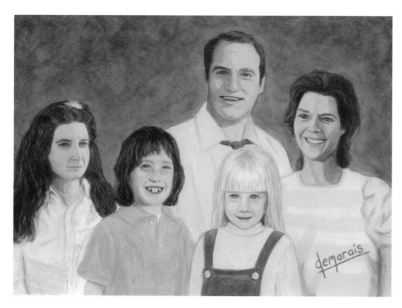

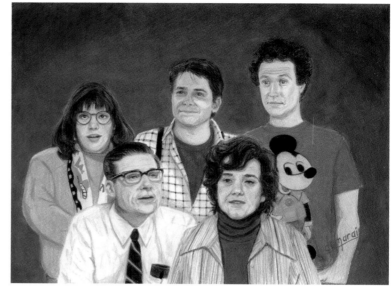

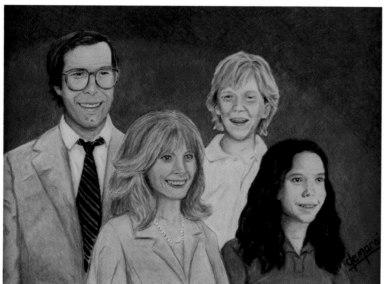

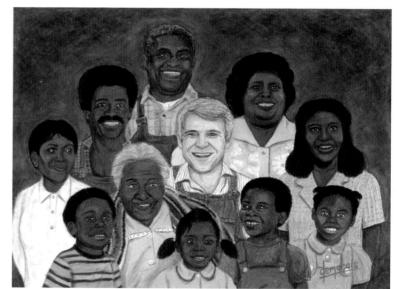

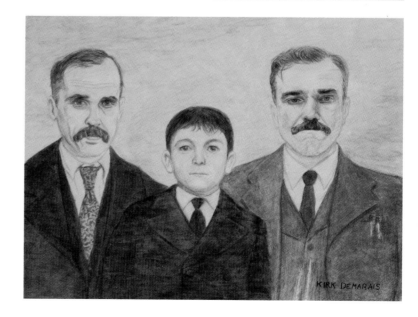

Clockwise from top left:
Kirk Demarais
'The Freelings', 'The McFlys', 'The Johnsons', 'The Plainviews', 'The Griswolds'
All colored pencil on paper, 14 x 11 inches
Poltergeist, Back to the Future, The Jerk, There Will Be Blood, National Lampoon's Vacation

Opposite:
Kirk Demarais
'The Torrances'
Colored pencil on paper, 11 x 14 inches
The Shining

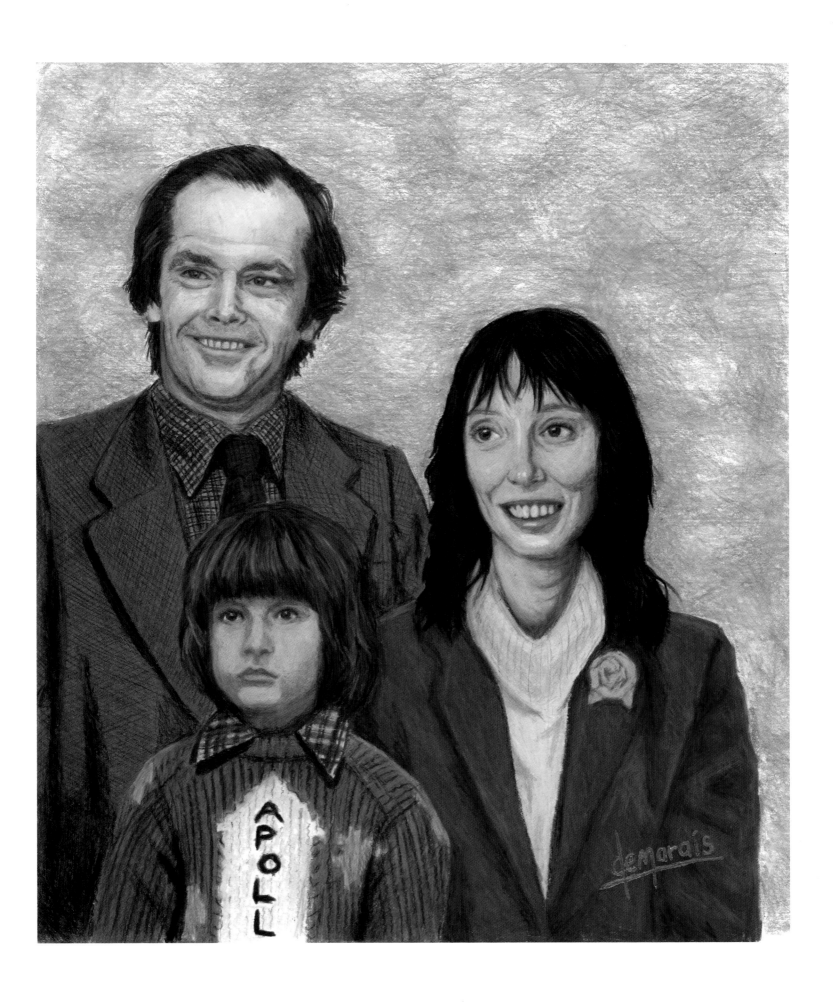

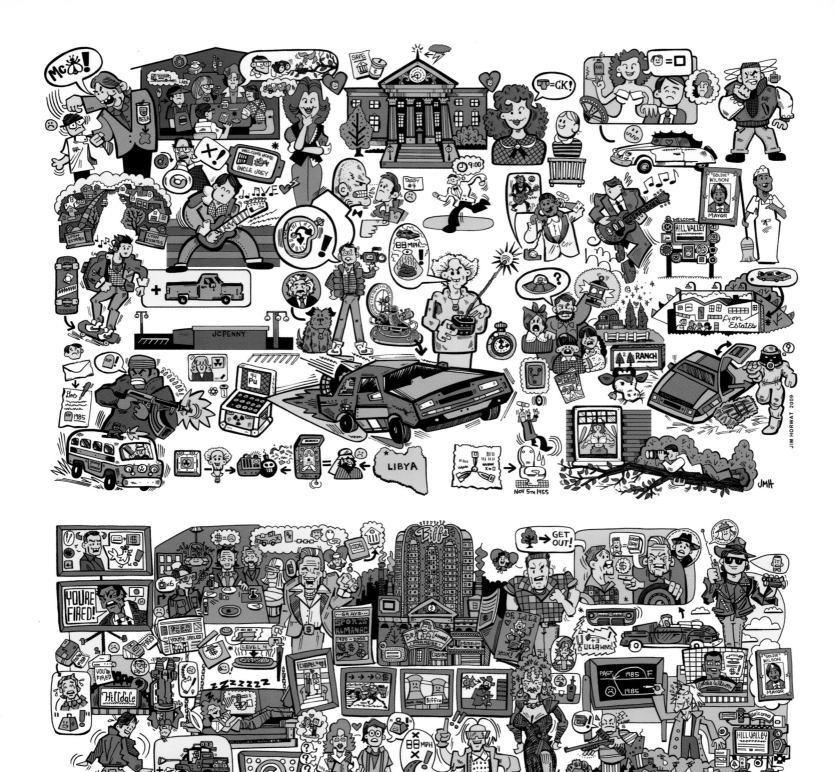

Top and above:
Jim Horwat
'Back to the Future Part 1', 'Back to the Future Part 2'
Pen and ink process/digital prints, 16 x 12 inches and 17 x 11 inches
Back to the Future, Back to the Future II

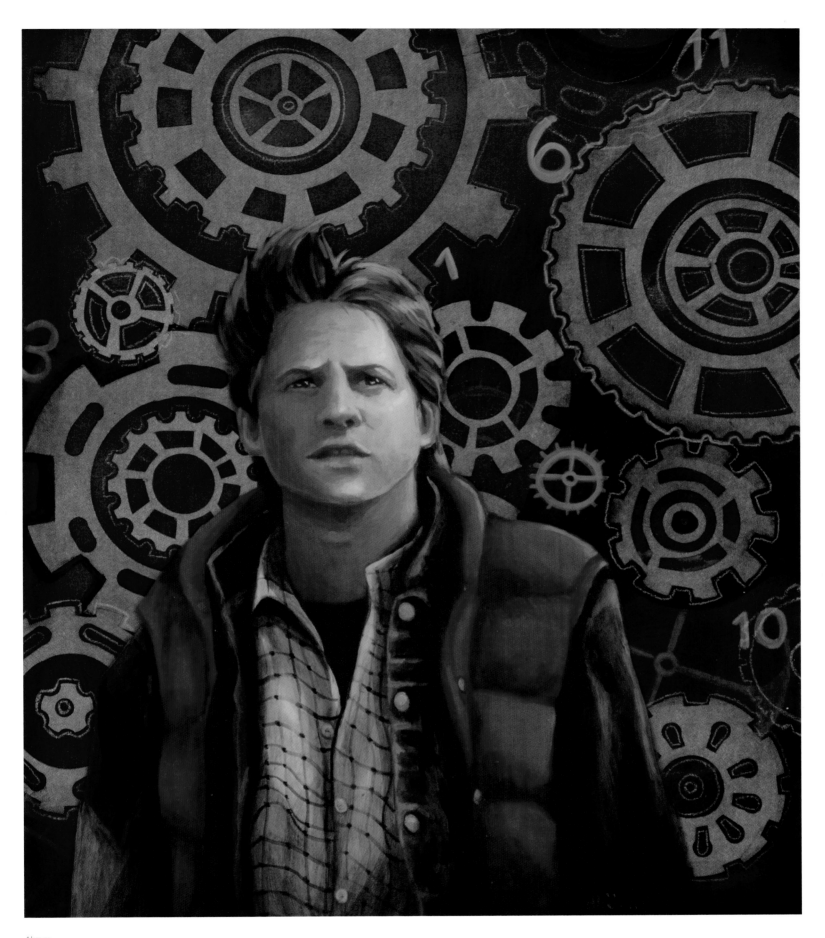

Above:
Danielle Buerli
'Marty'
Mixed media, 10 x 12 inches
Back to the Future

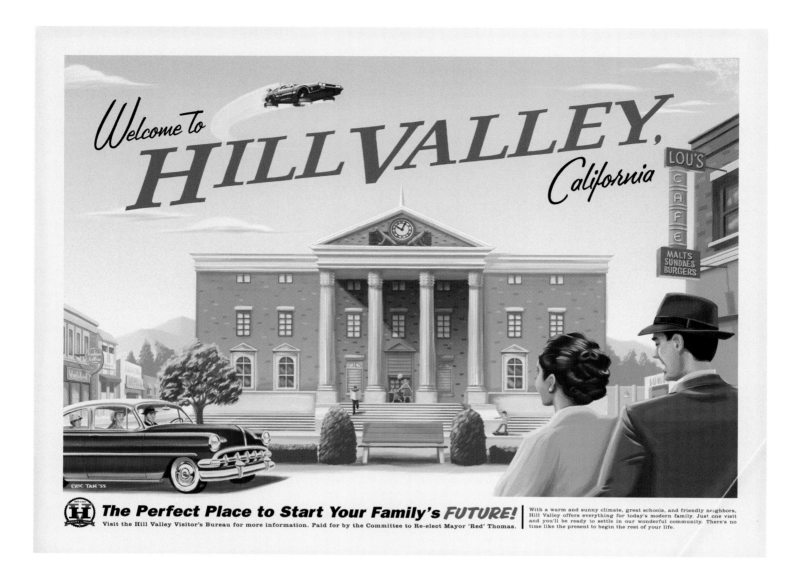

Above:
Eric Tan
'Hill Valley'
4 color offset print on heavyweight textured paper,
24 x 18 inches
Back to the Future

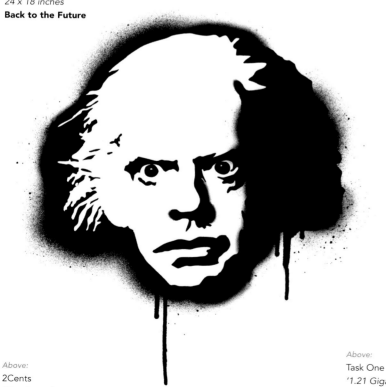

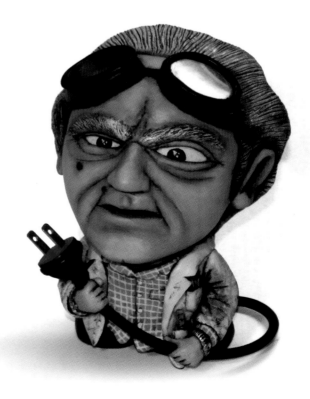

Above:
2Cents
'Doc Brown'
Hand-pulled screenprint, 16 x 20 inches
Back to the Future

Above:
Task One
'1.21 Gigawatts'
Acrylic and magic sculpt over plaster Munny,
8 inches tall. Photo by Andrew Susich
Back to the Future

Above:
Michael Steele
'Where We're Going, We Don't Need Roads'
Oil on canvas, 24 x 18 inches
Back to the Future

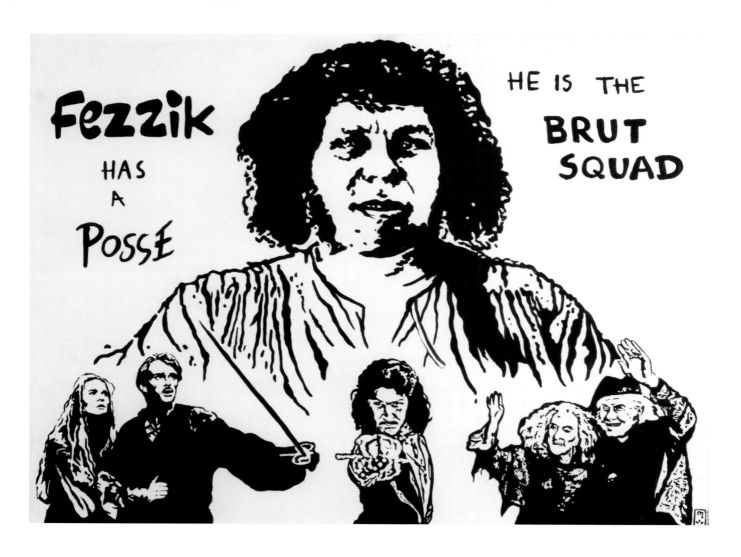

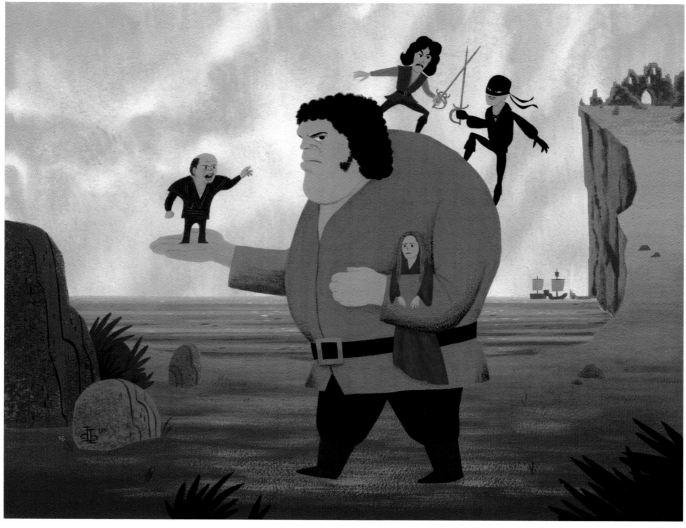

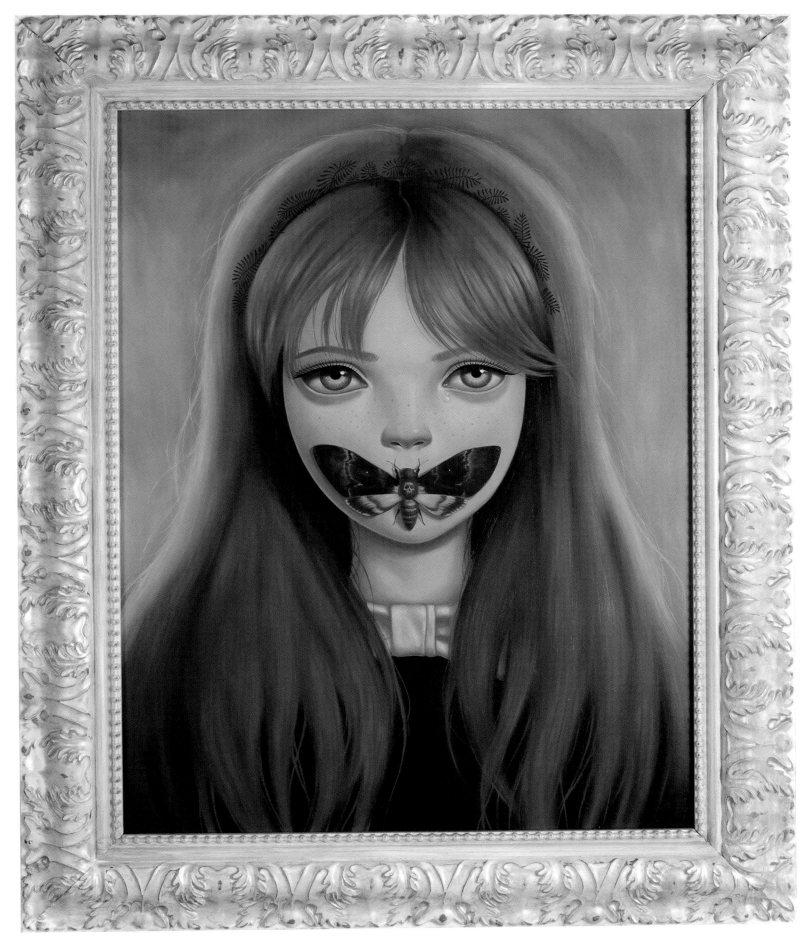

Opposite top:
Misha
'Fezzik Has a Posse'
Acrylic on canvas board, 24 x 18 inches
The Princess Bride

Opposite bottom:
Drake Brodahl
'There Was a Mighty Duel'
Cel vinyl acrylic on cradled panel, 14 x 11 inches
The Princess Bride

Above:
Ana Bagayan
'Silence'
Oil on wood, 18 x 24 inches
The Silence of the Lambs

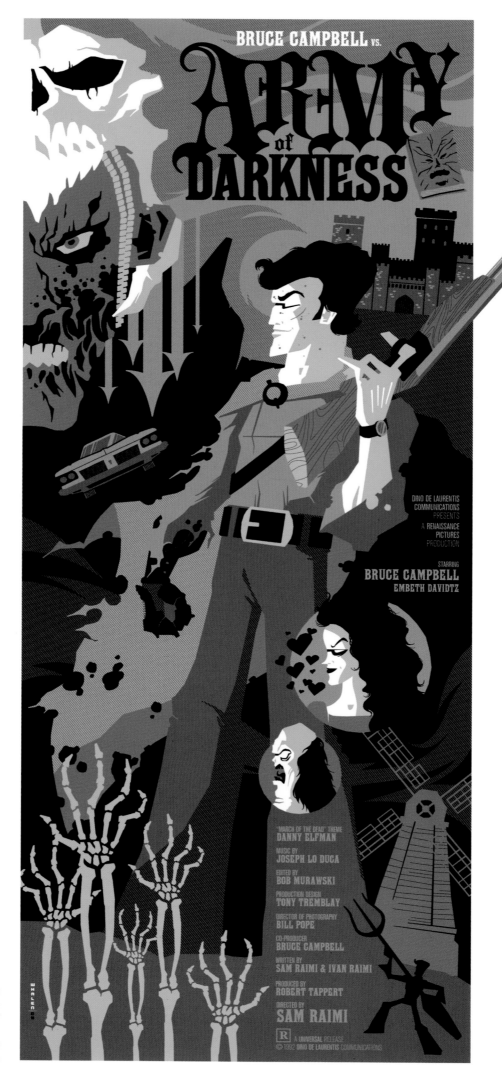

Right:
Keeley Carrigan
'Send Them Back to Hell'
Acrylic on canvas, 12 x 12 inches
The Evil Dead

Below:
James "Jimbot" Demski
'I'll Swallow Your Soul'
Acrylic on board, 15 x 20 inches
The Evil Dead

Right:
Yoskay Yamamoto
'Positive Surrender'
Acrylic on board, 9 x 12 inches
Akira

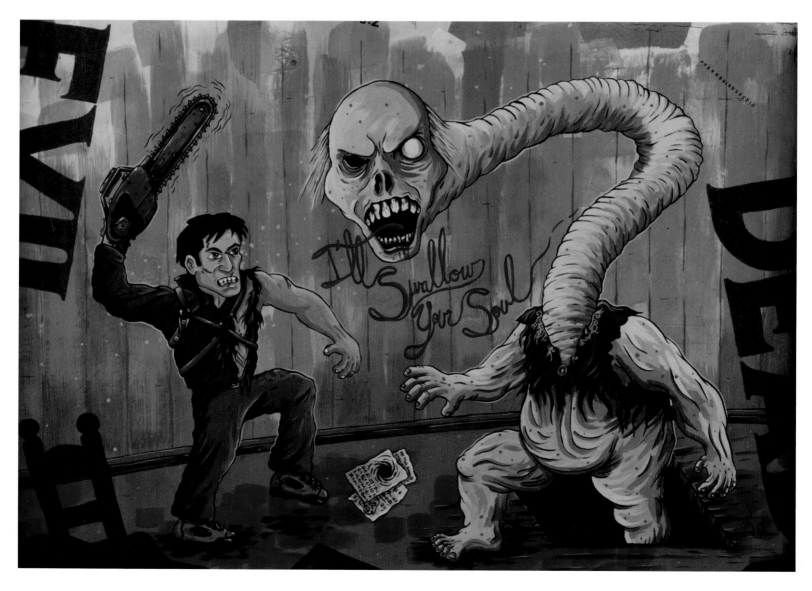

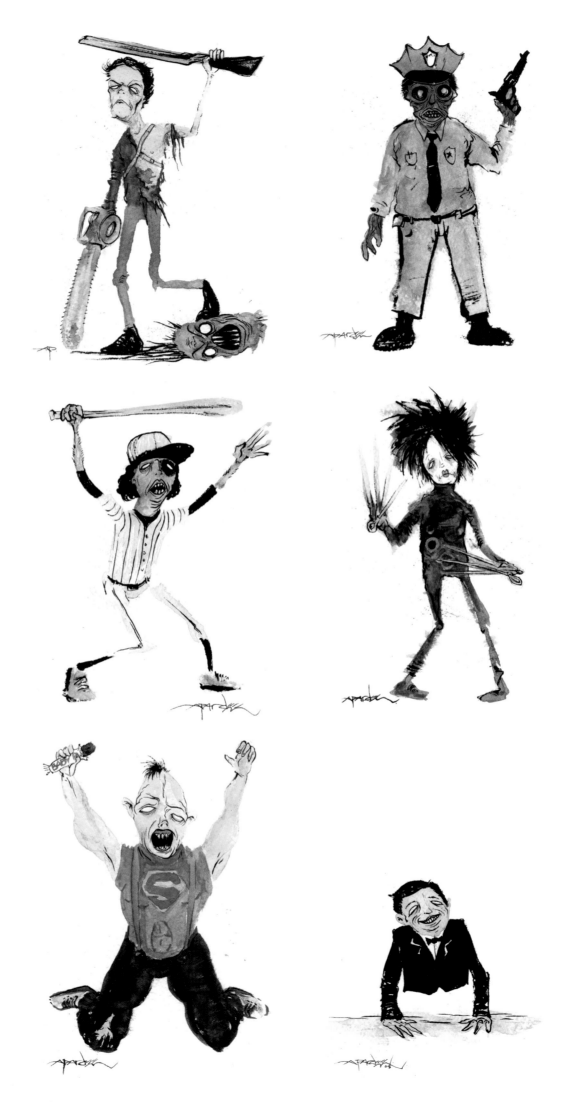

Clockwise from top left:
Alex Pardee
'Ash', 'Cop # 4',
'Edward Scissorhands',
'Johnny Eck', 'Sloth',
'Baseball Furie #1'
All watercolor on paper,
8 1/2 x 10 1/2 inches
The Evil Dead, They Live, Edward Scissorhands, Freaks, The Goonies, The Warriors

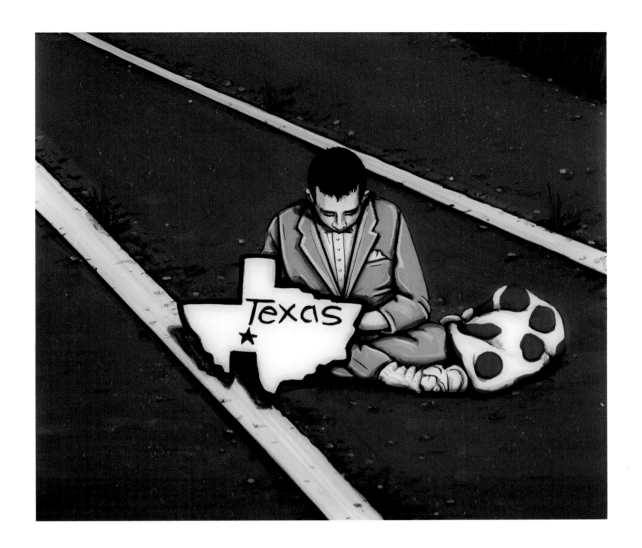

Top and above:
Kiersten Essenpreis
'To Texas', 'After the Fire'
Mixed media on panel, 6 1/2 x 6 inches and mixed media on board, 9 x 7 inches
Pee-Wee's Big Adventure

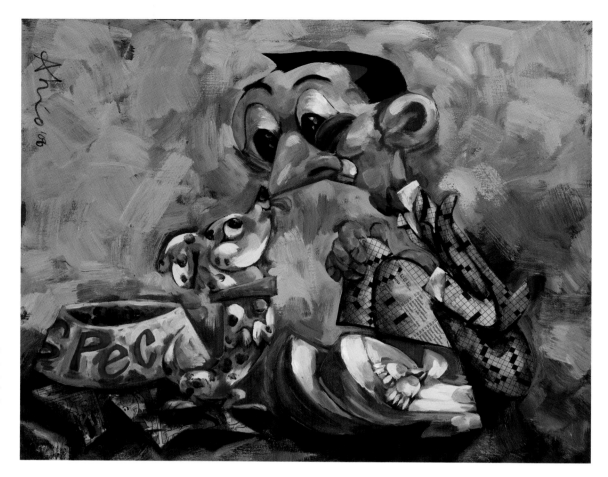

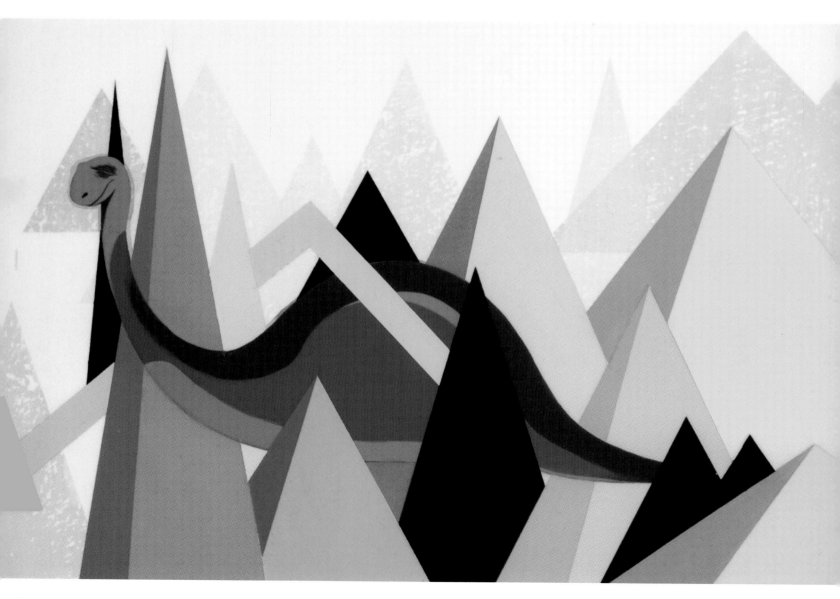

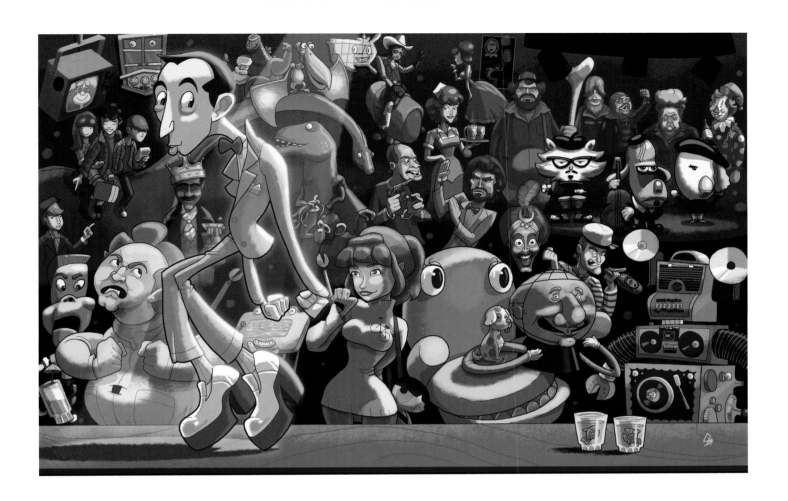

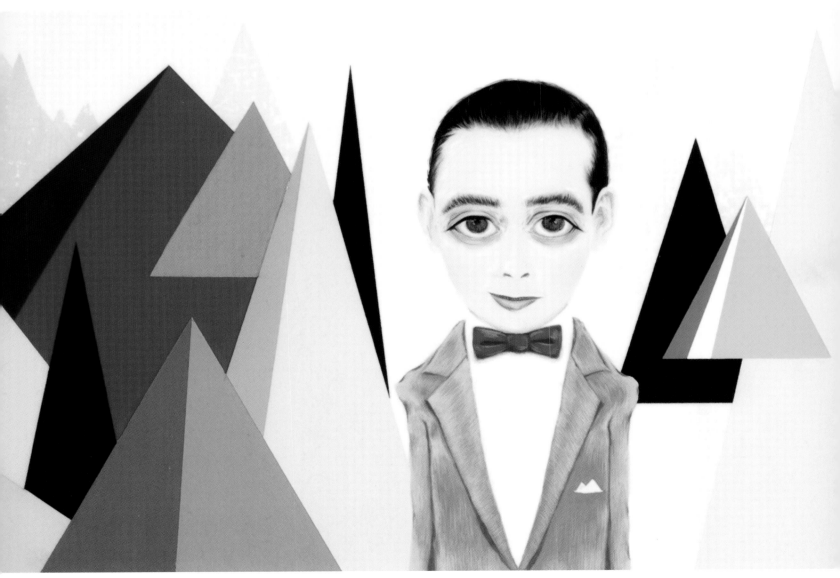

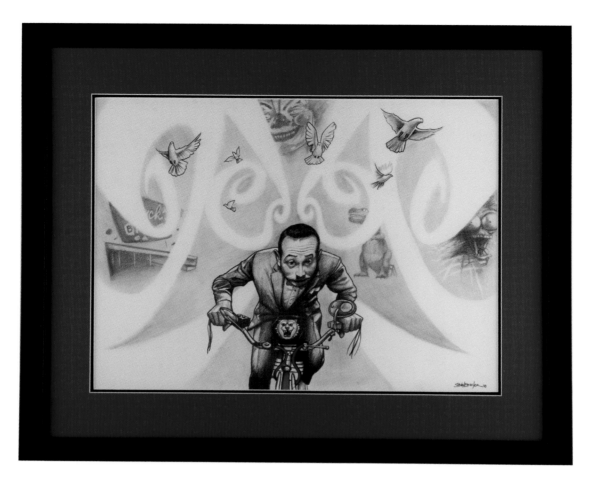

Above:
Steven Bossler
'Pee-Wee's Escape'
Graphite and watercolor on board,
27 x 22 1/2 inches
Pee-Wee's Big Adventure

Below:
Danielle Rizzolo
'I'm A Loner, A Rebel'
Oil on board, 16 x 13 inches
Pee-Wee's Big Adventure

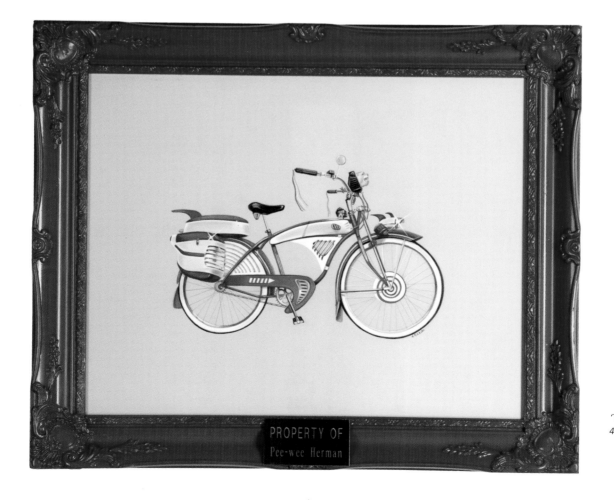

Right:
Little Friends of
Printmaking
'This Boy is a Hero'
4 color screenprint,
19 x 13 inches
**Pee-Wee's Big
Adventure**

Above:
Dan Lydersen
'Joyce'
Oil on wood panel, 24 x 20 inches
Edward Scissorhands

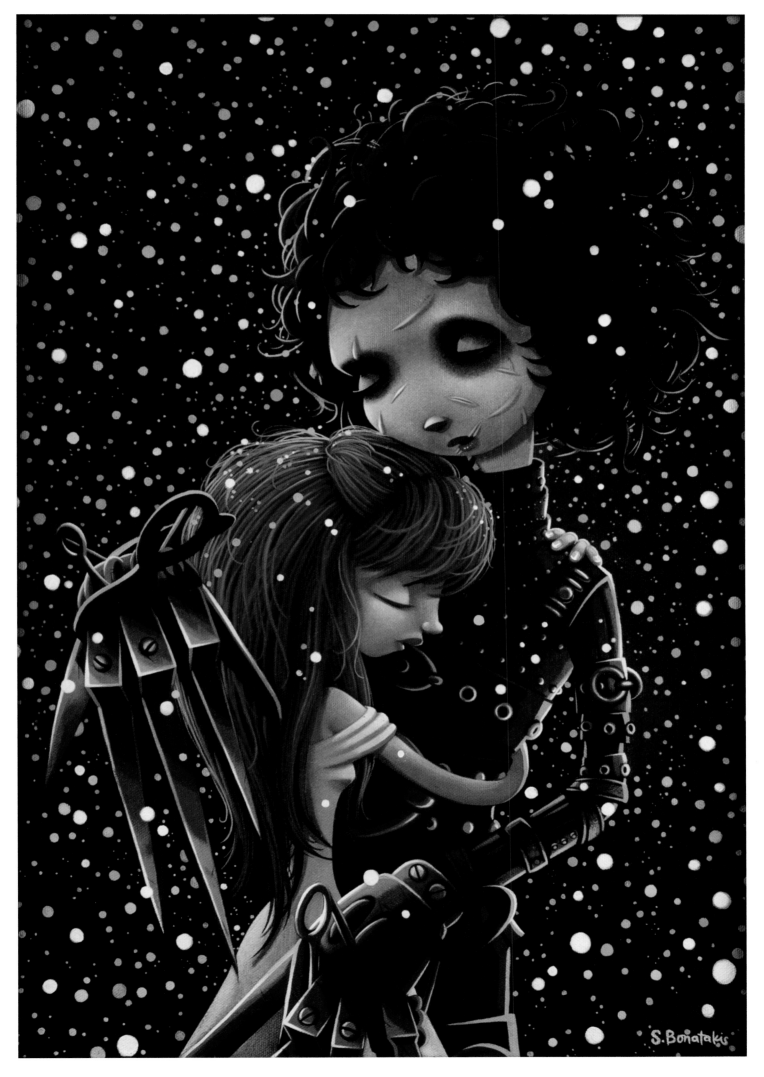

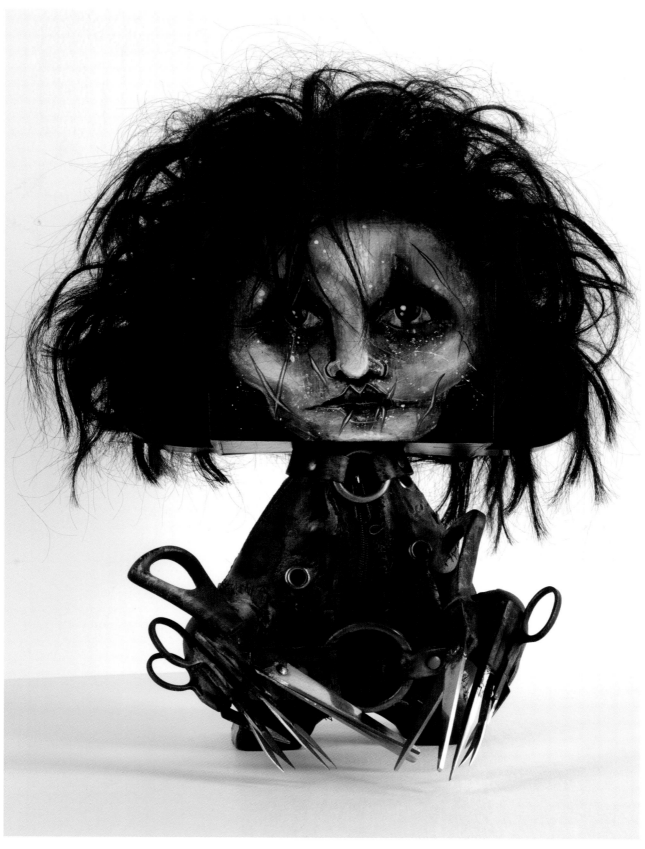

Above:
Brent Nolasco
'Edward'
Customized vinyl figure, 8 x 13 x 6 inches
Edward Scissorhands

Right:
Dan May
'Portrait of a Gentle Man'
Acrylic on wood, 12 x 16 inches
Edward Scissorhands

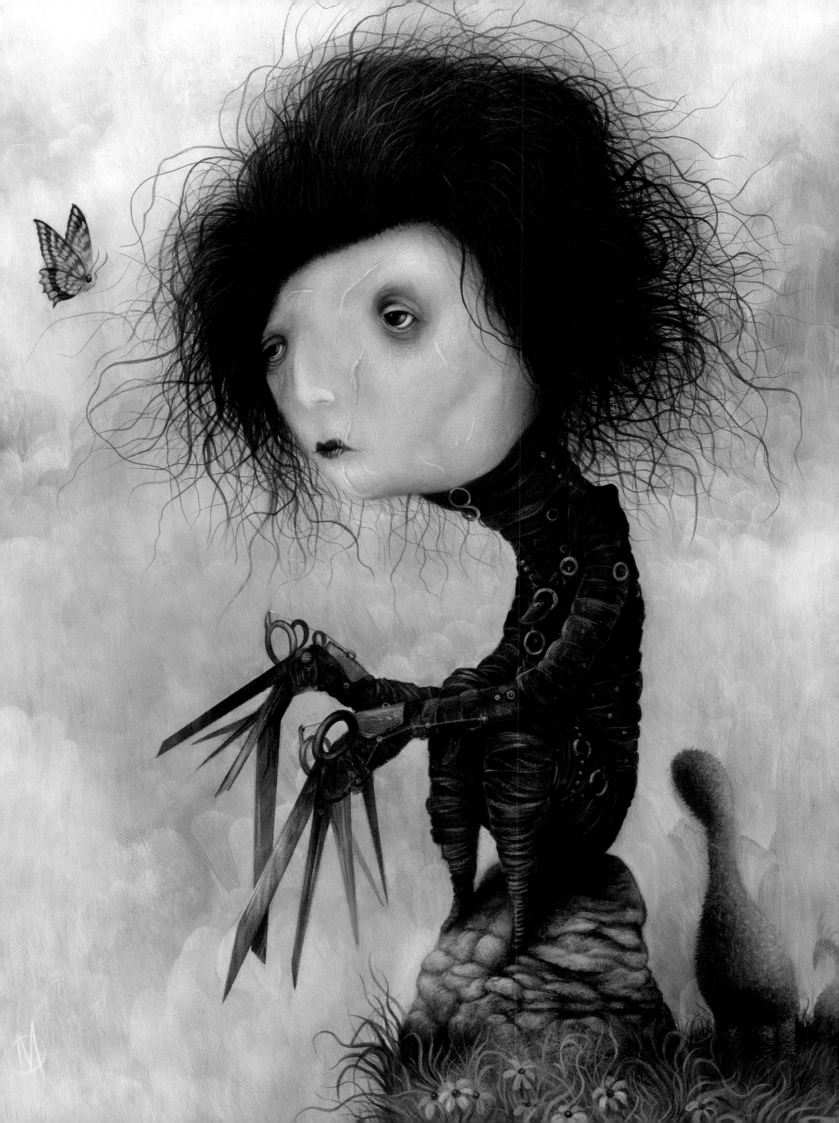

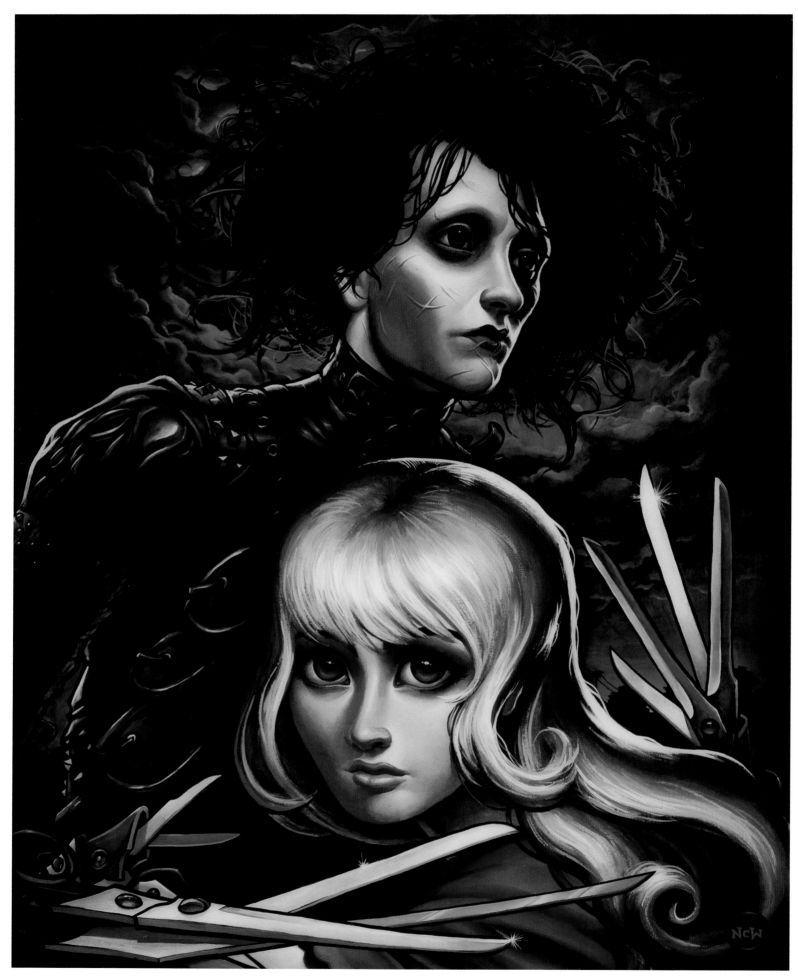

Above:
N.C. Winters
'Severed Edward'
Acrylic and resin on wood panel, 16 x 20 inches
Edward Scissorhands

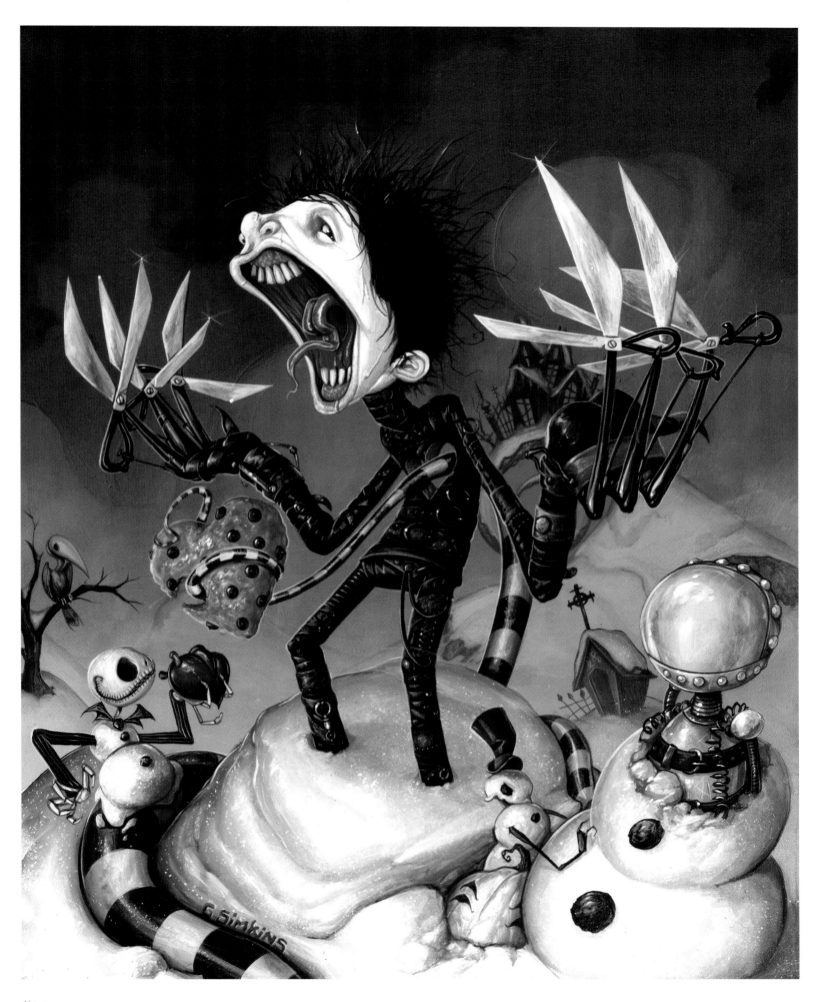

Above:
Greg Simkins
'Ed's Losing'
Acrylic on panel, 11 x 14 inches
Edward Scissorhands and The Nightmare Before Christmas

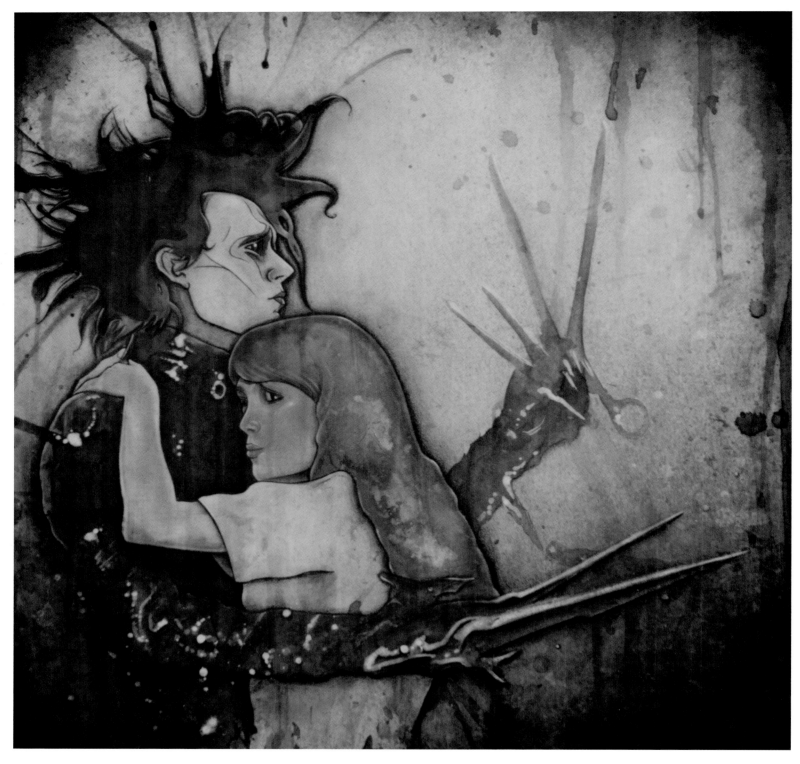

Above:
Alan Kocharian
'Eddie'
Mixed media, 12 x 12 inches
Edward Scissorhands

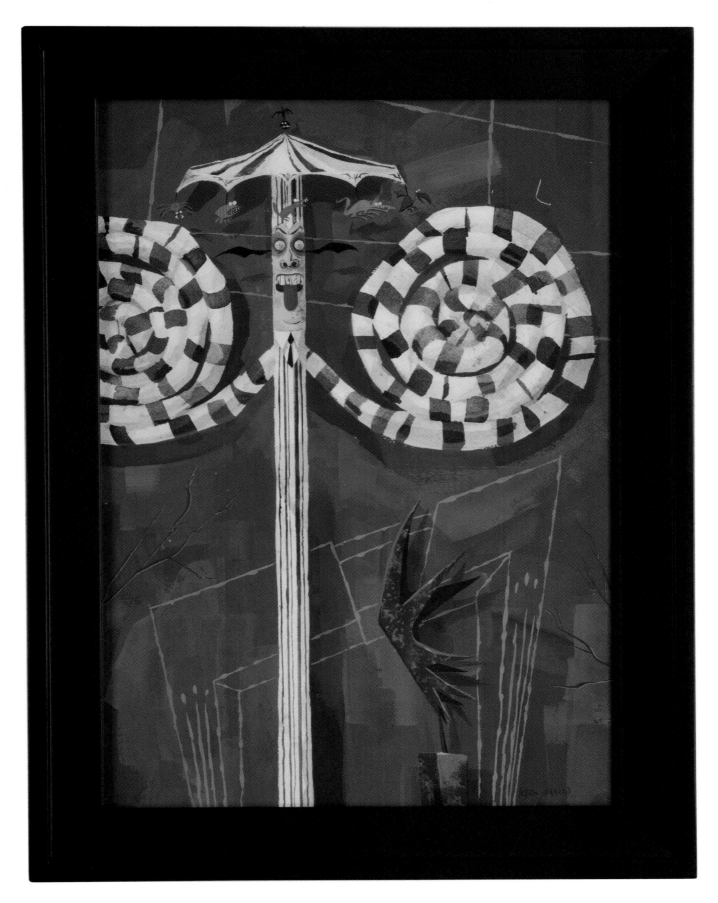

Above:
Alex Kirwan
'All Geused Up'
Gouache on paper, 10 x 14 inches
Beetlejuice

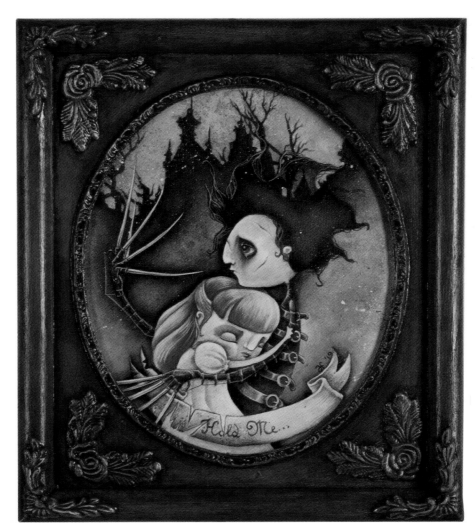

Right:
Alessandra Fusi
'Hold Me... I Can't'
Acrylic, watercolor, gouache and
ink on watercolor paper,
7 x 9 inches
Edward Scissorhands

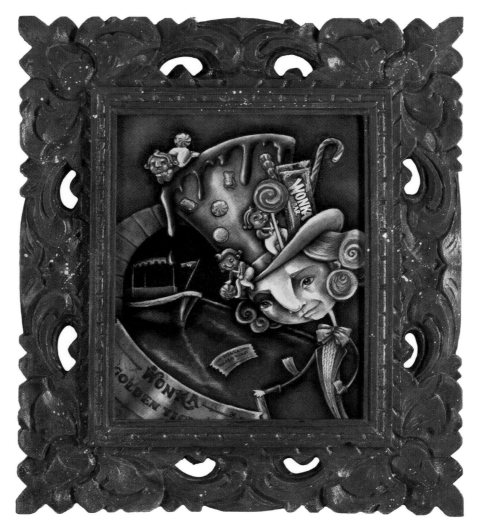

Right:
Alessandra Fusi
'The Dreamer of Dreams'
Acrylic, watercolor, gouache, ball-
point pen, colored pencil
and collage on watercolor paper,
7 3/4 x 10 inches
Willy Wonka & the
Chocolate Factory

Above and left:
Leontine Greenberg
'Self-Portrait (Edward)',
'Edward's Girl'
Both watercolor on paper,
9 x 9 inches
Edward Scissorhands

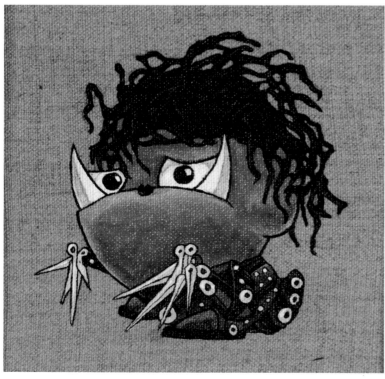
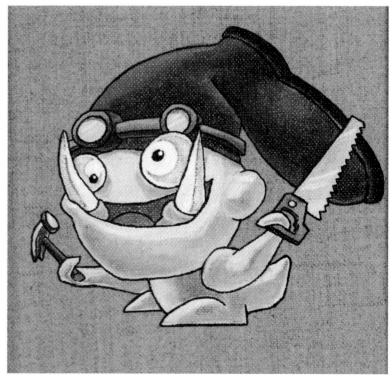

Clockwise from top left:
Justin Kalmen
'Al', 'Alex', 'Steve', 'Ed'
All acrylic on linen, 6 x 6 inches
UHF, A Clockwork Orange, Multiplicity,
Edward Scissorhands

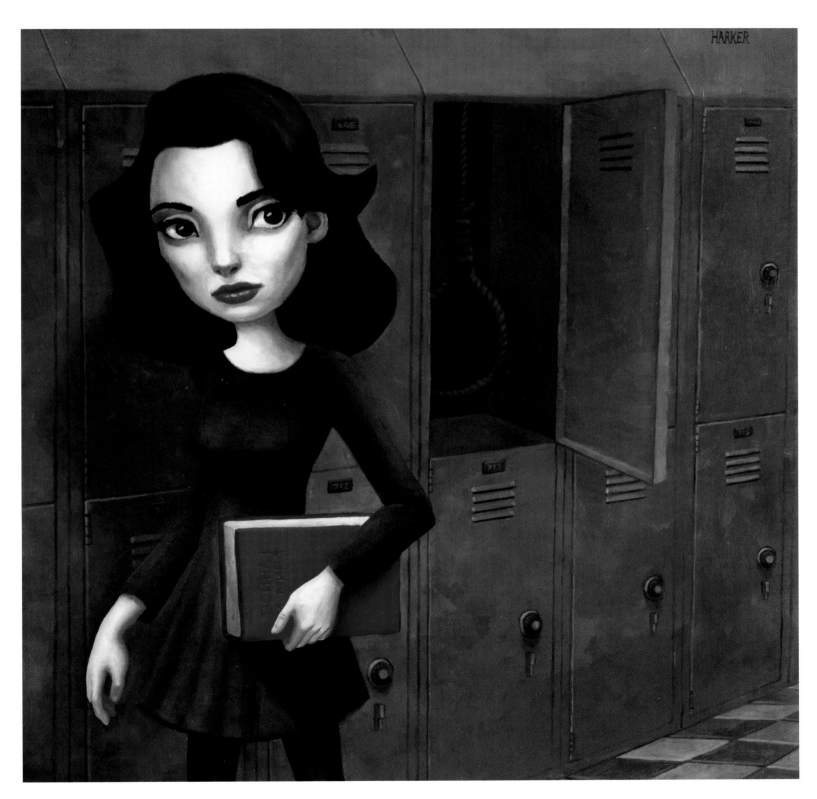

Above:
Jim Harker
'A World Without Heather'
Oil on wood panel, 16 x 16 inches
Heathers

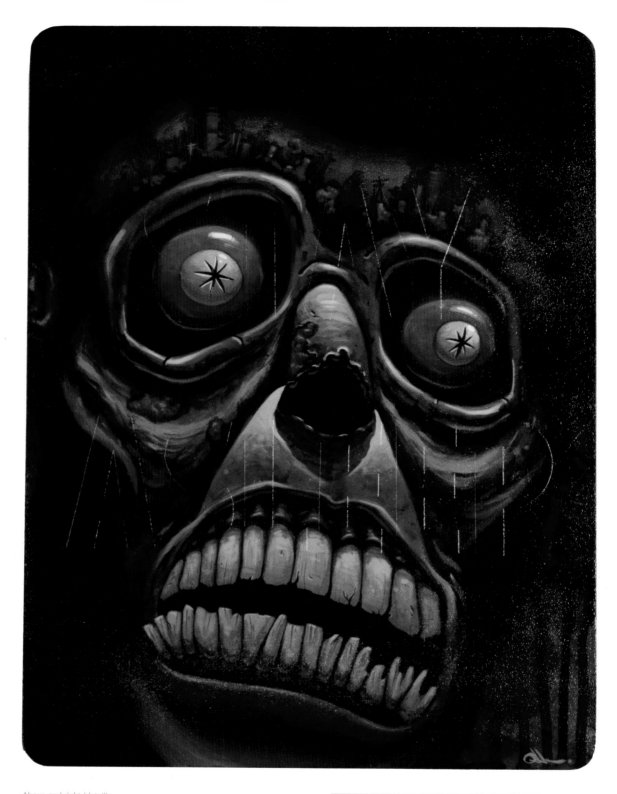

Above and right (detail):
Jay Oddzoo Doronio
'Sleep'
Mixed media on panel, 10 x 13 inches
They Live

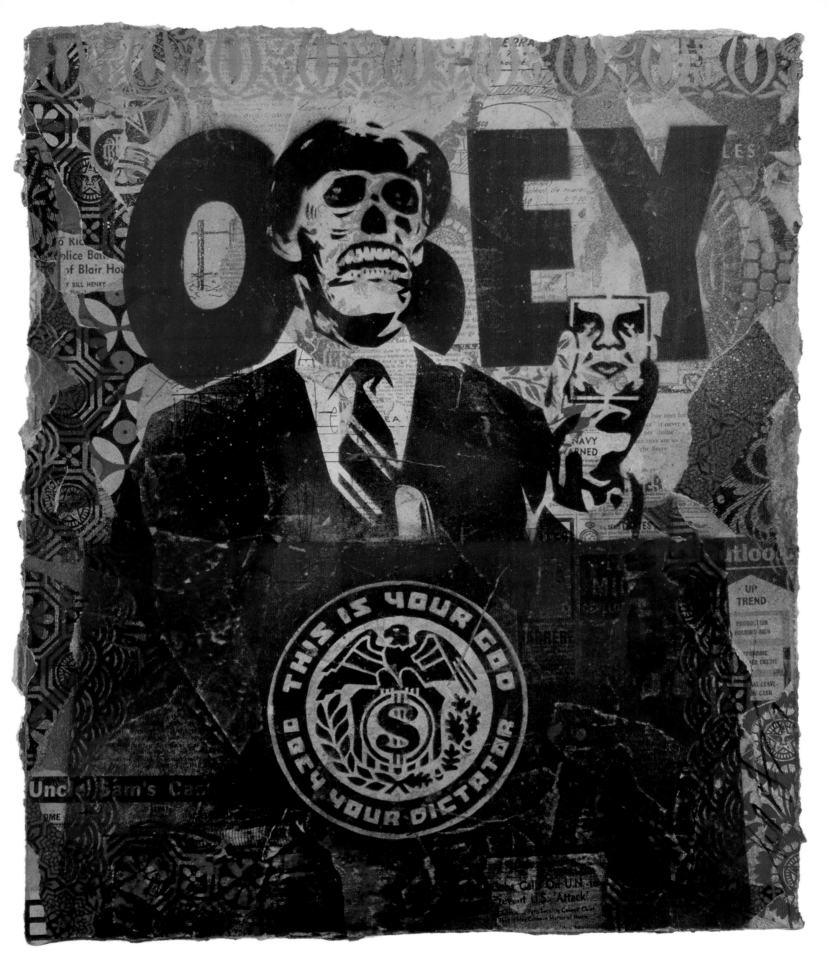

Shepard Fairey
'OBEY LIVES'
Stencil impression and mixed media collage on
paper, 10 x 14 inches
They Live

Above:
Charlie Immer
'Re-Animated'
Oil on panel, 8 x 10 inches
Re-Animator

Right:
Alex Pardee
'Re-Anim-Hater'
Acrylic, latex and ink on canvas, 30 x 40 inches
Re-Animator

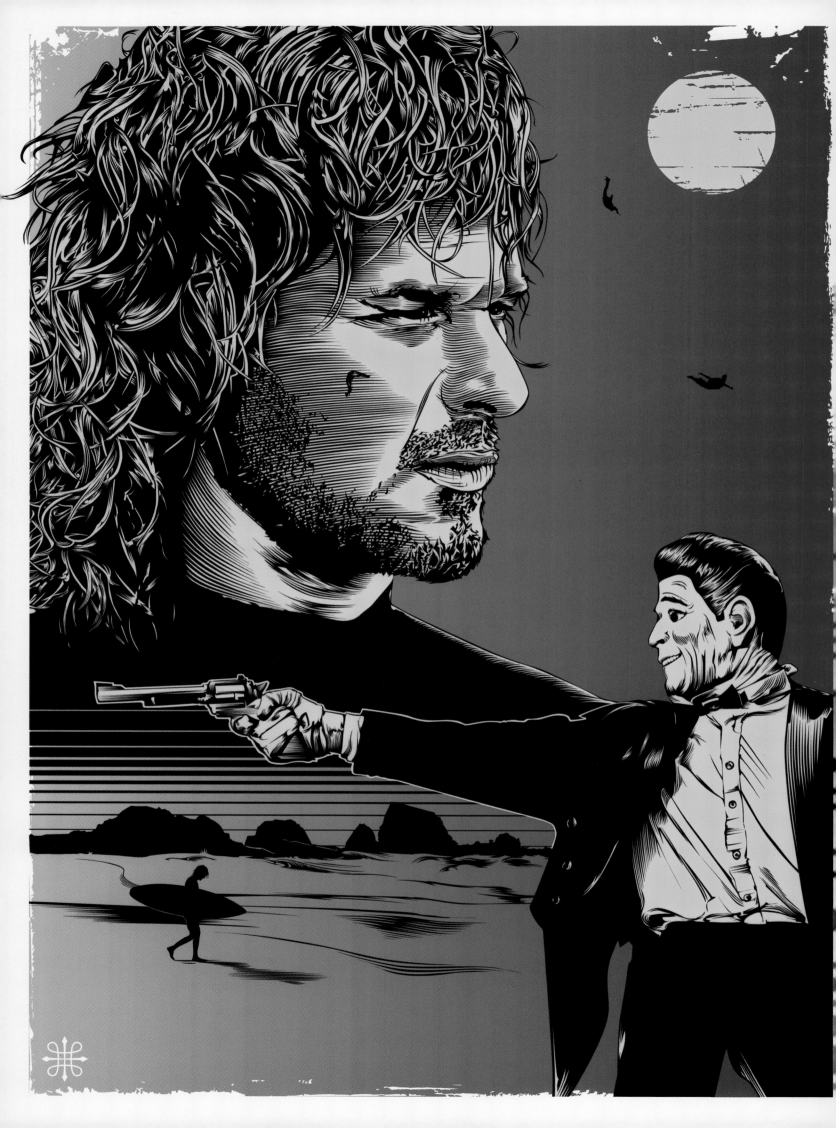

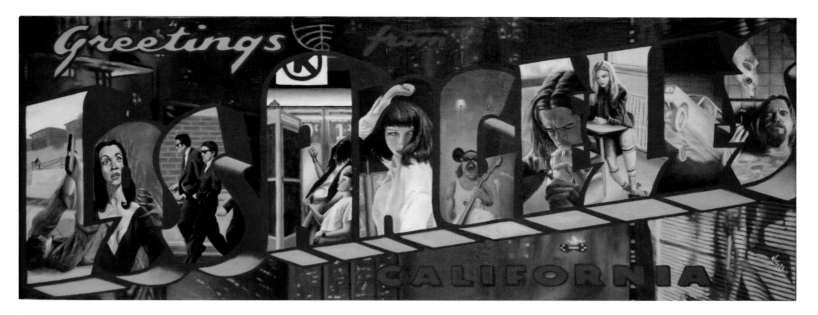

Above:
Nigel Sanders
'L.A. Plays Itself'
Oil on mounted paper, 27 x 10 3/4 inches
Various cult movies

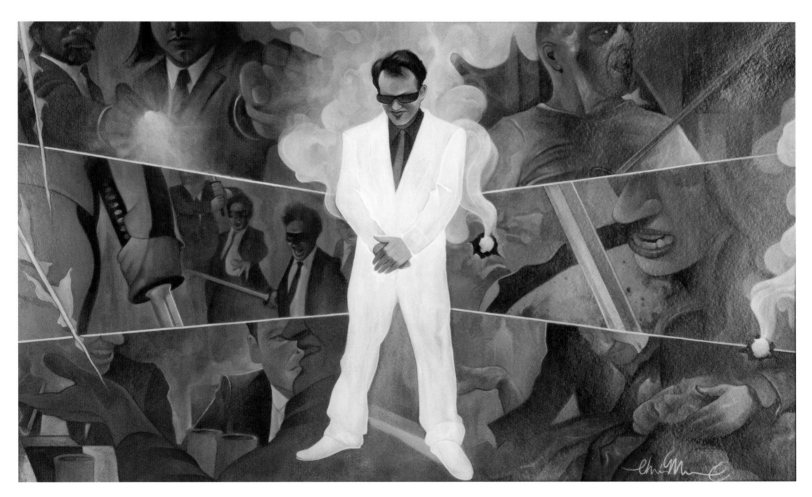

Above:
Chris B. Murray
'Maestro'
Acrylic on paper, 22 x 15 inches
Various Quentin Tarantino movies

Left:
Jeff Boyes
'Bodhi'
4 color screenprint (including a blend),
18 x 24 inches
Point Break

Following spread, left:
Bob Dob
'Let's Get a Taco'
Oil on panel, 6 x 8 inches
Reservoir Dogs

Following spread, right:
Bob Dob
'I Don't Tip'
Oil on panel, 6 x 8 inches
Reservoir Dogs

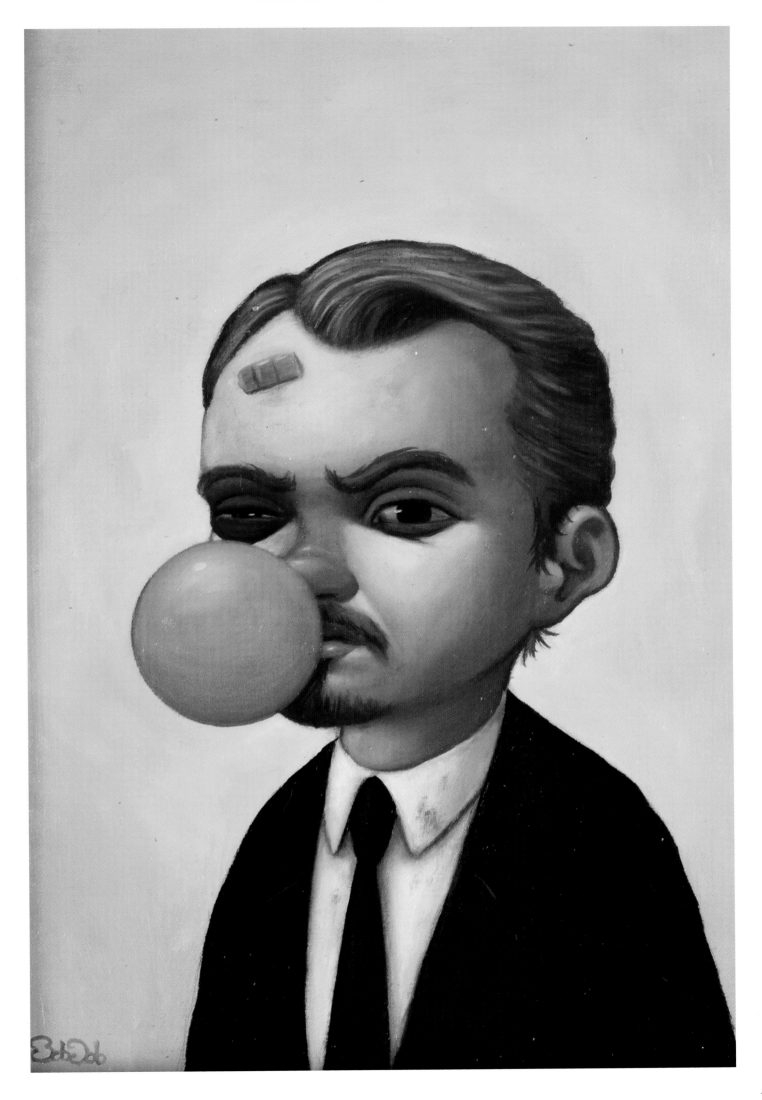

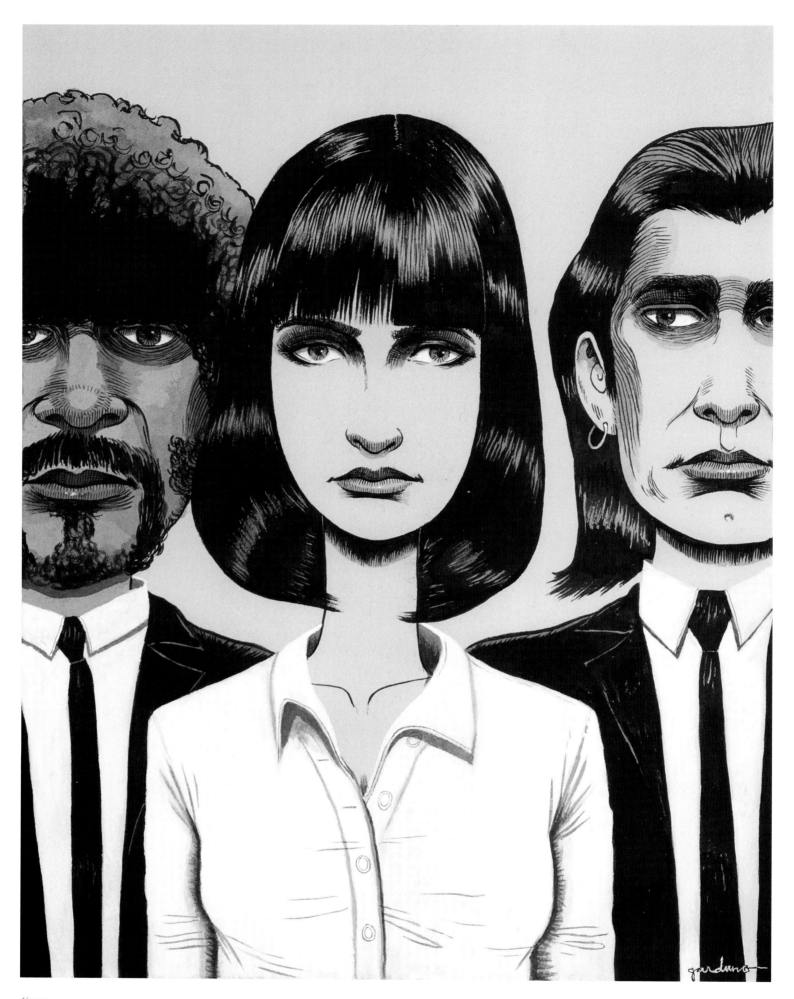

Above:
Ken Garduno
'Crowd'
Acrylic and ink on printmaking paper, mounted on board, 9 x 12 inches
Pulp Fiction

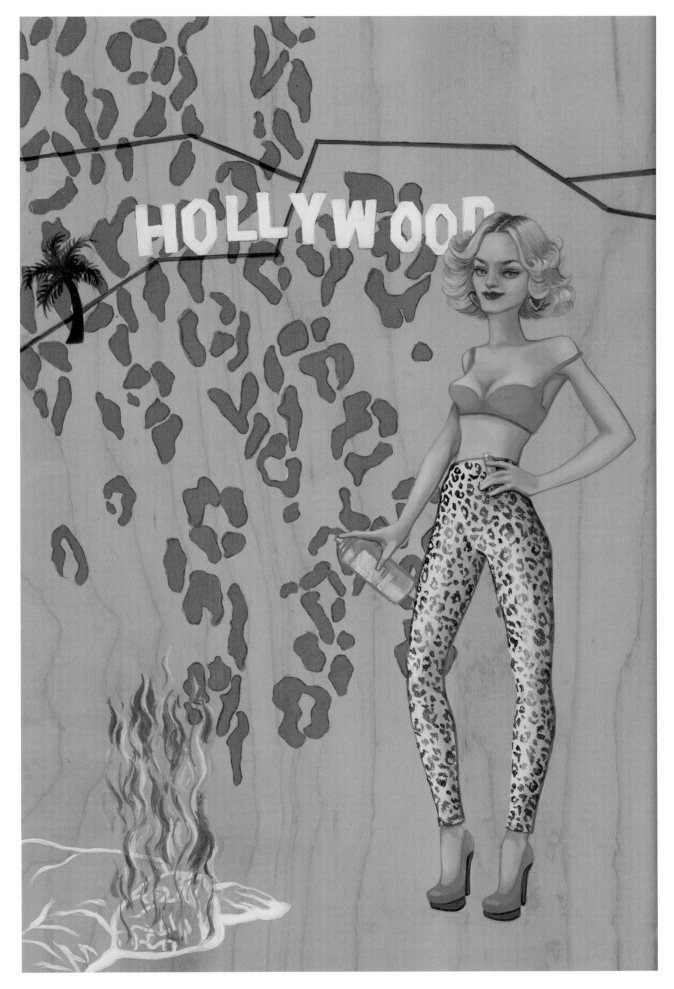

Above:
Erica Gibson
'Bam!'
Oil and acrylic on panel, 11 x 14 inches
True Romance

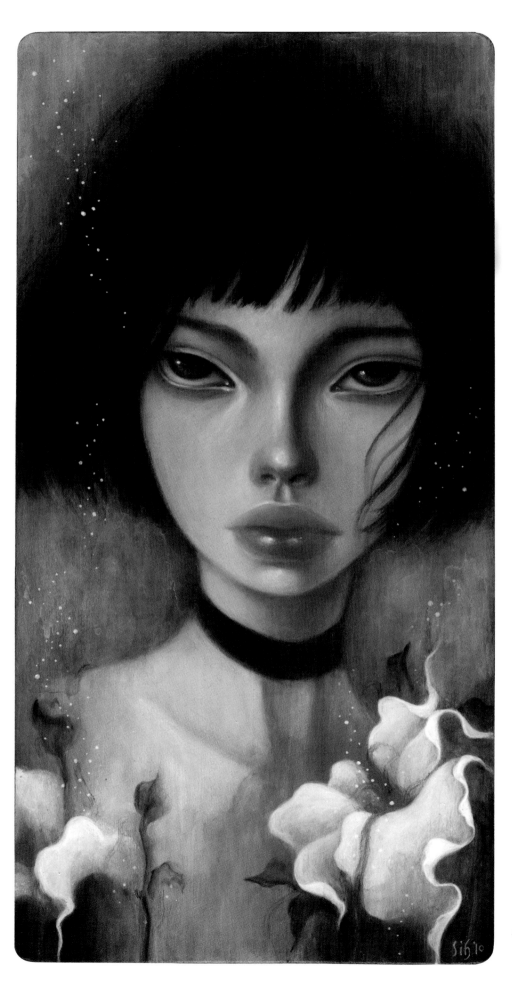

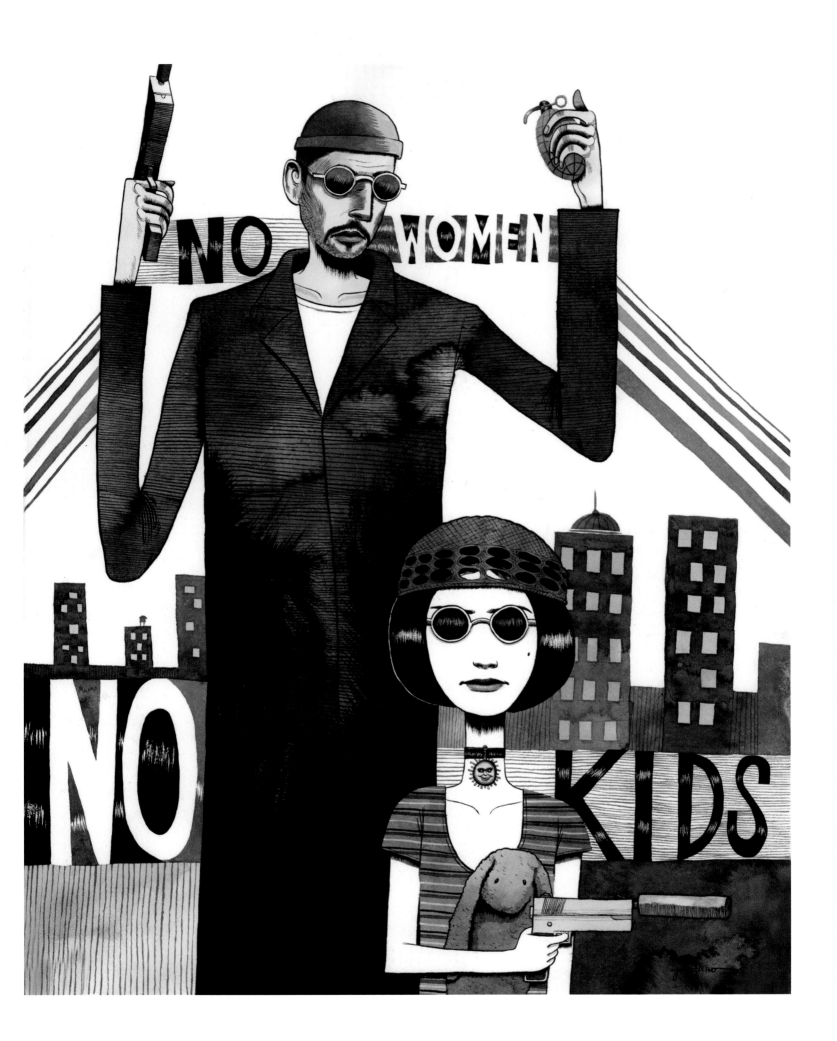

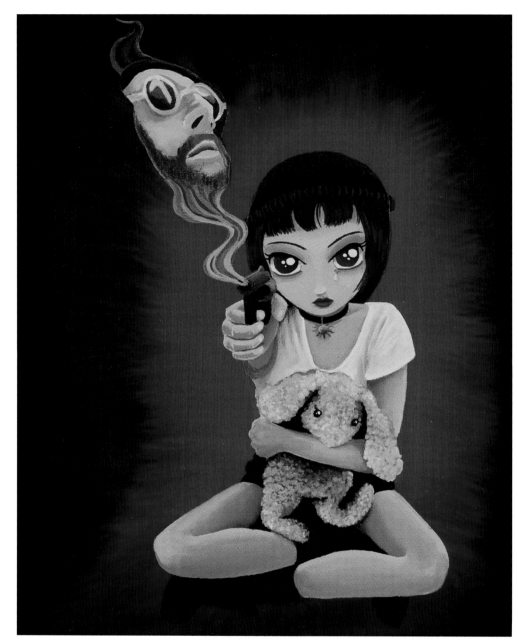

Right:
Misha
'My Protector'
Acrylic on canvas board,
8 x 10 inches
The Professional (aka Leon)

Below:
Jeff Boyes
'The Professional'
4 color screenprint on
archival paper,
26 x 13 inches
The Professional (aka Leon)

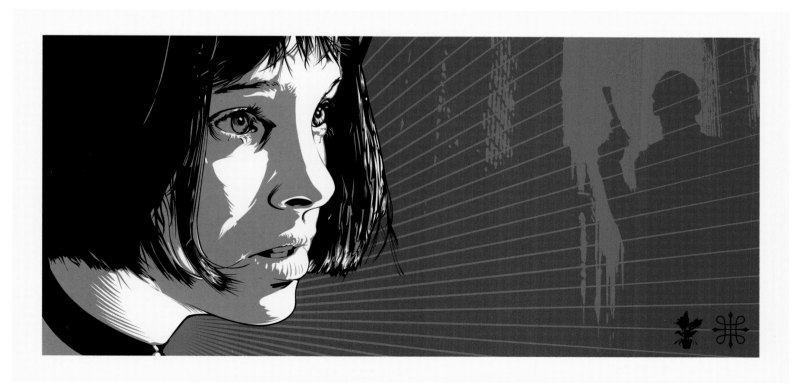

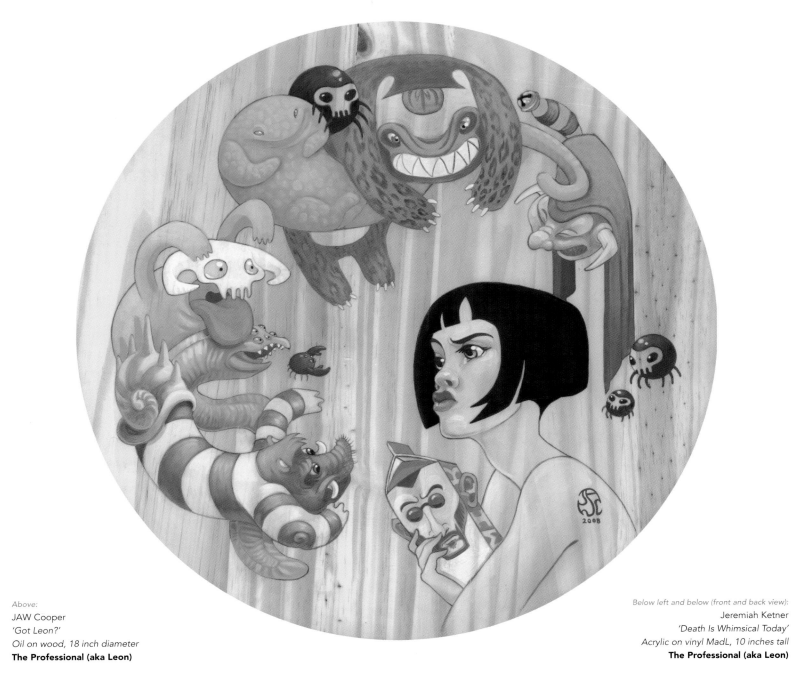

Above:
JAW Cooper
'Got Leon?'
Oil on wood, 18 inch diameter
The Professional (aka Leon)

Below left and below (front and back view):
Jeremiah Ketner
'Death Is Whimsical Today'
Acrylic on vinyl MadL, 10 inches tall
The Professional (aka Leon)

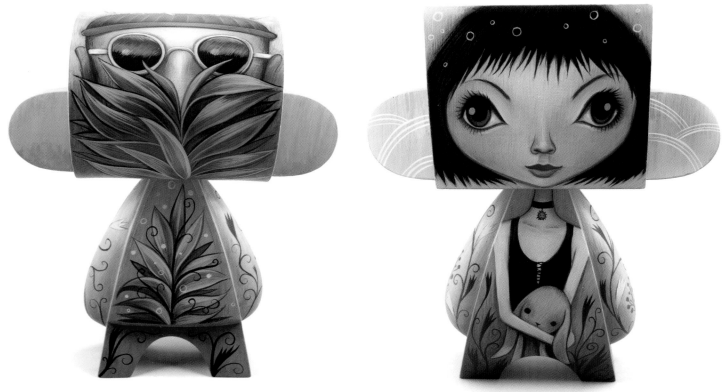

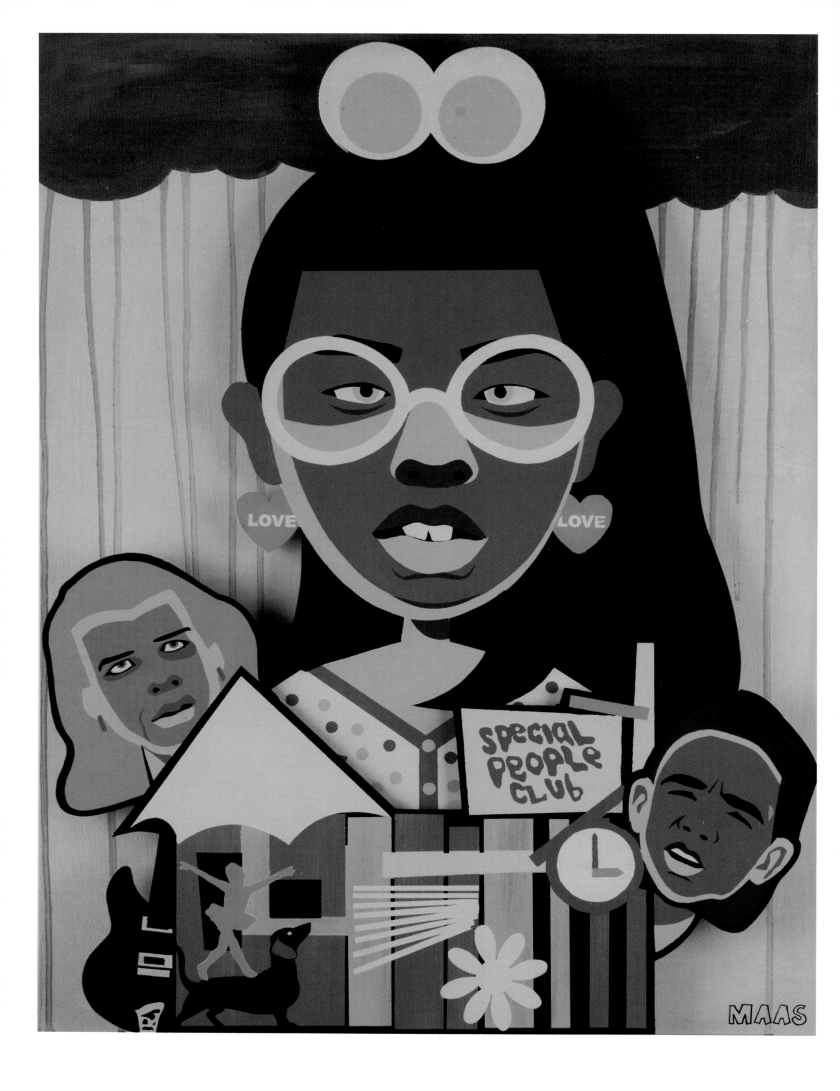

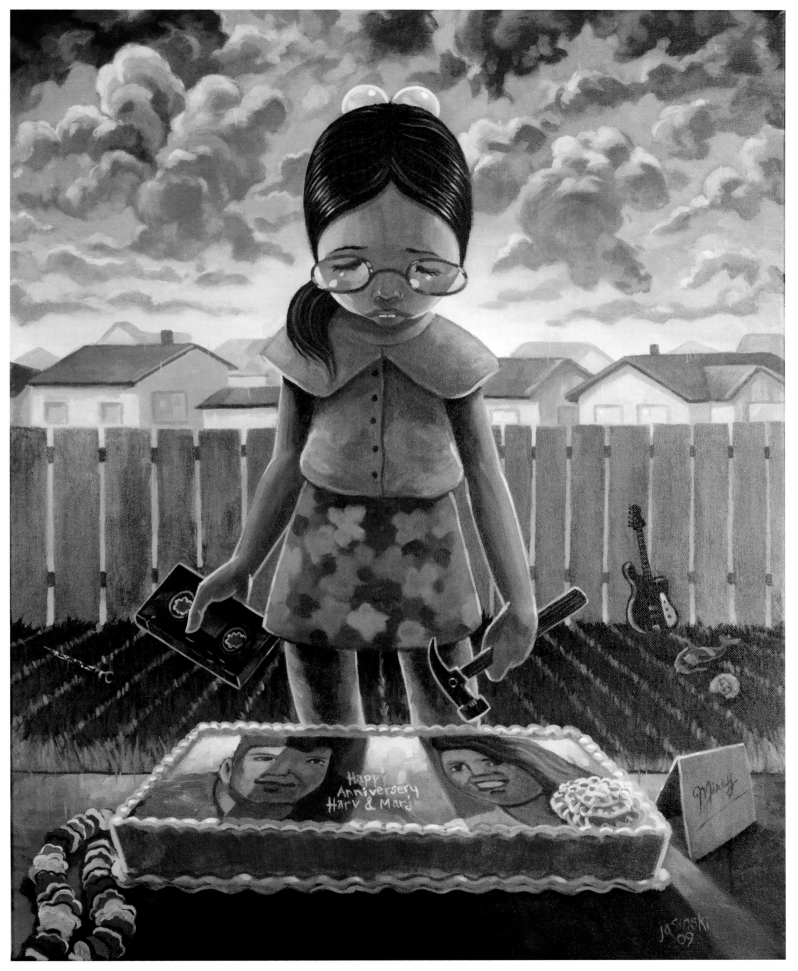

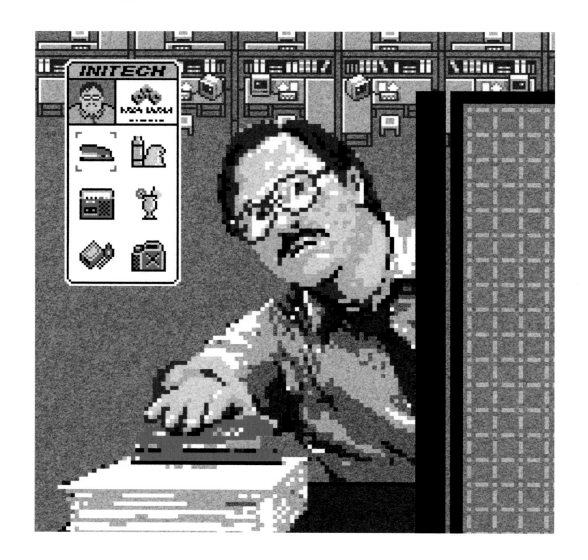

Above and right:
Jude Buffum
'Stapler', 'T.P.S. Reports'
Both giclee print on can-
vas, 12 1/2 x 12 1/2 inches
Office Space

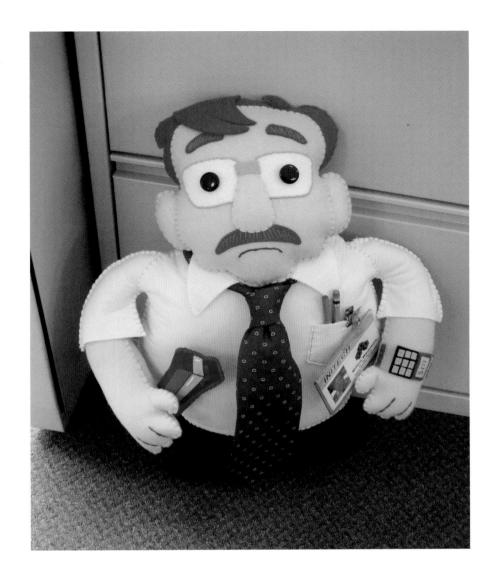

Right:
Jen Rarey
'Milton'
One of a kind hand-sewn plush,
19 inches tall
Office Space

Below:
Kelly Vivanco
'Excuse Me I Believe You Have My
Stapler'
Acrylic on wood panel,
20 x 14 inches
Office Space

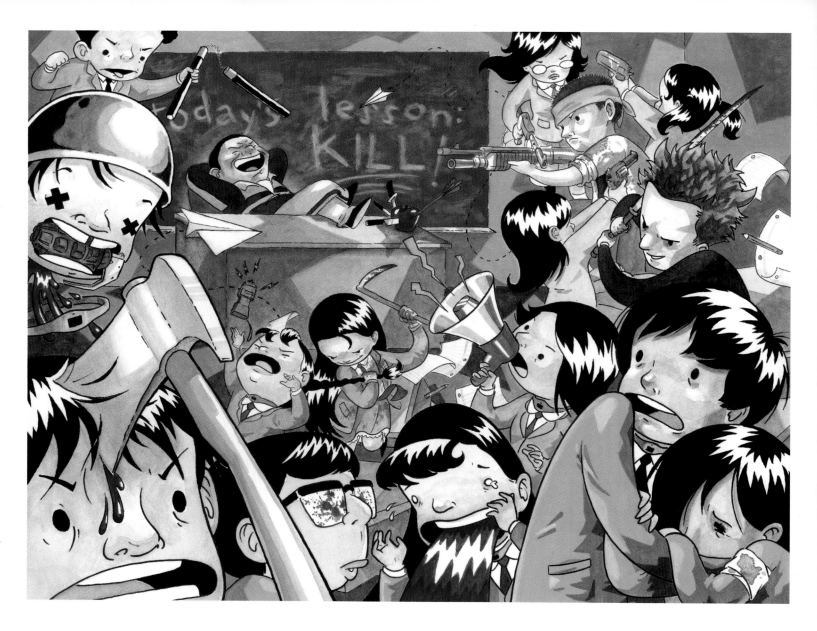

Above:
Julian Callos
'Class Dismissed'
Ink, acrylic and watercolor on
illustration board,
14 x 11 inches
Battle Royale

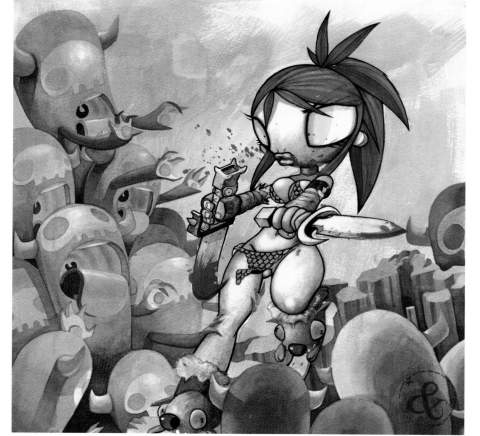

Right:
Andrew Wilson
'Red Sonja Fights the Devil
and Wins'
Ink wash and acrylic on board,
12 x 12 inches
Red Sonja

Right:
Allison Reimold
'Veritas, Aequitas'
Oil on board,
15 1/2 x 21 1/2 inches
The Boondock Saints

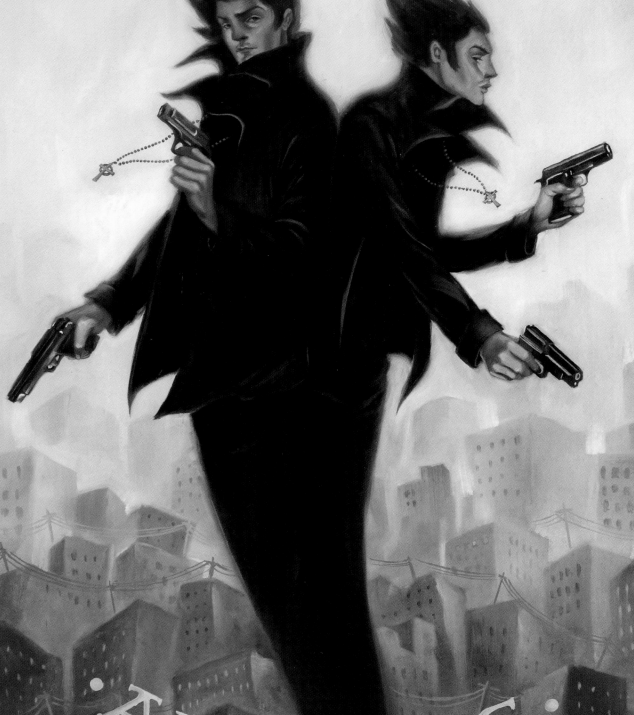

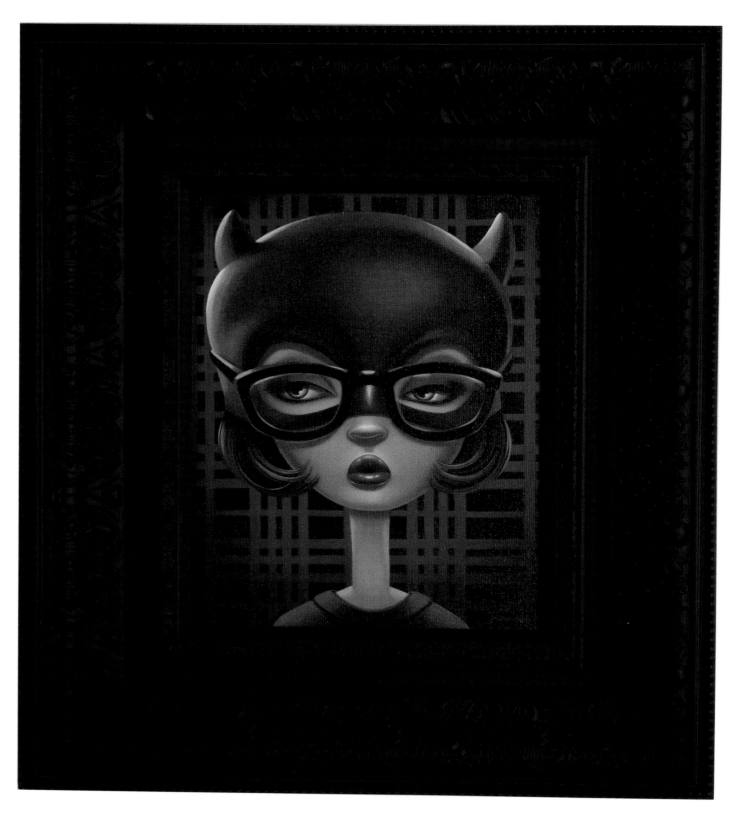

Above:
Shannon Bonatakis
'A Portrait of Enid Coleslaw'
Acrylic on canvas, 8 x 10 inches
Ghost World

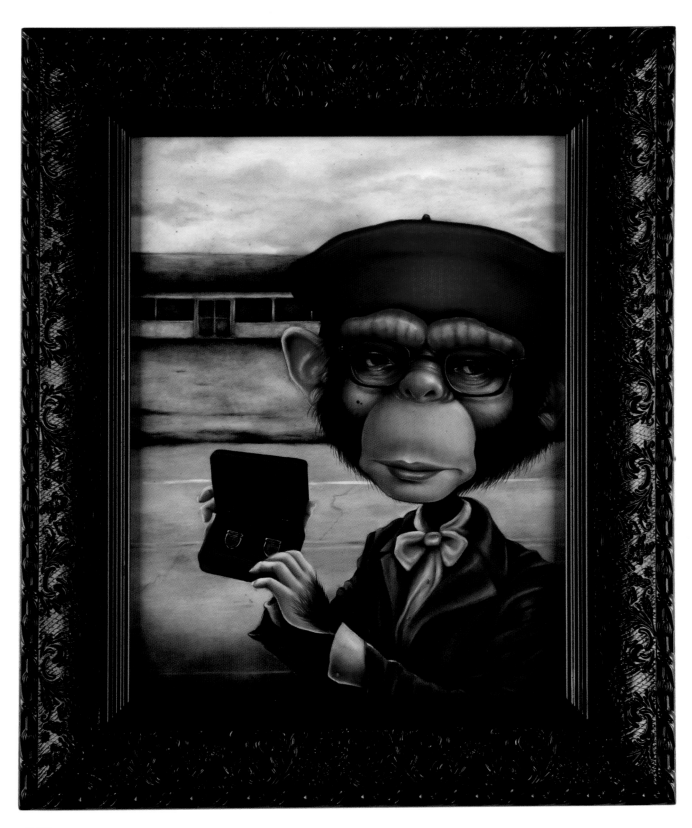

Above:
Ken Keirns
'I'll Take Punctuality'
Oil on board, 12 x 16 inches
Rushmore

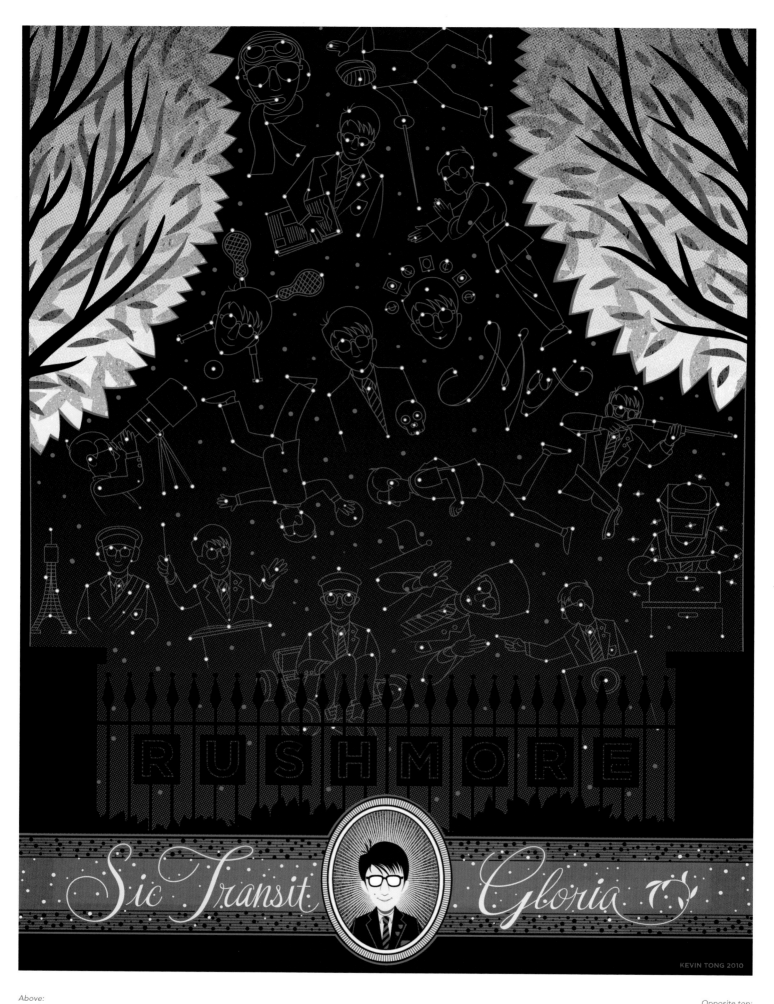

Above:
Kevin Tong
'Sic Transit Gloria'
Screenprint with metallic silver and glow in the
dark inks, 18 x 24 inches
Rushmore

Opposite top:
Casey Weldon
'Zissou Route'
Acrylic on wood, 30 x 20 inches
**The Royal Tenenbaums and The Life Aquatic
with Steve Zissou**

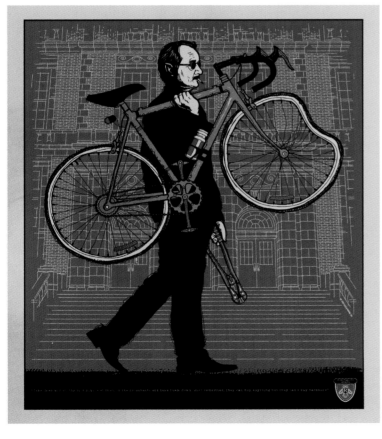

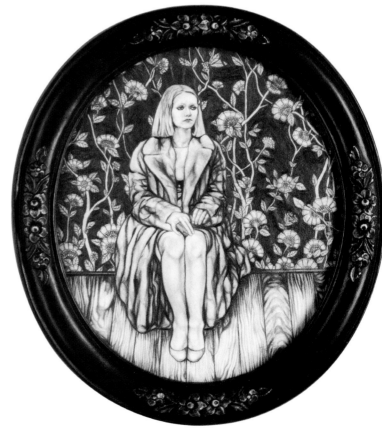

141

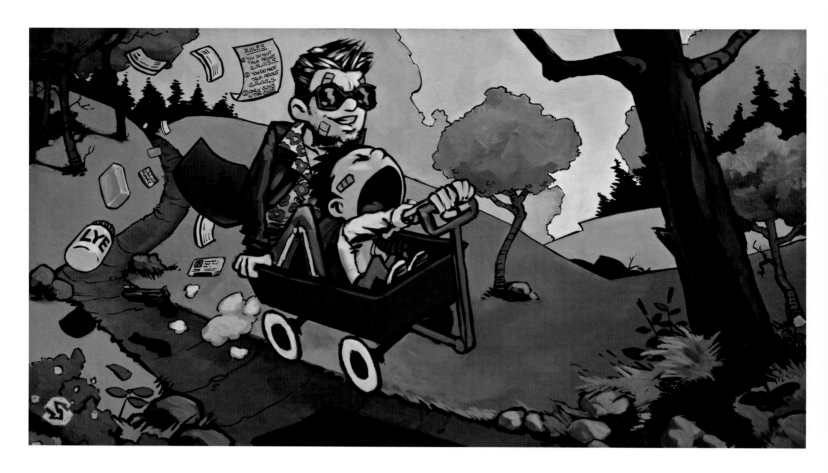

Above:
Sean Clarity
'Jack's Imaginary
Friend'
Acrylic on board,
20 x 11 inches
Fight Club

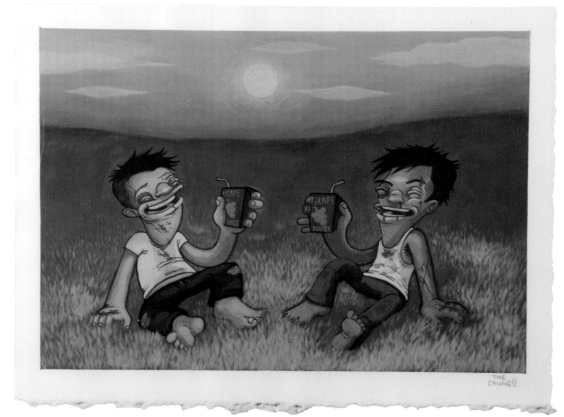

Right:
The Chung
'Fight Club is Where
BFF's Are Made'
Acrylic on paper,
10 x 8 inches
Fight Club

Right:
Stella Im Hultberg
'(The Big Tourist) Marla'
Oil and ink on tea-
stained paper,
9 x 12 inches
Fight Club

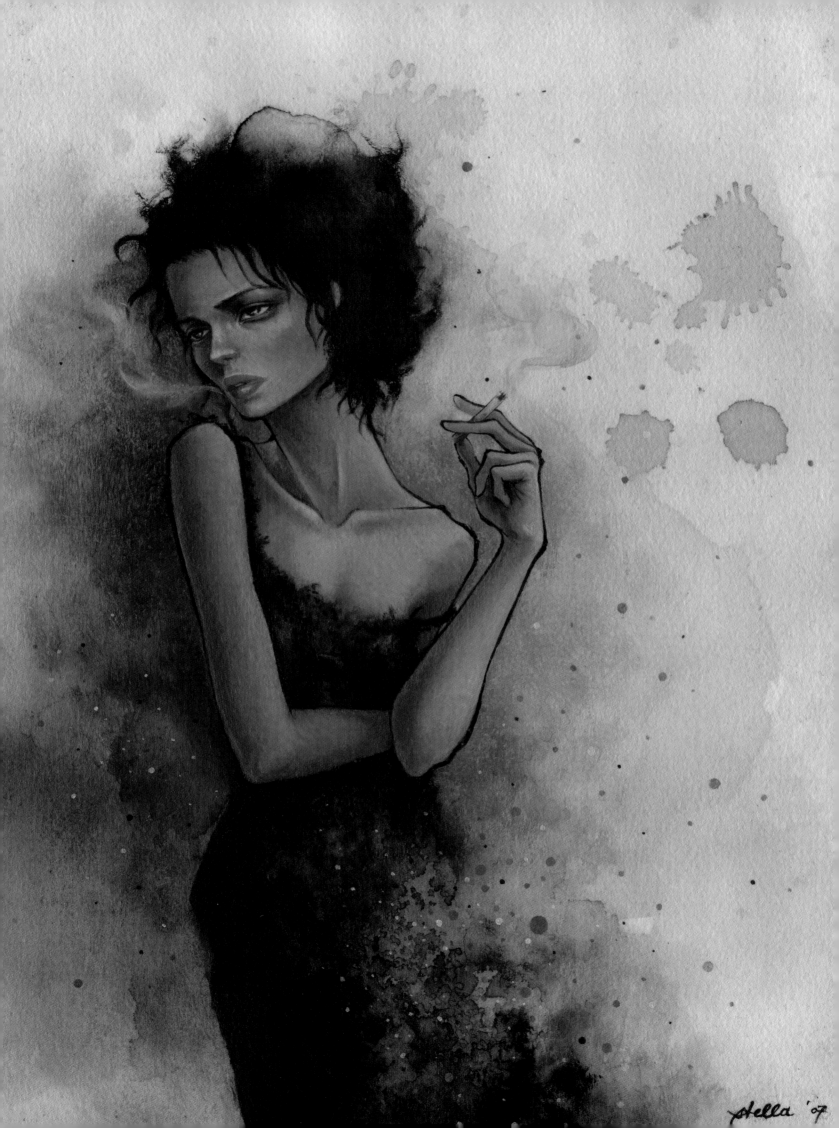

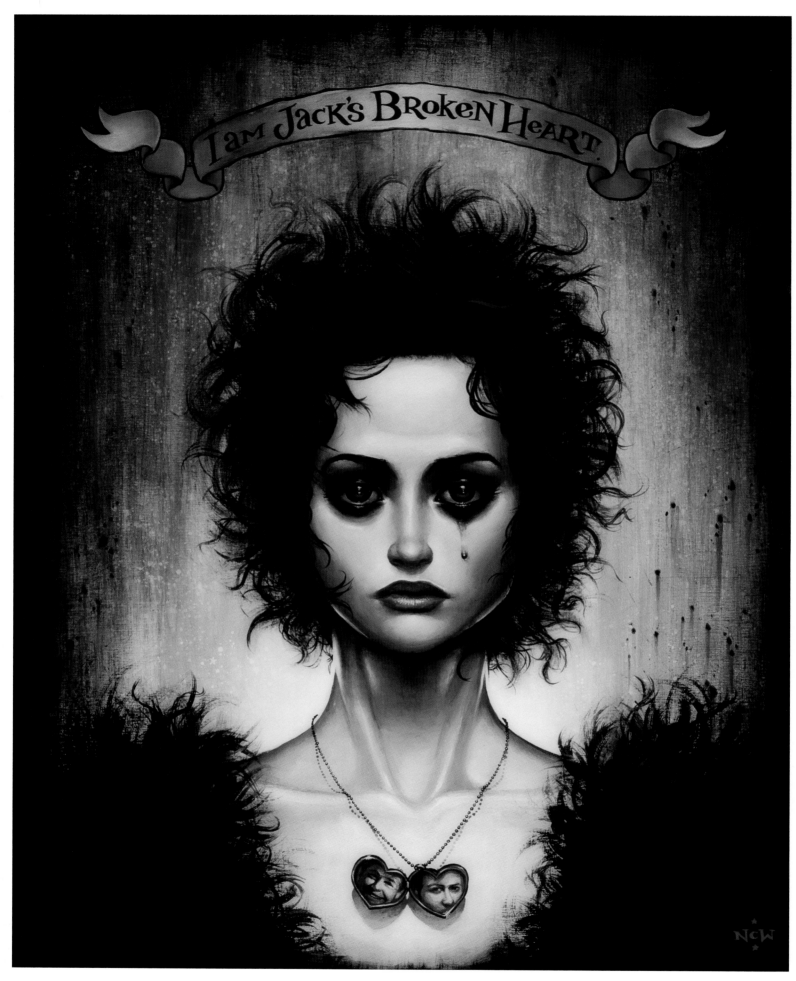

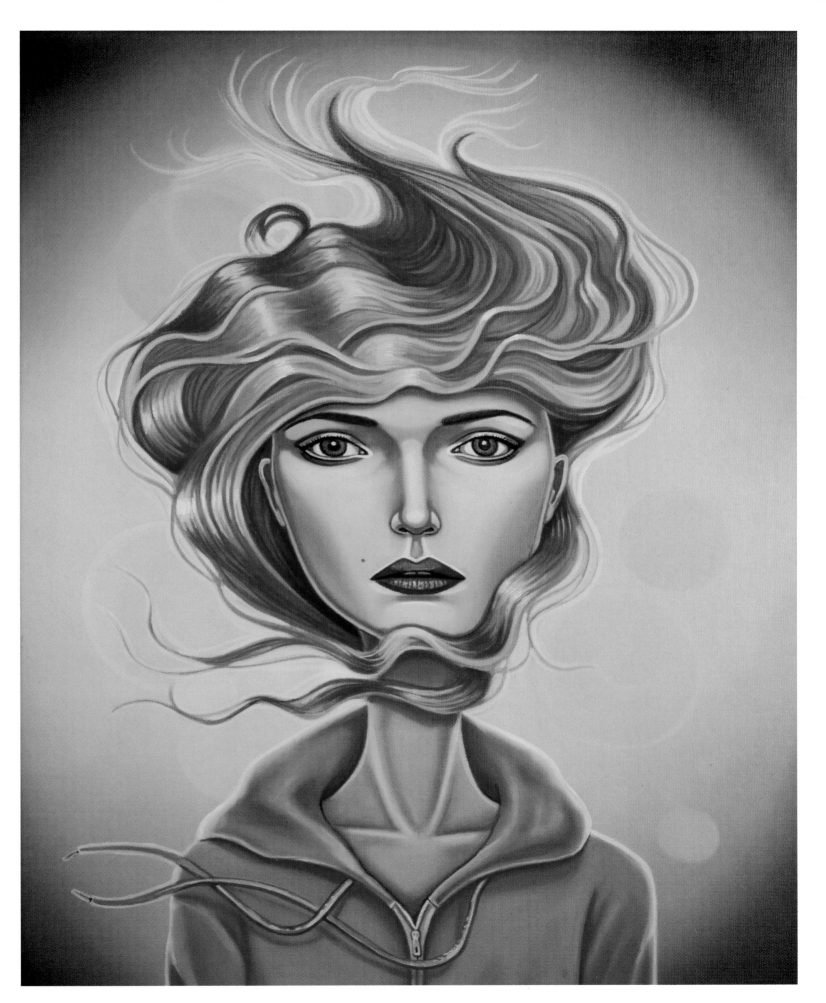

Above:

Audrey Pongracz

'The Eraser Guys Are Coming'

Oil on canvas, 18 x 24 inches

Eternal Sunshine of the Spotless Mind

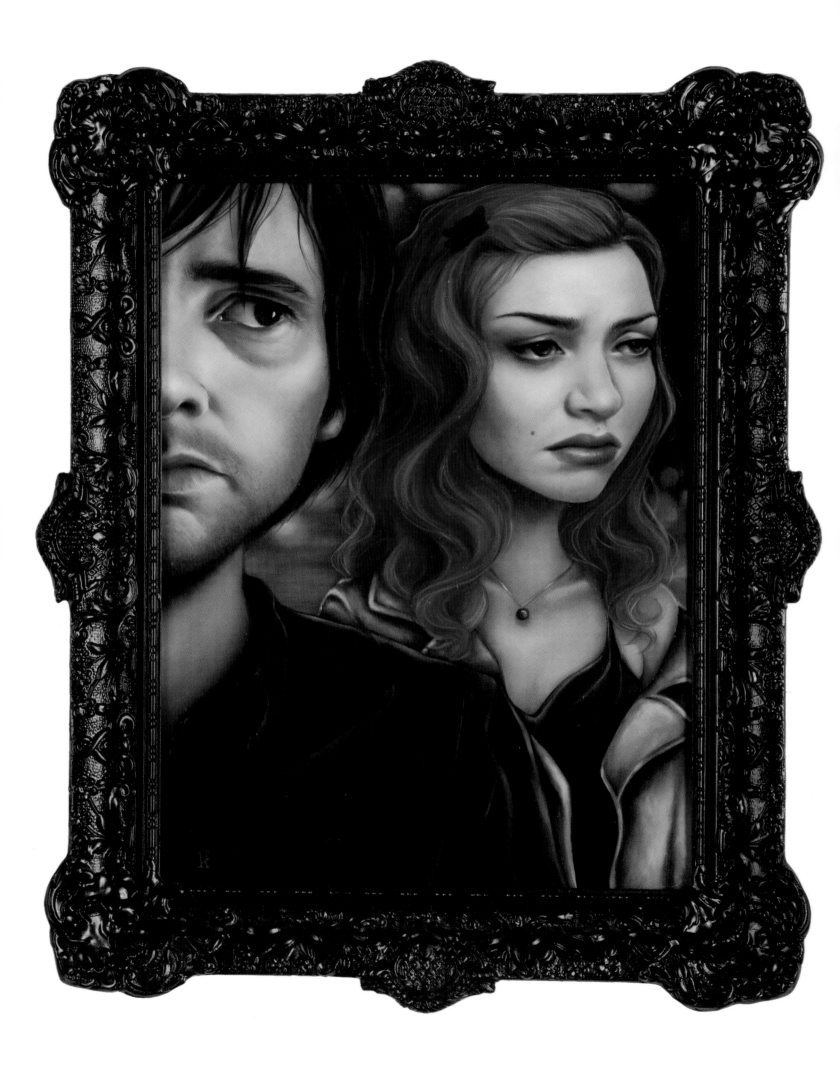

Left:
Ken Keirns
'This is the Last Time I Saw You'
Oil on board, 11 x 15 inches
Eternal Sunshine of the Spotless Mind

Above:
Joey Spiotto
'River Tam and the Fireflies'
Digital print, 19 x 13 inches
Serenity

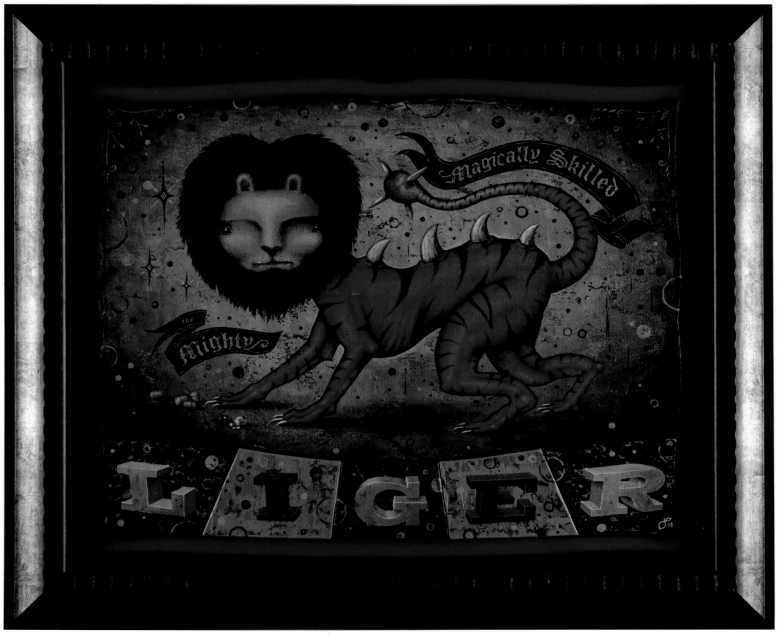

Above:
Jason Limon
'The Mighty Liger'
Acrylic on custom canvas panels, 25 x 22 inches
Napoleon Dynamite

Below and opposite below (left to right):
Dan Goodsell
'Soul Mate', 'Boondoogle Keychains', 'Uncle Rico',
'Feeding Tina', 'Vote for Pedro'
All watercolor on paper, 5 x 7 inches
Napoleon Dynamite

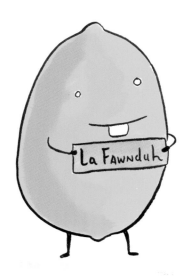

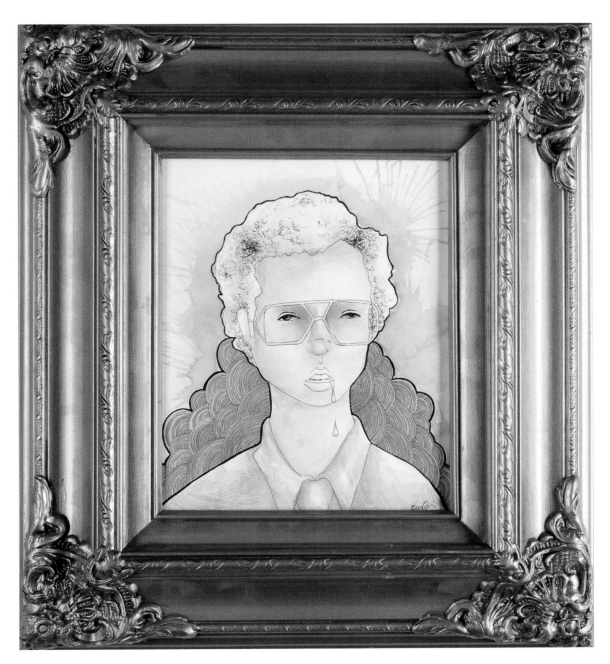

Above:
Eunice Choi
'Dynamite Portrait'
Watercolor, pen and ink, 15 x 17 inches
Napoleon Dynamite

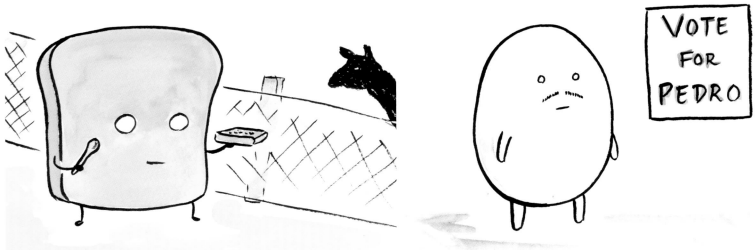

Above:
Brandon Schaefer
'Shaun of the Dead'
Digital poster, 13 x 18 inches
Shaun of the Dead

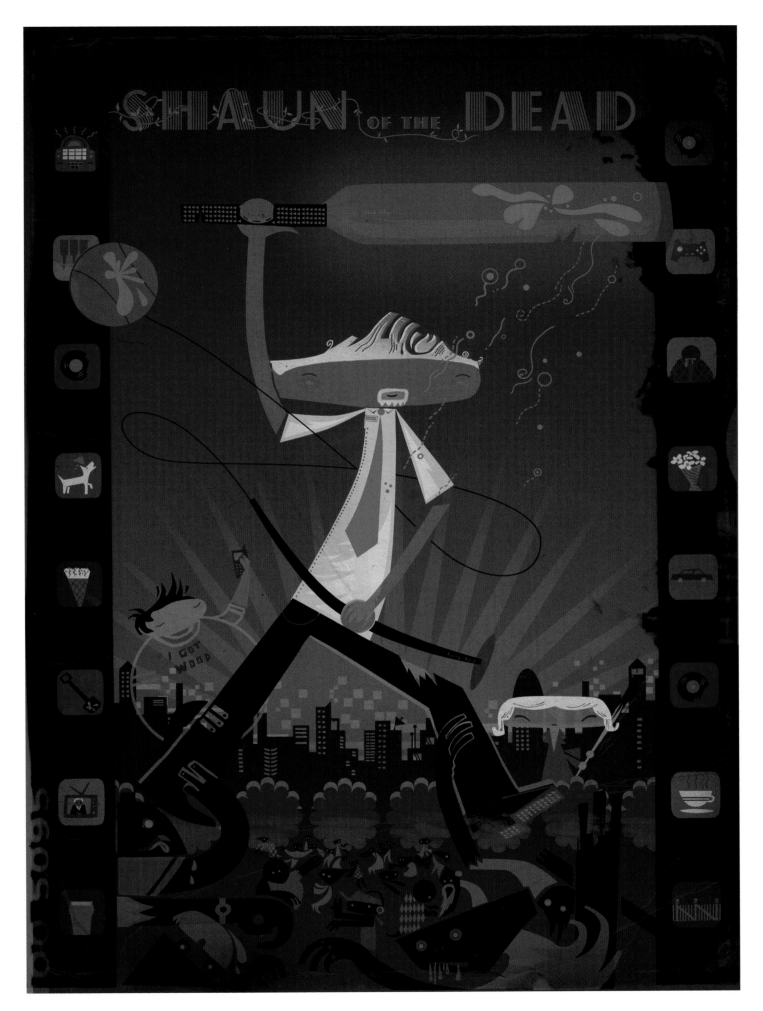

Above:
Graham Carter
'Red on You'
Giclee print on German Etch Archival Paper with foil blocking detail, 19 x 27 inches
Shaun of the Dead

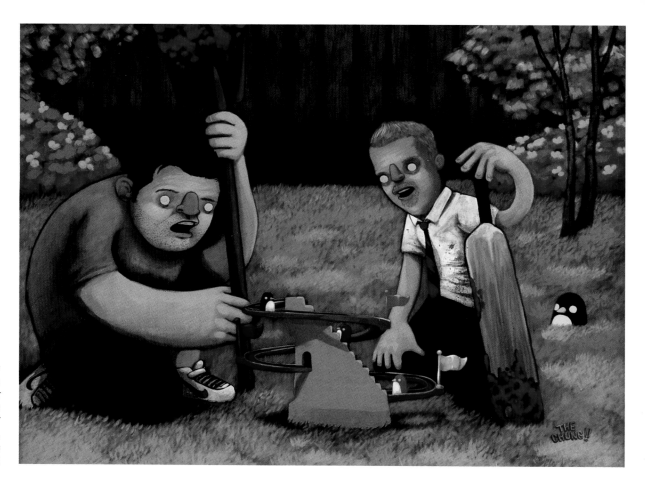

Right:
The Chung
*'Shaun and Ed Sharpen Their
Zombie Fighting Skills with a
Playful Penguin Race'*
*Acrylic on canvas,
24 x 18 inches*
Shaun of the Dead

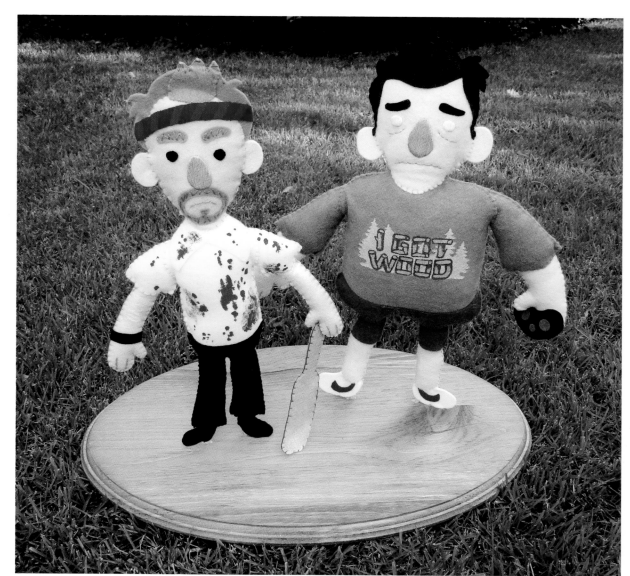

Right:
Jen Rarey
'You've Got Red on You'
*Hand-sewn & embroidered
felt, paper, 20 x 17 1/2 inches*
Shaun of the Dead

Opposite:
Chris B. Murray
'Bird Bath'
*Acrylic on watercolor paper,
10 x 15 inches*
Shaun of the Dead

Following two spreads:
Scott Campbell
'Great Showdowns' series
*All watercolor on paper,
3 1/2 x 3 1/2 inches*
Various cult movies

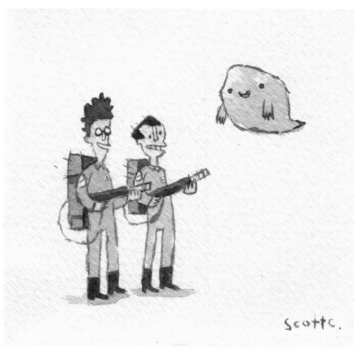
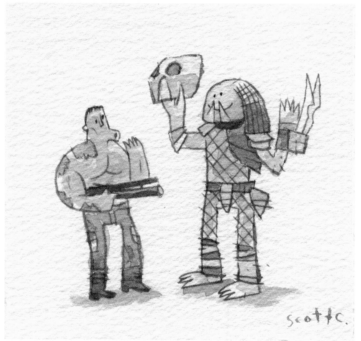
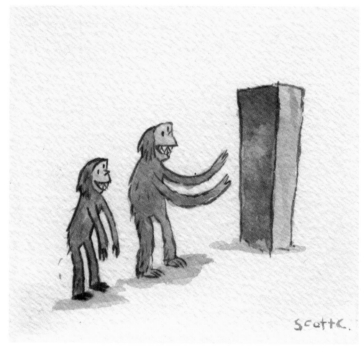
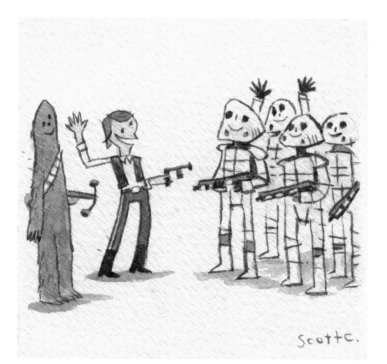

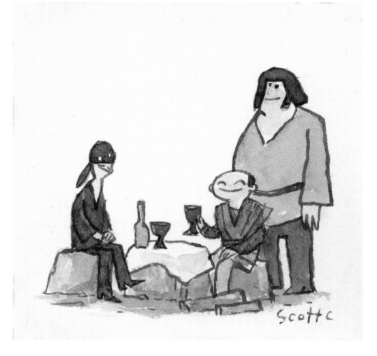

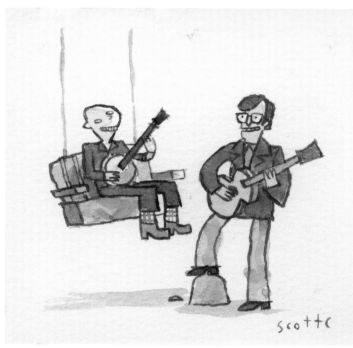

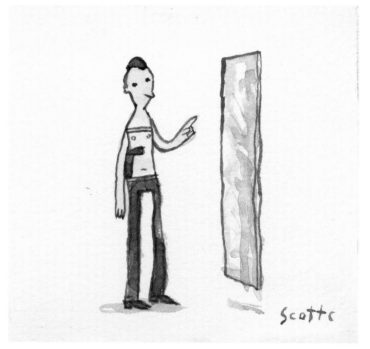

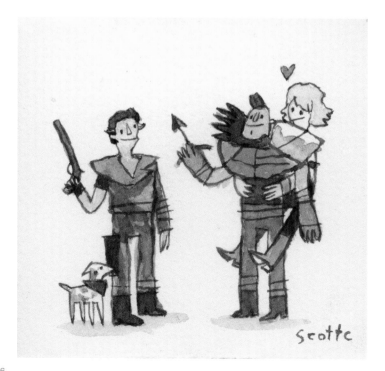

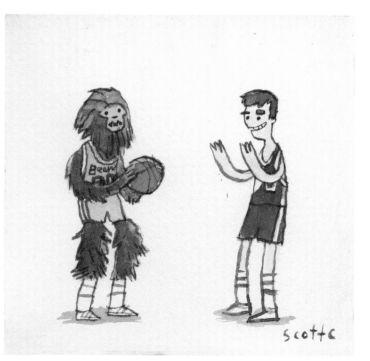

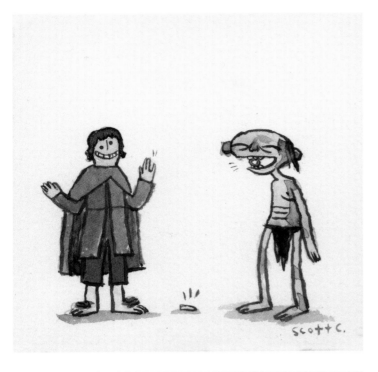

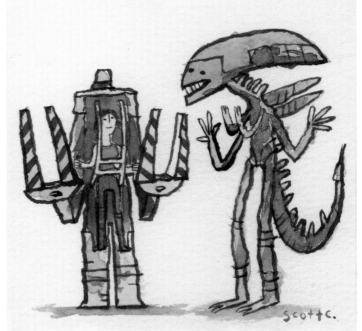

Above:
Ruel Pascual
'28 Days, 6 Hours, 42 Minutes,
12 Seconds... We're Almost Home'
Acrylic on wood, 18 x 24 inches
Donnie Darko

Right:
Wade Schin
'Donnie Darko'
Acrylic and spraypaint
on acrylic plastic,
one of a kind, 4 3/4 inches tall
Donnie Darko

Far right:
Blinky
'Frank's Favorite Figures'
Mixed media on wood, 20 x 18 inches
Donnie Darko and Clerks

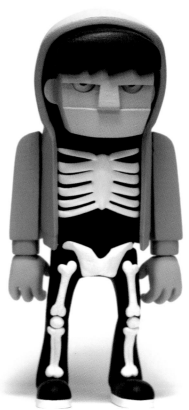

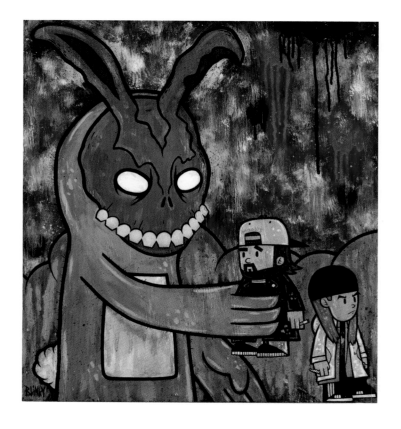

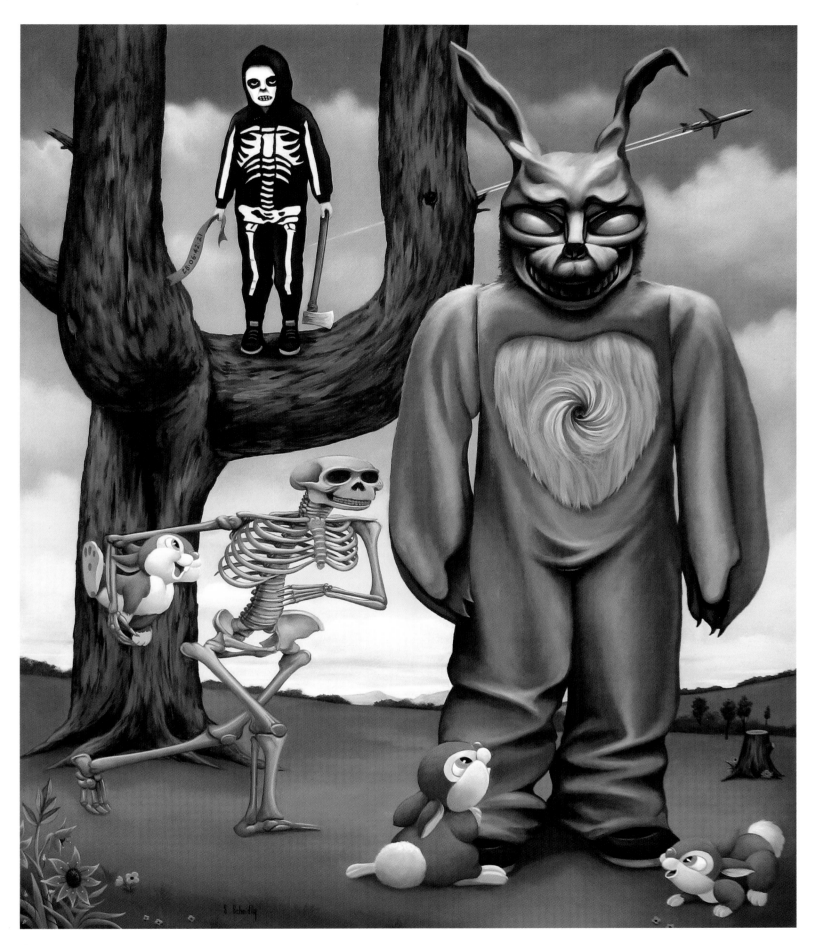

Scott Scheidly
'The Prophecy of Frank'
Acrylic on wood, 20 x 24 inches
Donnie Darko

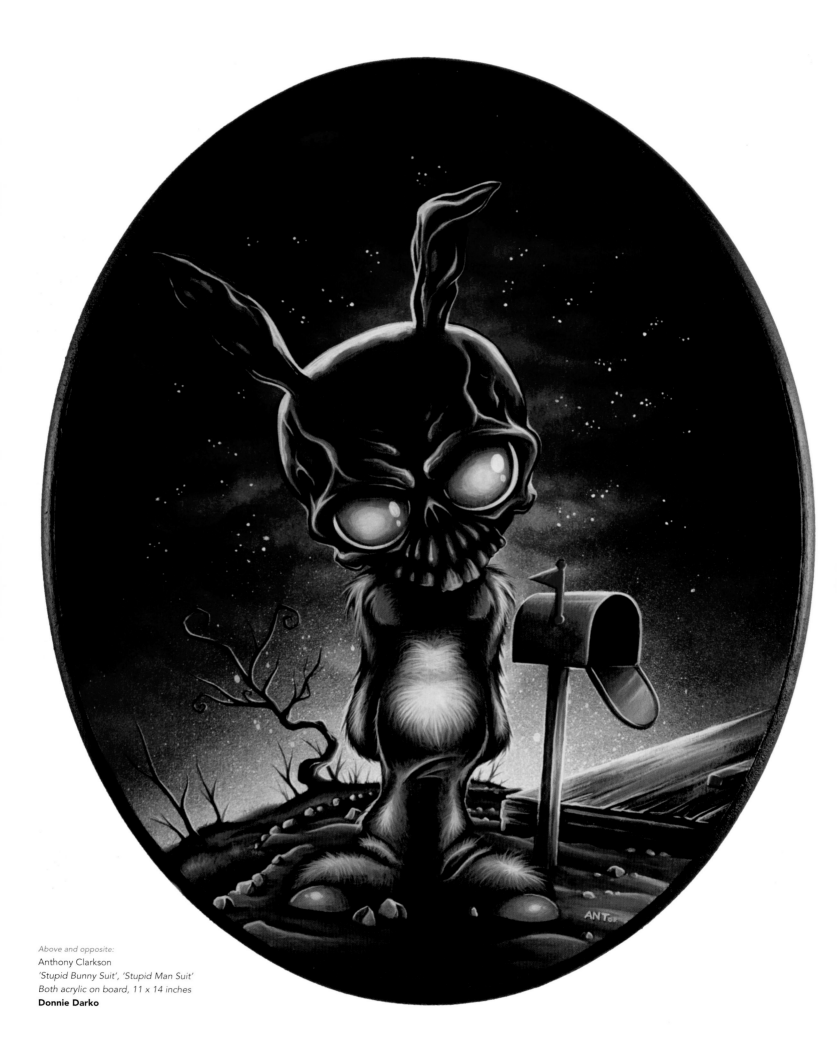

Above and opposite:
Anthony Clarkson
'Stupid Bunny Suit', 'Stupid Man Suit'
Both acrylic on board, 11 x 14 inches
Donnie Darko

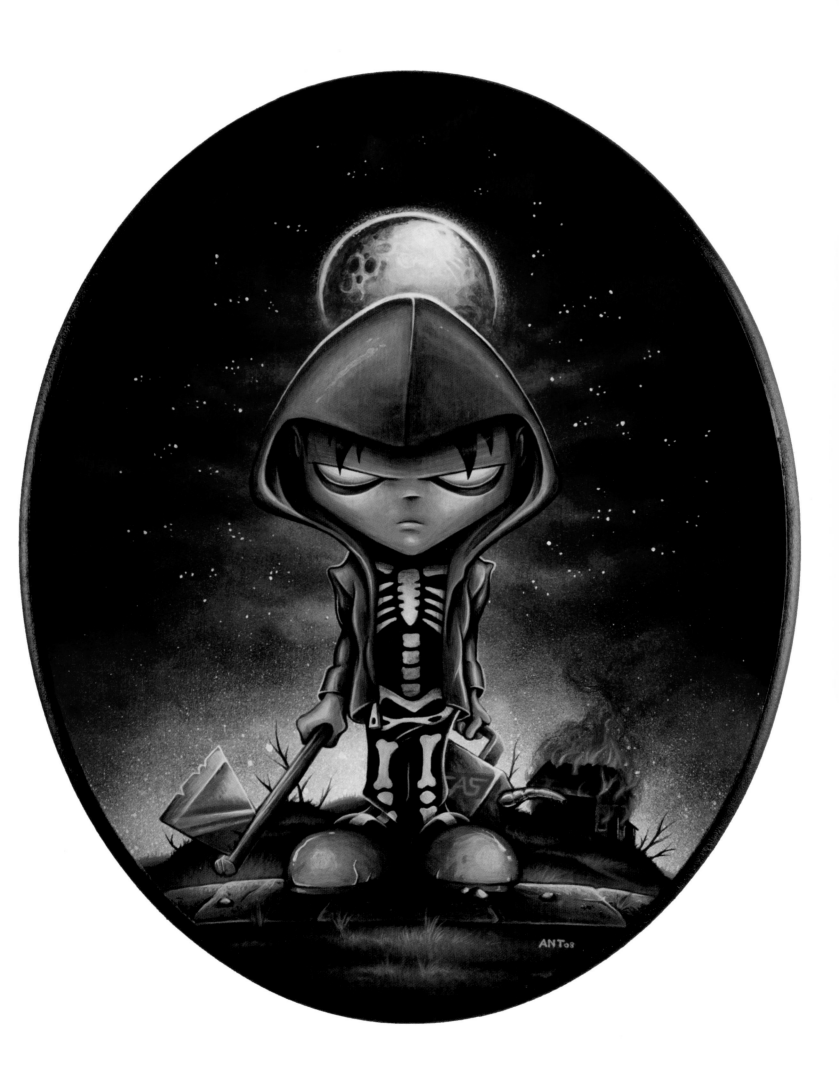

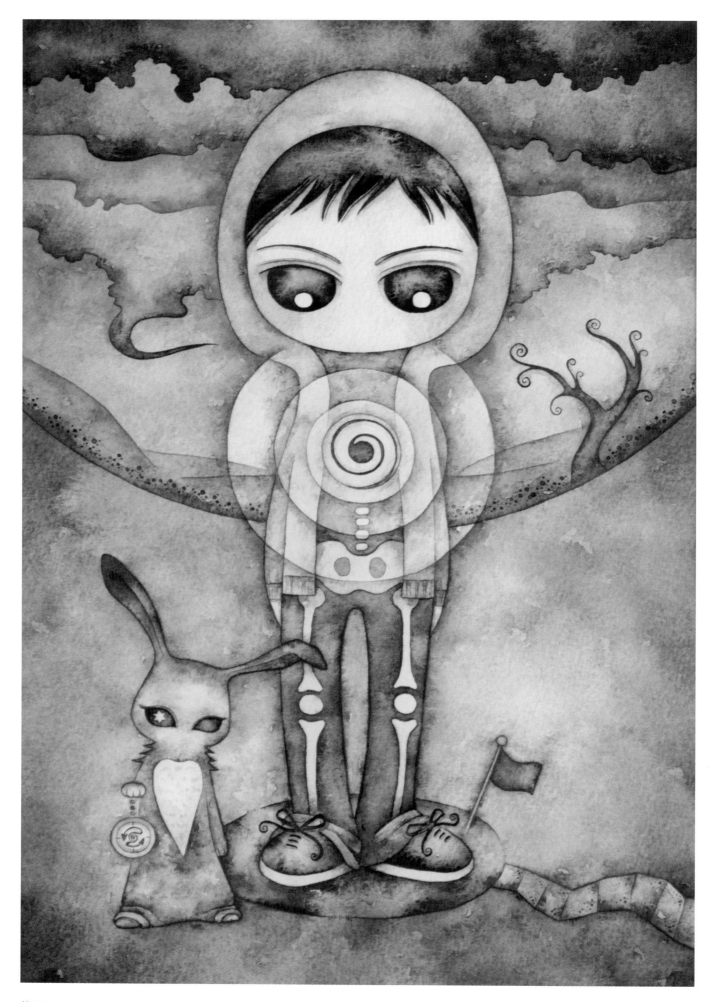

Above:
Juri Ueda
'Portal'
Watercolor on Arches watercolor paper, 7 1/2 x 11 inches
Donnie Darko

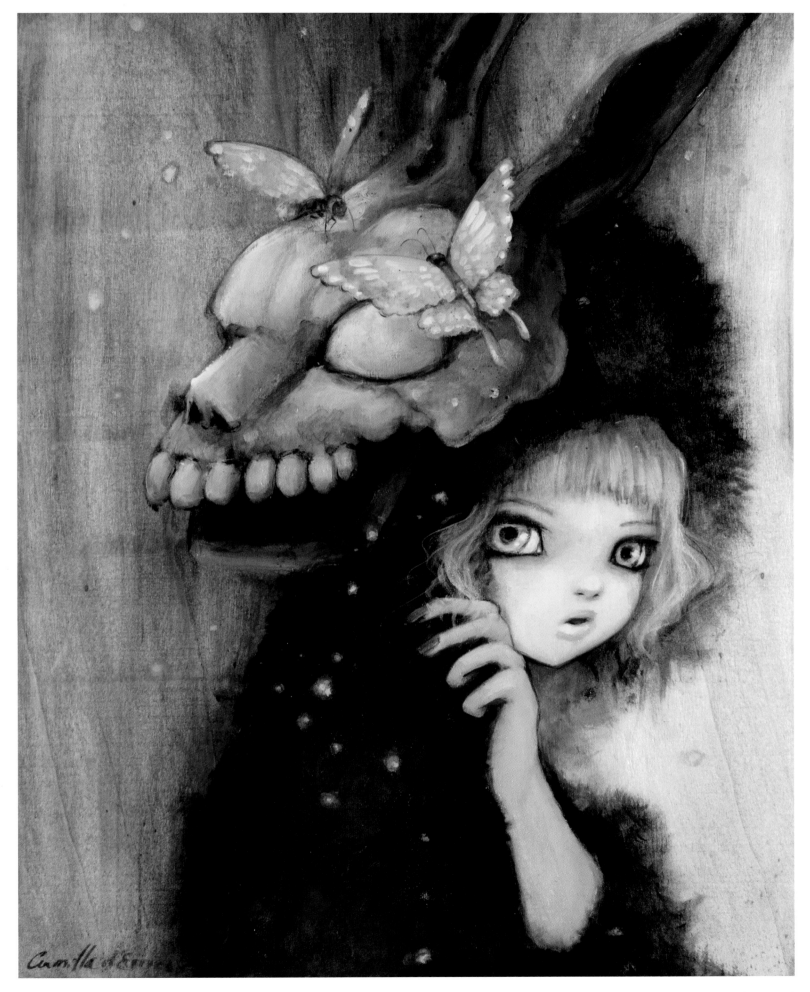

Above:
Camilla d'Errico
'The Little Dress Up Doll'
Oil on wood, 16 x 20 inches
Donnie Darko

Following spread:
Erica Gibson
'Woodchipper'
Acrylic on panel, 16 x 12 inches
Fargo

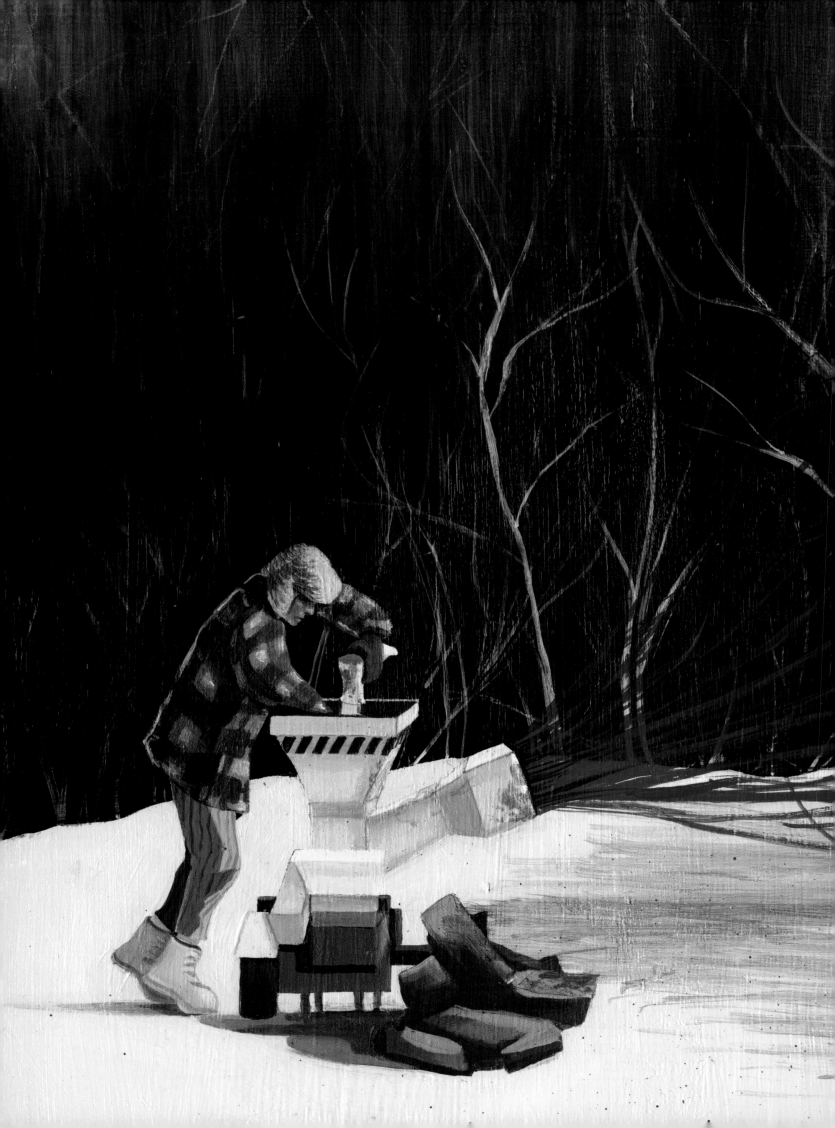

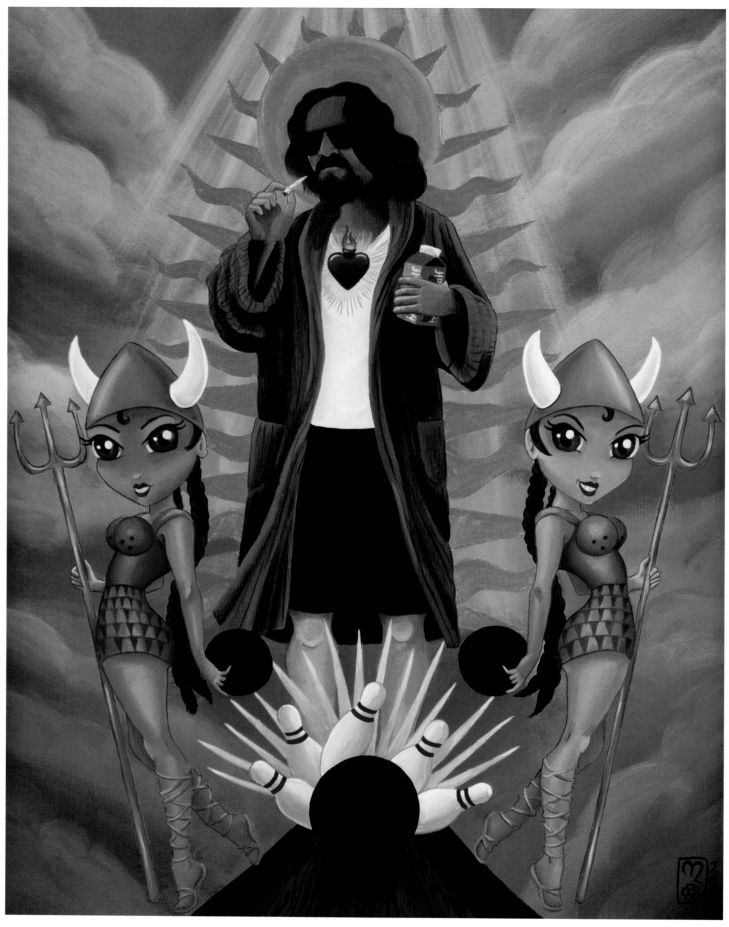

Above:
Misha
'Sometimes There's a Man'
Acrylic on canvas board, 16 x 20 inches
The Big Lebowski

Right:
David Eichenberger
'Stay Out of Malibu'
Acrylic on board, 18 x 24 inches
The Big Lebowski

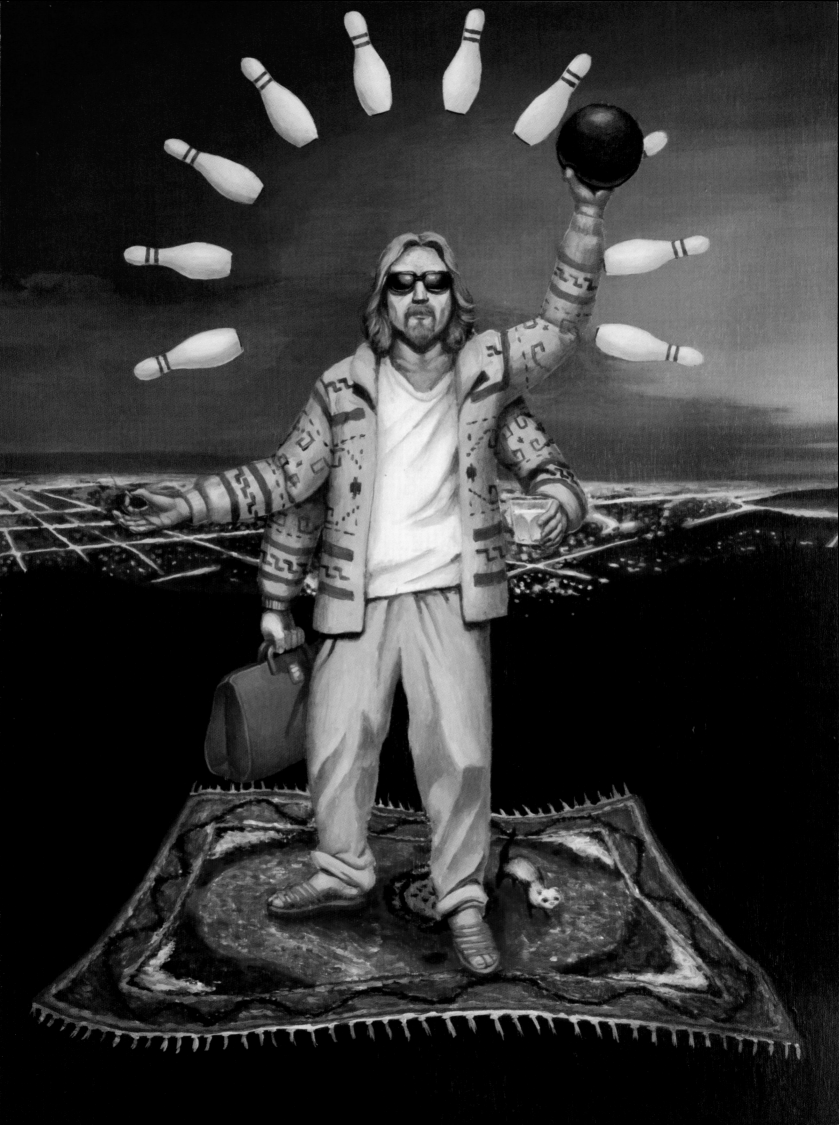

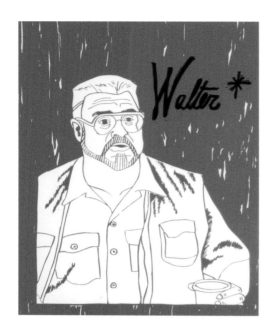

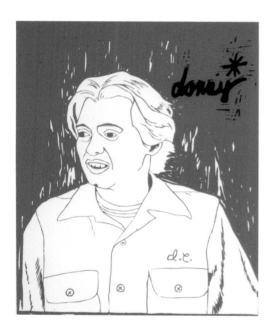

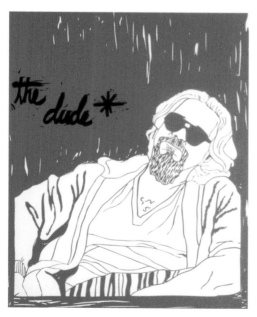

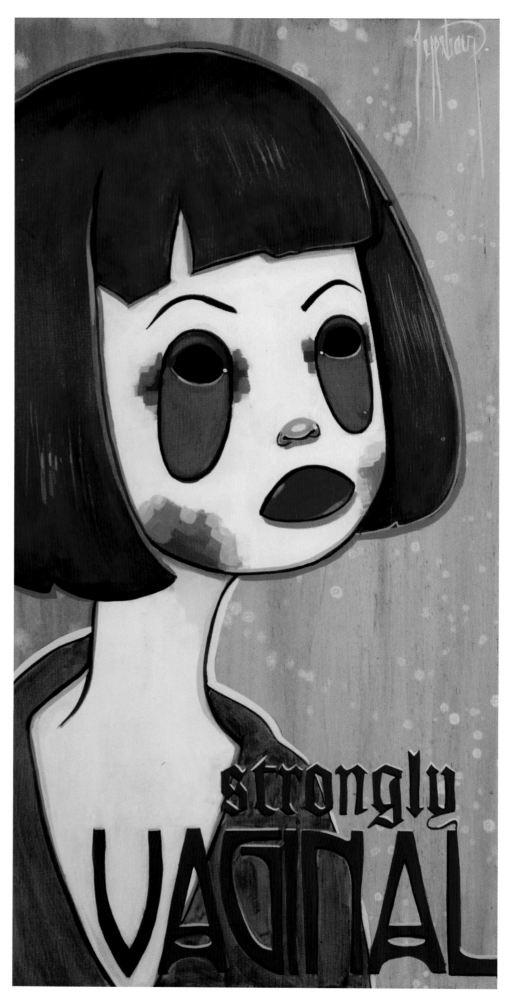

Top to bottom:
Leanne Biank
'Walter', 'Donny', 'The Dude'
All linoleum prints, one of a kind, 8 1/2 x 11 inches
The Big Lebowski

Above:
Lesley Reppeteaux
'Maude's Monologue'
Acrylic on board, 8 x 16 inches
The Big Lebowski

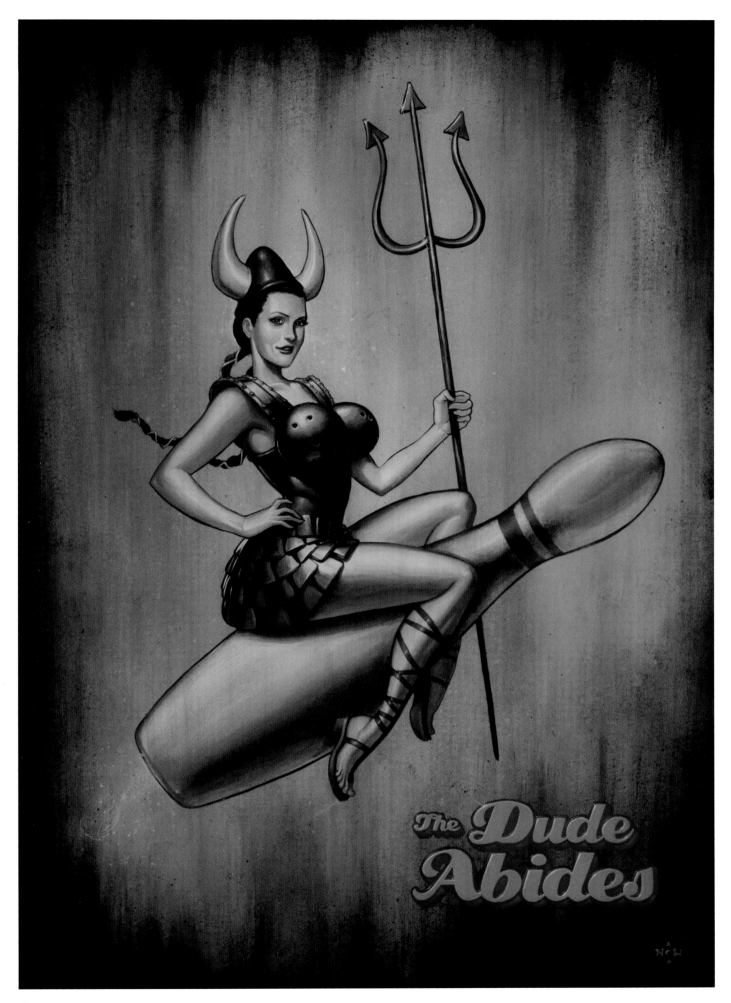

Above:
N.C. Winters
'The Dude Abides'
Acrylic on paper, mounted to wood panel with resin glaze, 19 x 27 inches
The Big Lebowski

Above:
Cory Benhatzel
'The Marmot Hearts Johnson's'
Acrylic on panel, 8 x 10 inches
The Big Lebowski

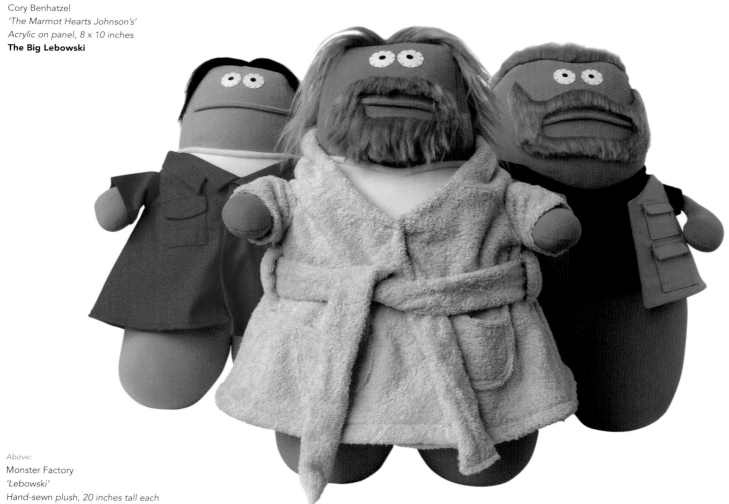

Above:
Monster Factory
'Lebowski'
Hand-sewn plush, 20 inches tall each
The Big Lebowski

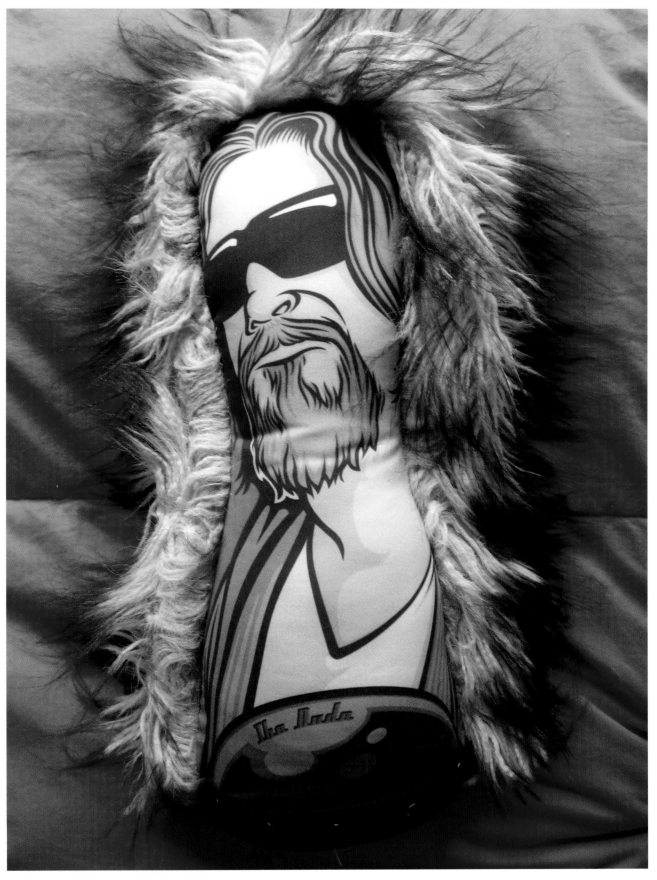

Above:

Reuben Rude

'Big Lebowski Circus Punk'

The Big Lebowski

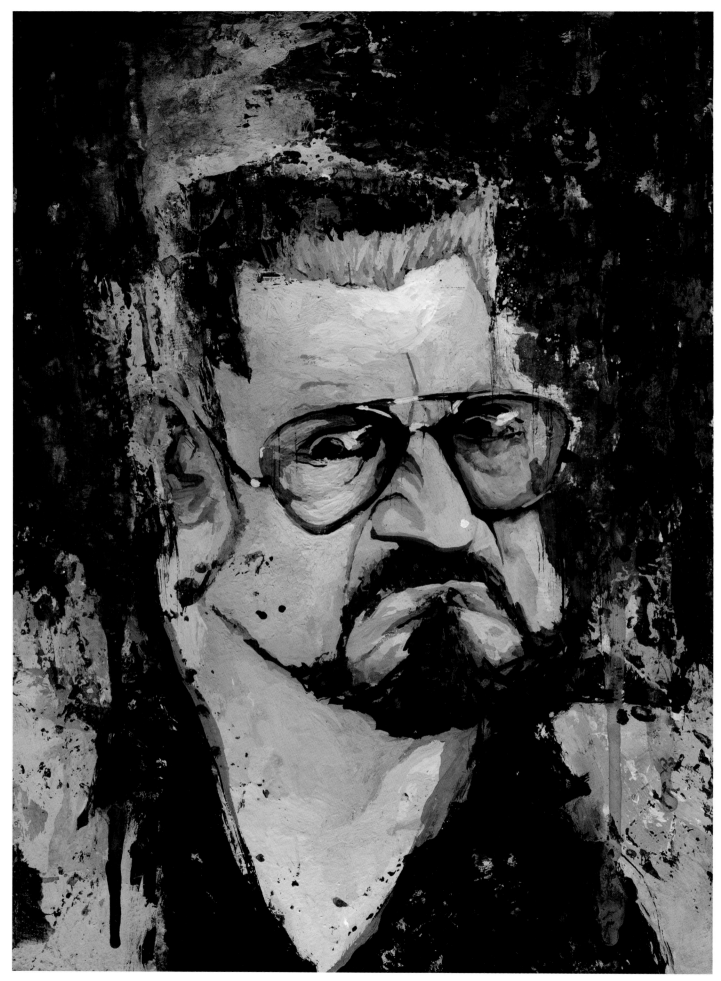

Above:
Rich Pellegrino
'Mr. Sobchak'
Gouache, ink, watercolor and acrylic on hardboard, 5 x 7 inches
The Big Lebowski

Right:
Carlos Ramos
'The Jesus'
Cel vinyl on wood
The Big Lebowski

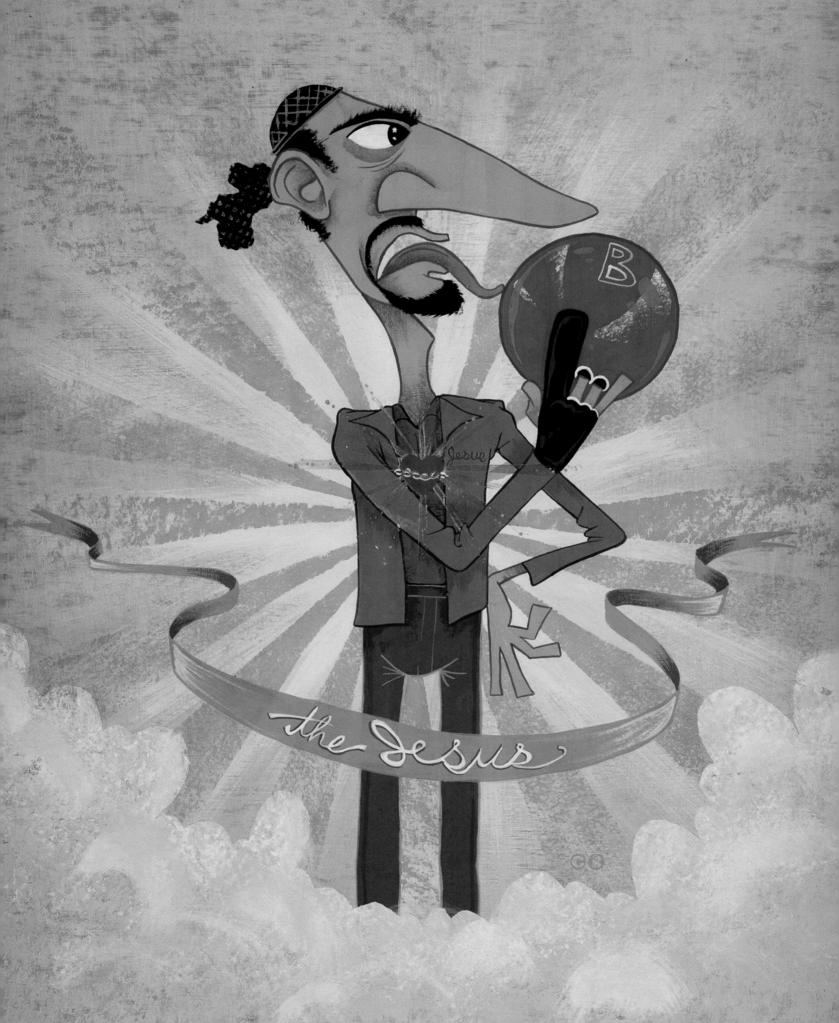

2Cents
www.yesyes.tv

64 Colors
www.64colors.com

APAK
www.apakstudio.com

Ana Bagayan
www.anabagayan.com

Paul Barnes
www.paul-barnes.com

Roger Barr
www.i-mockery.com

Scott Belcastro
www.scottbelcastro.com

Cory Benhatzel
www.corybenhatzel.com

Jonathan Bergeron
www.johnnycrap.com

Luke Berliner
www.lukeberliner.blogspot.com

Leanne Biank
www.leannebiank.com

Blinky
www.facebook.com/blinkyone

Mark Bodnar
www.markbodnar.com

Shannon Bonatakis
www.shannonbonatakis.com

Steven Bossler
www.greenseedstudios.com

Jeff Boyes
www.visualtechnicians.com

Drake Brodahl
www.drakebrodahl.com

Glen Brogan
www.albinoraven.com

Mark Brown
www.browntownstudios.com

Danielle Buerli
www.dbuerli.com

Jude Buffum
www.judebuffum.com

Julian Callos
www.juliancallos.com

Scott Campbell
www.pyramidcar.com

Keeley Carrigan
www.keeleycarrigan.com

Graham Carter
www.graham-carter.co.uk

Eunice Choi
www.unniq.blogspot.com

Kennis Chow
www.kennischow.com

Colin Christian
www.colinchristian.com

Sas Christian
www.saschristian.com

Luke Chueh
www.lukechueh.com

The Chung
www.thechung.com

Sean Clarity
www.fnaok.com

Anthony Clarkson
www.anthonyclarksonart.com

JAW Cooper
www.jawcooper.com

Nic Cowan
www.niccowan.com

Jason d'Aquino
www.jasondaquino.com

Justin Degarmo
www.justindegarmo.com

Andrew DeGraff
www.andrewdegraff.com

Kirk Demarais:
www.kirkdemarais.com

James "Jimbot" Demski
www.jimbot.com

Camilla d'Errico
www.camilladerrico.com

Bob Dob
www.bobdob.com

Jay Oddzoo Doronio
www.parallel-play.com

DrilOne
www.drils.com

David Eichenberger
www.david-eichenberger.carbonmade.com

Daniel Elson
www.danielelson.com

Kiersten Essenpreis
www.youfail.com

Shepard Fairey
www.obeygiant.com

Louis Fernet-Leclair
www.i-mockery.com

Ewelina Ferruso
www.ferrusos.com

Brendon Flynn
www.brendonflynn.net

Eric Fortune
www.ericfortune.com

Alessandra Fusi
www.alessandrafusi.com

Ken Garduno
www.kengarduno.com

Erica Gibson
www.iamericagibson.com

Lucas Gluesenkamp
www.lucasgluesenkamp.com

Frank Gonzales
www.frankgonzales.net

Dan Goodsell
www.mistertoast.com

Leontine Greenberg
www.leontinegreenberg.com

Sunny Gu
www.sunnygu.weebly.com

Kurt Halsey Frederiksen
www.kurthalsey.com

Jim Harker
www.jeremyharker.com

Naoto Hattori
www.wwwcomcom.com

Tom Haubrick
www.haubscomix.com

Jason Hernandez
www.jasonhernandezart.com

Jim Horwat
www.jimhorwat.com

Stella Im Hultberg
www.stellaimhultberg.com

Krista Huot
www.kristahuot.com

Charlie Immer
www.charlieimmer.com

Mari Inukai
www.mariinukai.com

Aaron Jasinski
www.aaronjasinski.com

Ron Job
www.artbyronjob.com

Sarah Joncas
www.teapartylove.digitalinkz.com

Justin Kalmen
www.jkalmen.com

Ayami Kawashima
www.ayamikawashima.com

Andy Kehoe
www.andykehoe.net

Ken Keirns
www.kenkeirns.com

Jeremiah Ketner
www.jeremiahketner.com

Megan Kimber
www.megankimber.com

Alex Kirwan
www.alexkirwanportfolio.com

Alan Kocharian
www.alankocharian.com

Christopher Lee
www.thebeastisback.com

Jason Limon
www.jasonlimon.com

Scott Listfield
www.astronautdinosaur.com

Little Friends of Printmaking
www.thelittlefriendsofprintmaking.com

Travis Louie
www.travislouie.com

Dan Lydersen
www.danlydersen.com

Mike Maas
www.greenfuzz.net

Dave MacDowell
www.macdowellstudio.com

Jim Mahfood
www.40ozcomics.com

Laz Marquez
www.lazmarquez.com

Dan May
www.dan-may.com

Jeff McMillan
www.jeffmcmillan.com

Brandi Milne
www.brandimilne.com

Misha
www.misha-art.com

Mike Mitchell
www.sirmikeofmitchell.com

Monster Factory
www.monsterfactory.net

Chris B. Murray
www.chrisbmurray.com

Mylan Nguyen
www.lonelywithoutyou.com

Brent Nolasco
www.brentnolasco.blogpsot.com

Keith Noordzy
www.wonderingart.com

Kathie Olivas
www.miserychildren.com

Yuta Onoda
www.yutaonoda.com

Nathan Ota
www.nathanota.com

Augie Pagan
www.augiepagan.com

Alex Pardee
www.eyesuckink.com

Ruel Pascual
www.ruelpascual.com

Rich Pellegrino
www.richpellegrino.com

Dave Perillo
www.montygog.blogspot.com

Billy Perkins
www.cultofpenhead.com

Brandt Peters
www.brandtpeters.com

Audrey Pongracz
www.audreypongracz.com

Steve Purcell
www.spudvisionblog.blogspot.com

Jeff Ramirez
www.jefframirez.com

Carlos Ramos
www.thecarlosramos.com

Jen Rarey
www.jenrarey.com

Allison Reimold
www.allisonreimold.com

Lesley Reppeteaux
www.reppeteaux.com

Irma Rivera
www.eltiempodelacolmena.blogspot.com

Danielle Rizzolo
www.danieller.com

Reuben Rude
www.reubenrude.com

Hee Ryoung
www.heeryoung.blogspot.com

Chris Sanchez
www.chrissanchezart.com

Israel Sanchez
www.israelsanchez.com

Ryan Sanchez
www.ryansanchez.com

Nigel Sanders
www.nothingrhymeswithnigel.com

Brandon Schaefer
www.seekandspeak.com

Marcus Schafer
www.chunkymaggots.de

Scott Scheidly
www.flounderart.com

Wade Schin
www.atibia.com

Scribe
www.scribeswalk.com

Shark Toof
www.sharktoof.com

Greg Simkins
www.imscared.com

Todd Slater
www.toddslater.net

Jon Smith
www.smithbellcraft.com

Sarah 'Sae' Soh
www.saesoh.com

Amy Sol
www.amysol.com

Joey Spiotto
www.jo3bot.com

Nathan Stapley
www.nathanstapley.com

Michael Steele
www.steeleart.com.au

Andy Suriano
www.andyupdates.blogspot.com

Roland Tamayo
www.rolandtamayo.com

Eric Tan
www.erictanart.blogspot.com

Task One
www.taskoner.com

Cameron Tiede
www.camerontiede.com

Kevin Tong
www.tragicsunshine.com

Juri Ueda
www.juriueda.com

Joe Vaux
www.joevaux.com

Kelly Vivanco
www.kellyvivanco.com

Casey Weldon
www.caseyweldon.com

Tom Whalen
www.strongstuff.net

Andrew Wilson
www.andrewandavid.blogspot.com

N.C. Winters
www.ncwinters.com

Cherri Wood
www.c-wood.tumblr.com

Yoskay Yamamoto
www.yoskay.com

Johnny Yanok
www.johnnyyanok.com

Chet Zar
www.chetzar.com

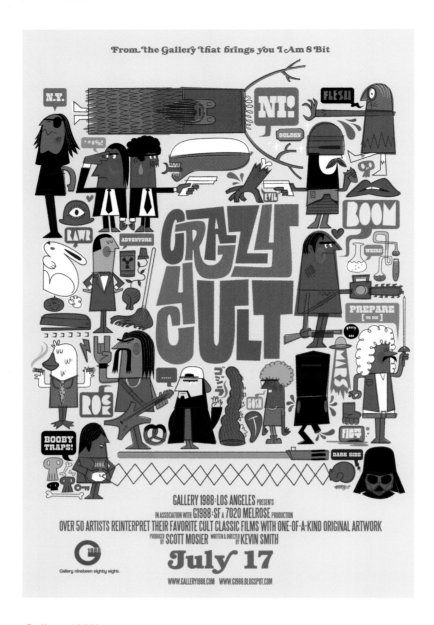

Right:
Christopher Lee
'Crazy 4 Cult Commemorative Show Poster'
Digital poster, 24 x 36 inches
Various cult movies

Front cover:
Billy Perkins
'Mushroom Cloud-Layin' MF'
4 color screenprint on 100lbs cover stock, 20 x 26 inches
Pulp Fiction

Back flap:
2Cents
'Silent Bob'
Hand-pulled screenprint, 16 x 20 inches
Clerks

Case front:
Scott Campbell
'Crazy 4 Cult Tree'
Watercolor on paper, 20 x 30 inches
Various cult movies

Case back:
Dan Lydersen
'Seven Deadly Sins'
Oil on wood, 30 inch diameter
Various cult movies

Gallery 1988's
CRAZY 4 CULT: CULT MOVIE ART
ISBN: 9780857681034

Published by
Titan Books
A division of Titan Publishing Group Ltd.
144 Southwark St.
London
SE1 0UP

First edition: June 2011
10 9 8 7 6 5 4 3 2 1

Did you enjoy this book? We love to hear from our readers. Please e-mail us at:
readerfeedback@titanemail.com or write to Reader Feedback at the above address.

To receive advance information, news, competitions, and exclusive offers online, please sign up for the Titan newsletter on our website: **www.titanbooks.com**

A CIP catalogue record for this title is available from the British Library.

Printed in China by C&C Offset Printing Co., Ltd.